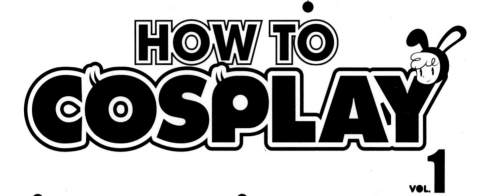

VOL. **1**

HOW TO COSPLAY 1
COS☆NOTE
Transformation and Special-effects Make-up

Copyright © 2009 Graphic-sha Publishing Co., Ltd.

This book was first designed and published in 2008 by Graphic-sha
Publishing Co., Ltd.
1-14-17 Kudankita, Chiyoda-ku, Tokyo 102-0073 Japan

This English edition was published in 2009 by Graphic-sha Publishing
Co., Ltd.

Supervisor and Illustlation: Kyoko Nakano
Original layout and cover design: Yukiko Wakabayashi
Photography: Nanao Kikuchi
Make-up: Keizo
Special-effects make-up: Hyakutake Studio/ Tomo Hyakutake,
Manabu Namikawa, Mitsuhiko Hirata, Keiko Nakanishi
Editor: Kaori Okumura
Project editor: Sahoko Hyakutake (Graphic-sha Publishing Co., Ltd.)
English edition cover design: Hidetaka Koyanagi (Raidensha Co., Ltd.)
English edition Layout: Shinichi Ishioka
English Translation: Mary Kennard
Overseas edition project coordinator: Takako Motoki (Graphic-sha
Publishing Co., Ltd.)
Project management: Kumiko Sakamoto (Graphic-sha Publishing Co.,
Ltd.)

Special thanks to Kota Oohashi and Sodeka Namikawa.

First printing: April 2009

ISBN: 978-4-7661-1960-2
Printed and bound in China

Contents

004 Opening photographs

004 VAMPIRE HUNTER AULBATH

007 The Melancholy of Suzumiya Haruhi

009 PERSONA 3

012 Rozen Maiden

015 Black Jack

018 Chapter 1
 Comprehensive Guide to Base Make-up

019 1-0 The Basics: Getting Ready – The Basic Tools You'll Need

020 1-1 Foundation Basics

022 1-2 Covering Up Skin Flaws

026 Column: Basics - Removing Make-up

028 Chapter 2
 Eyes, Eyebrows and Eyelashes

029 2-1 Eyebrows and Eyelashes

032 2-2 Covering Up Eye Flaws

043 2-3 Characters

046 Chapter 3
 Shadowing and Highlights

047 3-0 Basic Methods: Shadowing and Highlights

048 3-1 Make-up that Follows the Bone Structure of the Face

060 3-2 Make-up Patterns

062 Column: Changeover: Natural → White (dyed)

063 Chapter 4
 Basics of Male and Female Costumes

064 4-1 Eye and Eyebrow Patterns: Male Costumes

074 4-2 Eye and Eyebrow Patterns: Female Costumes

082 Chapter 5
Comprehensive Guide to Greasepaint

083 5-1 Basics of Greasepaint

088 5-2 Character Make-up

092 Chapter 6
Introduction to Special Effects Make-up!

093 6-1 Blood-stained Bandages

096 6-2 Faded Battle Scars

096 6-3 Fresh Wounds

097 6-4 Painted-on Stitched Wounds

098 6-5 Bullet Holes

100 6-6 Facial Blood Vessels

102 6-7 Facial Bruises

103 6-8 Tattoo on the Nape of the Neck

104 6-9 Wrinkles and Blood Vessels on the Hand

106 6-10 Webbing

108 6-11 Scales on the Back

109 Chapter 7
"Making of" the Opening Photographs

110 Rozen Maiden: Suigintou

112 Black Jack

116 VAMPIRE HUNTER AULBATH

120 Event Report

132 World CosPlay Summit 2008 Special Report

137 Information

144 Model Profile

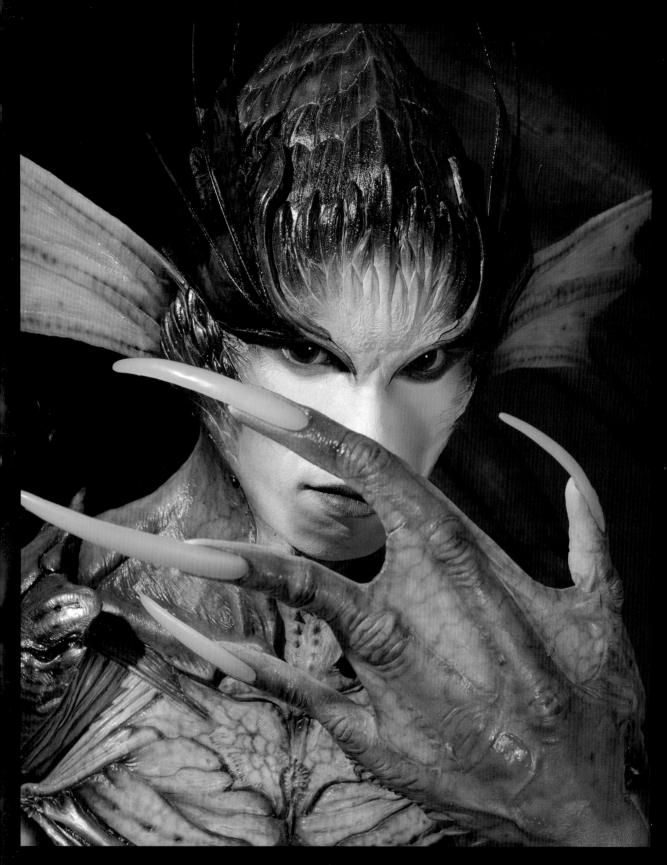

VAMPIRE HUNTER
AULBATH

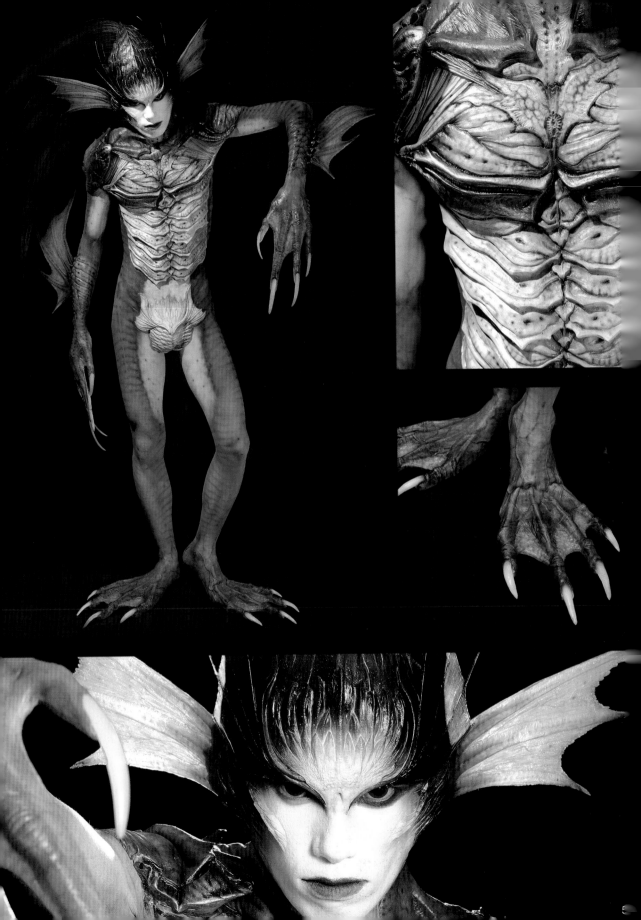

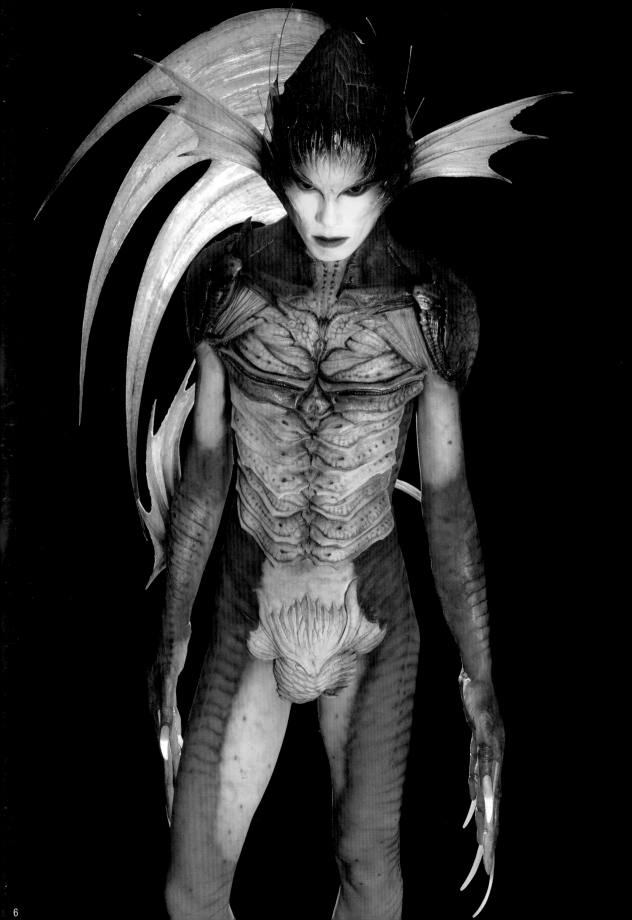

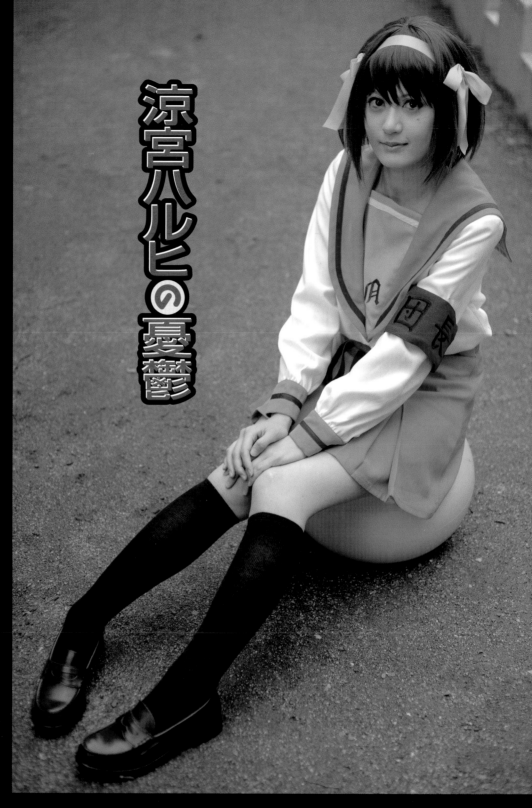

涼宮ハルヒの憂鬱

The Melancholy of Haruhi Suzumiya

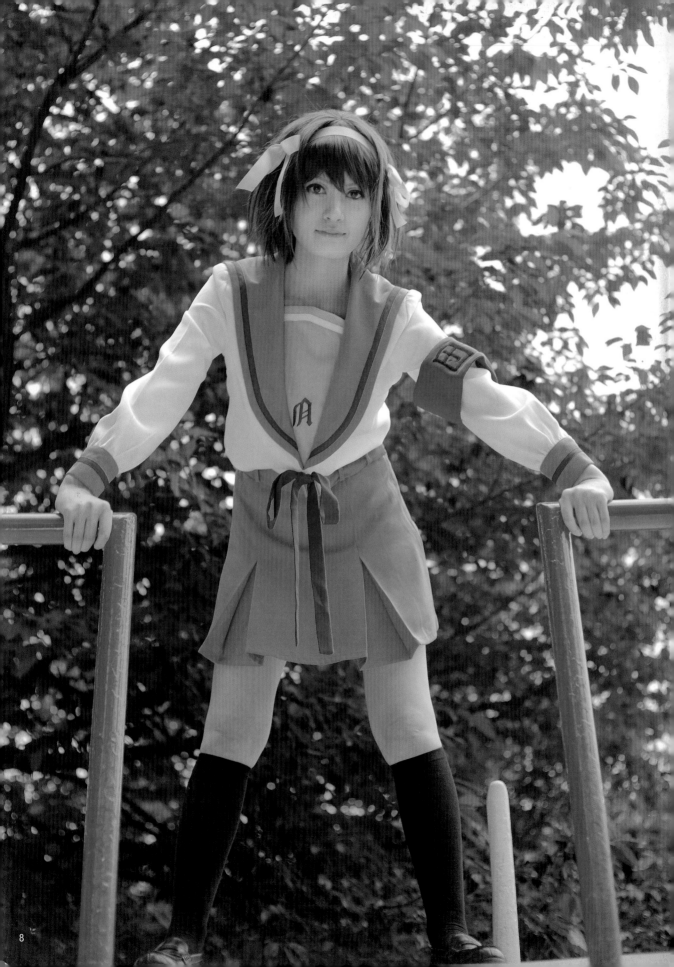

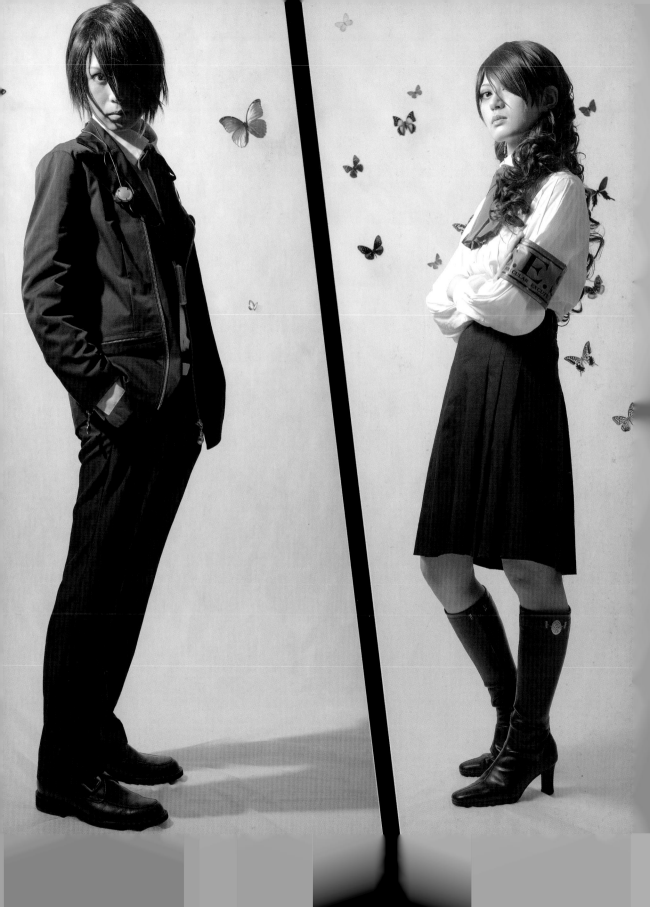

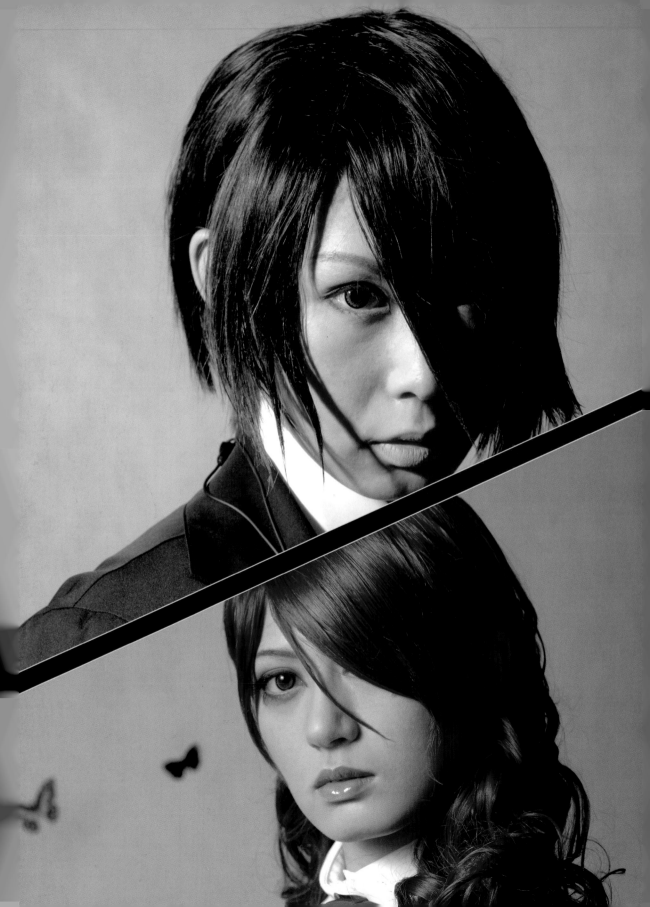

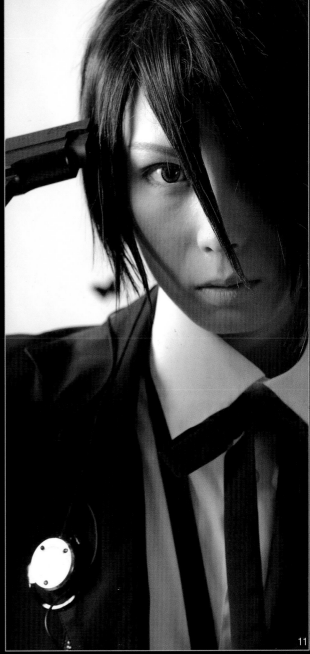

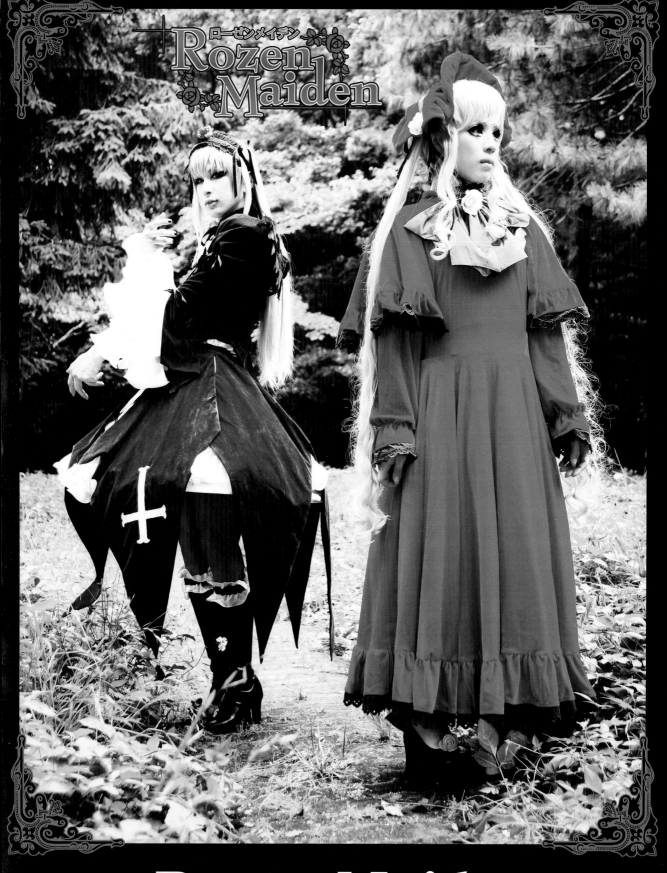

Rozen Maiden

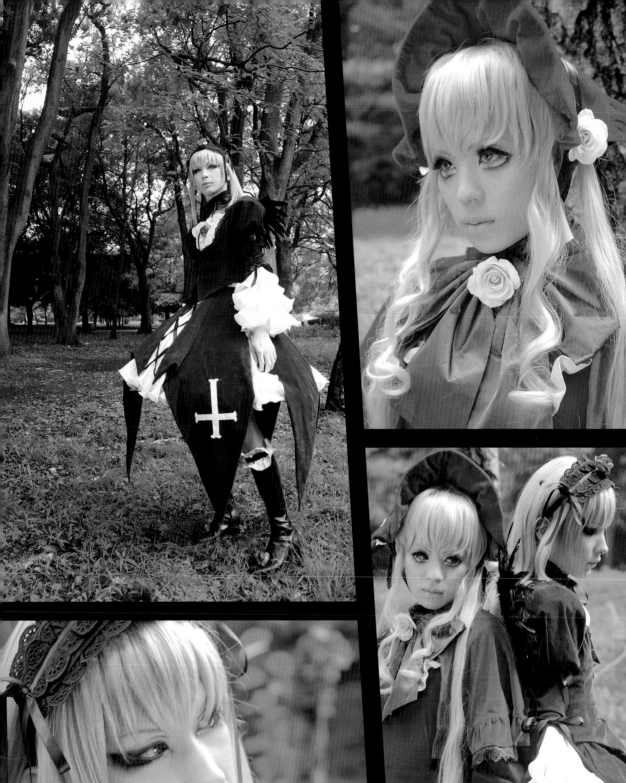
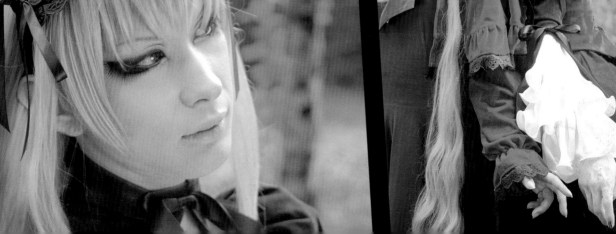

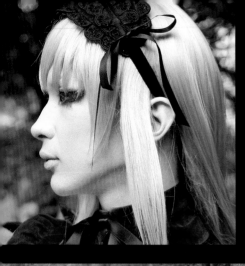
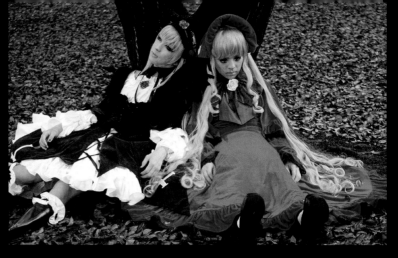
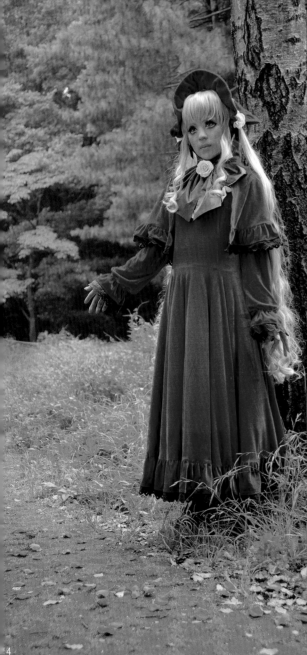
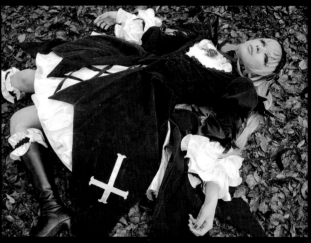
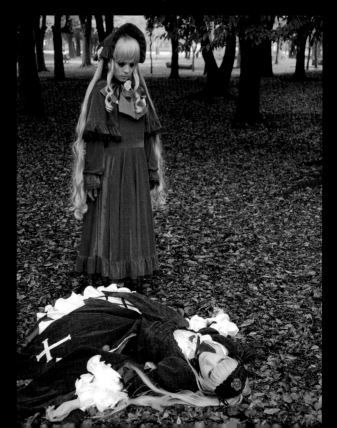

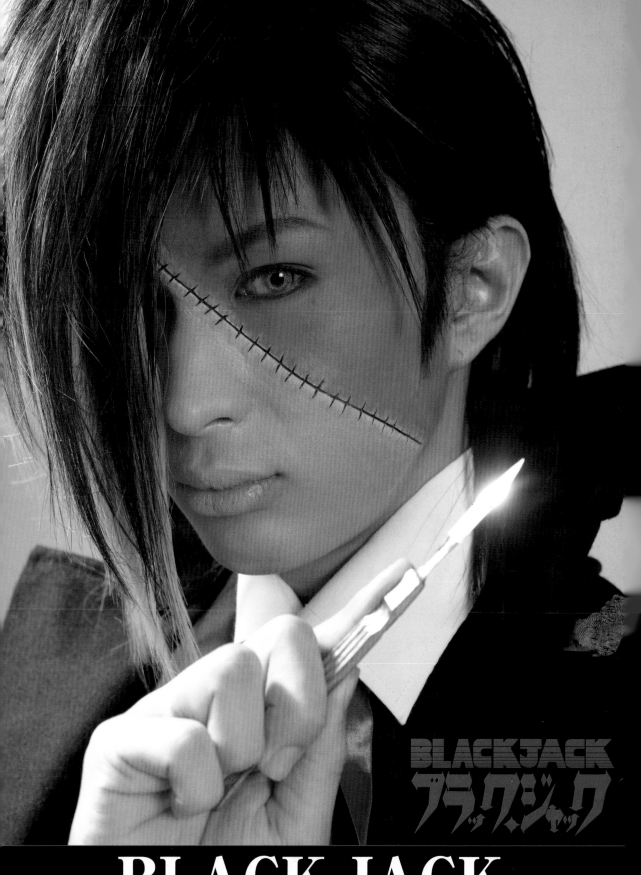

BLACK JACK

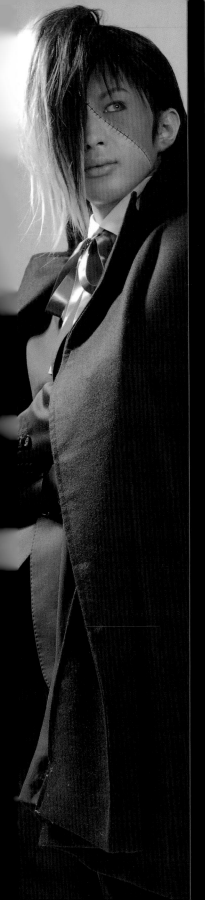
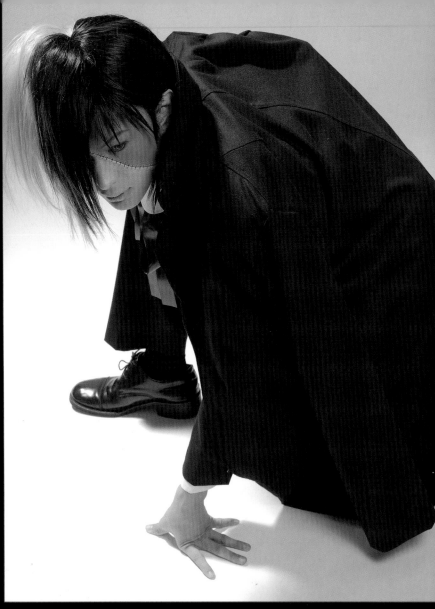
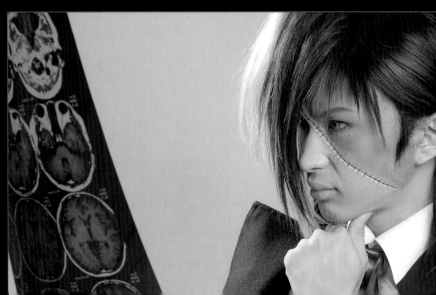

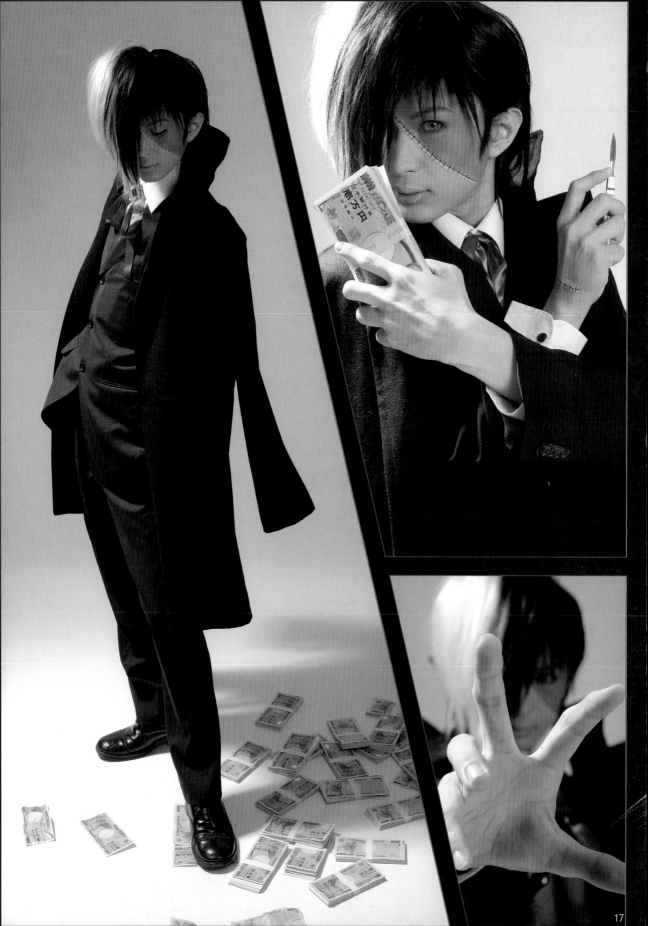

Chapter 1

Comprehensive Guide to Base Make-up

Put red paint on white paper and then on paper that has been stained with tea; both reds are beautiful.

Base make-up is the foundation upon which you will layer your final make-up. If the resulting color contrasts look beautiful, then you have applied your make-up successfully.

If the base is a beautiful skin color, then you will only need a very light layer of make-up. With a matte foundation, if you don't use richer colors, the make-up won't stand out very much. In other words, you have to use heavier make-up.

When it comes to foundation, for both beginners and those with experience, we recommend mastering the basics of "Creating a light, beautiful foundation"!

1.0 Foundation Edition Here's what you will need!
Basic make-up tools

You'll need to gather four types – base make-up, liquid foundation, concealer and powder.
Here we introduce the base make-up that the models in this book used. First, visit a cosmetics shop or similar store to find out if your skin is oily or dry, and if your skin tone is yellow (ochre) or red (pink). Choose products that suit your skin type and tone.

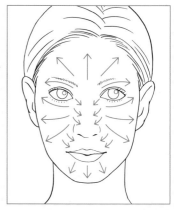

Get these ready!
Base make-up and cosmetics

Powder (Mitsuyoshi Loose Powder Natural)

Cream Foundation
(Mitsuyoshi Stage Foundation Pro)

Make-up Base
Example: Sharena Make-up Base

Liquid Foundation
Example: Sharena Liquid Foundation
(HV-13, HV-14, HV-16)

Make-up remover for around the eyes
Example: MAKE UP FOR EVER
Sens'Eyes

Cleansing Oil
Example: Sharena
Cleansing Oil

Before putting on make-up…
Conceal wrinkles, moles and facial hair

Get these ready!
Example of concealer

MAKE UP FOR EVER Full Cover (No. 9, No. 10)
Mitsuyoshi Stage Foundation Pro Men's
(Choose the same color as your skin. When covering bags under the eyes or facial hair, use a reddish-brown color.)

How to remove make-up correctly

Don't scrub; remove make-up gently.
Eyebrows and around the eyes: Use a left to right action. Elsewhere, use a circular motion as show in the illustration.

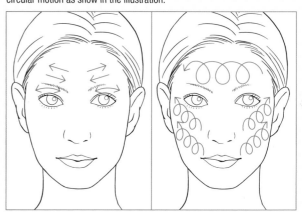

Foundation Basics

You've got the perfect handmade costume – but that charming costume will be wasted if your face is drab and bare of make-up.

It's said that if you use bace make-up to lay a good foundation, your job is halfway done. Bace make-up is just as important if you're dressing up in a men's costume or as an alien creature. This is a point we can't emphasize strongly enough.

Before [make-up]

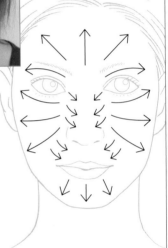

Apply in an upward direction along the nose, and sweeping outward under the eyes and on the forehead and chin. Use a face brush to apply powder in the final step.

Make-up item

There are four basic products you will need – make-up base, liquid foundation, concealer, and powder. If you don't buy anything else, get these four items. Make sure they are high quality and suited to your skin type. *signifies a must-have item

*1. Sharena Make-up base

2. Liquid foundation
Sharena Liquid Foundation
(HV-13, HV-14, HV-16)

*4. Powder
(Mitsuyoshi Loose Powder Natural)

3. Concealer
MAKE UP FOR EVER Full Cover
(No. 9, No. 10),
Mitsuyoshi Stage Foundation Pro Natural
Ochre

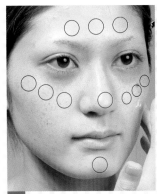

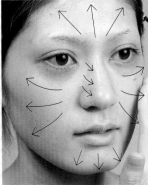

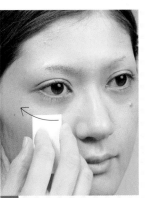

2

Using your finger, apply liquid foundation in the direction indicated by the arrows, beginning with the cheekbones. Around the mouth and eyes, where the skin is thinner, put a small amount of foundation on your finger and spread it so that it doesn't gather in the wrinkles there. You can mix Sharena HV-13, HV-14 and HV-16 here.

1 Apply Sharena Make-up Base (Transparent), using your finger. You'll apply most of the make-up in this book the same way. Next apply dots of foundation where the circles are, beginning with the broadest part of the cheekbones. Choose a color that is either one level darker than your skin color or the same color as the skin of your neck. If the color is too light, your face will seem to "float", and will look larger than it really is. At this point the foundation can become lumpy if you rub it.

3 Spread the foundation using a sponge, from the center of your face to the outer edges.

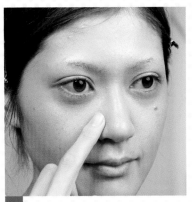

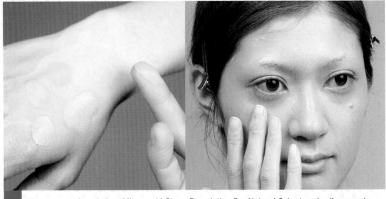

4 To lighten up the area on the side of the nose, which can look dull, apply a concealer such as MAKE UP FOR EVER Full Cover 9 or 10, using your finger. Be careful not to use too much concealer in the soft areas, such as under the eyes; it may look cracked and dry.

5 Use a cream foundation (Mitsuyoshi Stage Foundation Pro Natural Ochre) under the eyes to brighten them up. Use the back of your hand as a palette to check the color, and then apply little by little. Use your middle finger to apply the make-up, and it is easier to regulate the pressure applied. Cover dark areas and flaws under the eye and on the cheeks.

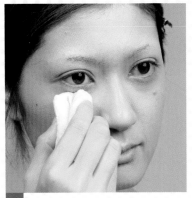

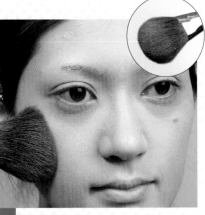

6 Use a sponge to blot any tracks left by your finger.

7 Use a face brush to dust powder (Mitsuyoshi Loose Powder Natural) lightly over the foundation to set it. Don't use too much. Start with the areas next to the eyes and nose.

8 Use the brush to dust off extra powder and you're finished.

1.2 Covering Up Skin Flaws

1 Covering up moles, bags and shaving nicks

Before the make-up, and even before the base make-up, there's the "pre-make-up"!

Before

It's impossible to completely cover flaws, so the object is to expand the gradation, without making the make-up look unnatural.

Make-up item

Sharena Liquid Foundation (HV-16, HV-17)

Mitsuyoshi Loose Powder Natural

Mitsuyoshi Stage Foundation (Men's, Ochre)

Bags and Beards

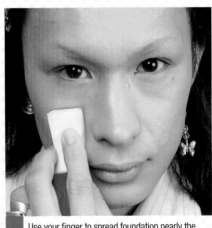

1 Use your finger to spread foundation nearly the same color as the bags or shaving nicks (a mixture of Sharena Liquid Foundation HV-16 HV-17), and pat with a sponge.

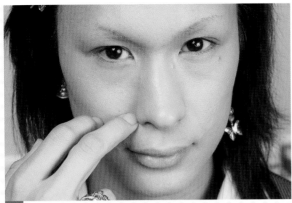

2 Use your finger to spread the foundation you applied in 1, and blend in to form a gradation of the entire face.

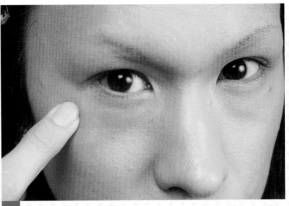

3 On top of this layer, apply a color similar to the bags or beard as they look now (mix Mitsuyoshi Stage Foundation Men's and Ochre), and spread it with your finger to broaden the gradation.

4 Bags and beards have a bluish tint, so apply a small amount of red-tinted foundation directly to the beard or bags. Be really careful here, because if you use too much, it will have the opposite effect to that intended – the eye will be drawn to that spot!

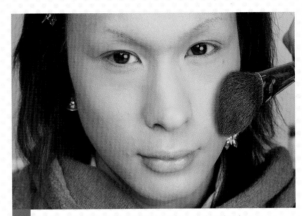

5 Brush a light powder over the entire face, and you're done.

Hiding moles

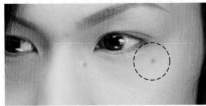

1 If the mole is flush with the skin, and color is the only problem, just use a concealer to cover it up. But if the mole is raised, use cream foundation to blend it in.

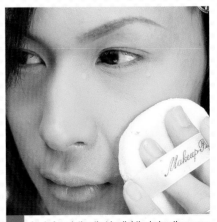

2 Apply foundation that is slightly darker than your skin (mix Mitsuyoshi Stage Foundation Men's and Ochre) to the mole and spread it so that if forms a circle slightly larger than the mole.

Tricks for hiding shine and preventing make-up from wearing off

Your make-up wears off because your skin grows oilier as time passes. In other words, areas that are shiny are also the places where your make-up wears off the fastest. Generally, if you cover an oil-based product with a water-based product and then with powder, your make-up will last longer.

Before

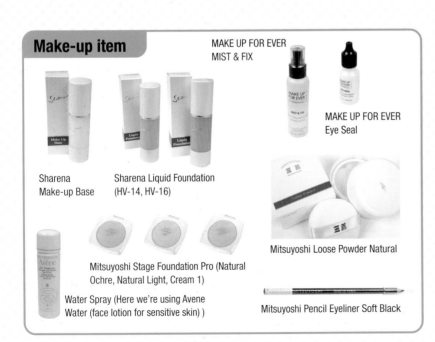

Make-up item

Sharena Make-up Base

Sharena Liquid Foundation (HV-14, HV-16)

MAKE UP FOR EVER MIST & FIX

MAKE UP FOR EVER Eye Seal

Mitsuyoshi Stage Foundation Pro (Natural Ochre, Natural Light, Cream 1)

Water Spray (Here we're using Avene Water (face lotion for sensitive skin))

Mitsuyoshi Loose Powder Natural

Mitsuyoshi Pencil Eyeliner Soft Black

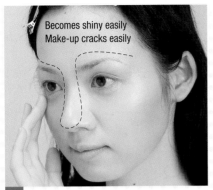

Becomes shiny easily
Make-up cracks easily

1 Apply Sharena Make-up Base, and then foundation (for lighter areas, use Sharena Liquid Foundation HV-14; for darker areas, use HV-16). Instead of concealer, use a cream foundation (mix Mitsuyoshi Stage Foundation Pro Natural Ochre + Natural Light + Cream 1) under the eyes and at the sides of the nose.

2 Pat on powder (Mitsuyoshi Loose Powder Natural).

3 Coat everything with water spray. Here we are using Avene Water (face lotion for sensitive skin). Hold the bottle away from your face and spritz to cover the entire surface.

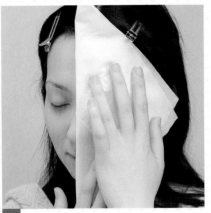

4 Open out a tissue and gently cover your face with it. Press slowly and then remove. After removing the tissue, apply powder (Mitsuyoshi Loose Powder Natural) again.

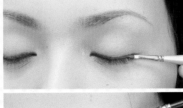

5 Use an eyeliner (Mitsuyoshi Pencil Eyeliner Soft Black), and coat with Mitsuyoshi Eye Seal. If you are drawing in eyebrows, do that now, and coat those with Mitsuyoshi Eye Seal as well.

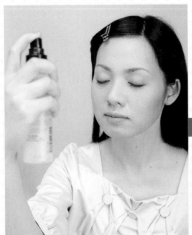

6 If you are particularly worried about your make-up wearing or flaking off (especially for those with oily skin) spray Mitsuyoshi Mist & Fix over your entire face, and you're done. If you have problems with your make-up in the middle of an event, blot the oil with a tissue and apply powder foundation with a make-up pad.

Basics - Removing Make-up

Before getting down to serious skin care, you have to get all of that make-up off first! Here we're going to tell you how to remove your make-up completely, as well as how to remove some make-up if you're at an event.

If you need to remove this kind of make-up…

→

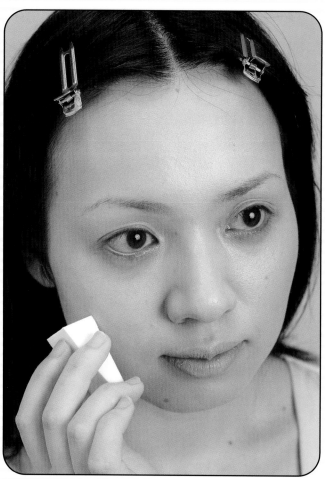

MAKE UP FOR EVER
Sens'Eye (Make-up Remover)

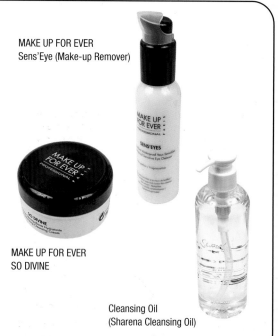

MAKE UP FOR EVER
SO DIVINE

Cleansing Oil
(Sharena Cleansing Oil)

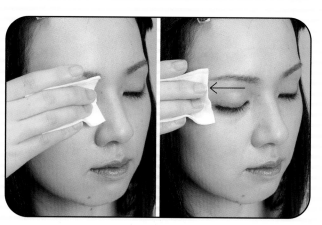

1 Put MAKE UP FOR EVER Sens'Eye (Make-up Remover) on a cotton pad and hold it over your eye for about 5 seconds, before swiping it toward the outer edge of the eye.

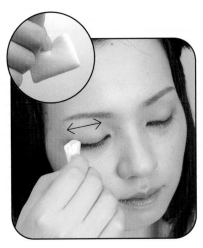

2 Fold the cotton pad and use a corner to wipe off finely applied make-up.

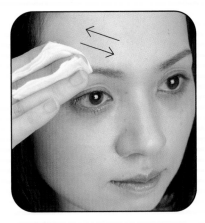

3 Also use the cotton to clean off your eyebrows and lips. Hold the cotton over the area to be cleaned for about 5 seconds, and then wipe in the direction of the arrows.

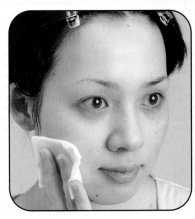

4 Clean your entire face using the cotton pad.

5 Put some cleansing oil (Sharena Cleansing Oil) on your fingers and spread it evenly over your face in circles, as shown in the photo. Be sure to rinse with hot water. The hot water emulsifies the oil and washes it away. After that, wash your face again using a facial cleansing foam.

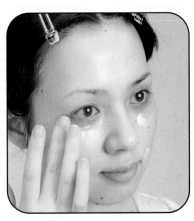

6 Apply cream to areas where wrinkles form easily, such as around the eyes, and you're done.

When you want to remove make-up quickly while at an event…

Make-up Item
MAKE UP FOR EVER SO DIVINE
Hot water (or cleansing sheets available at stores.

Important!
This is just partial make-up removal. When you get home, be sure to use cleansing oil and hot water to remove all of the make-up.

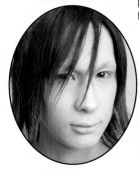

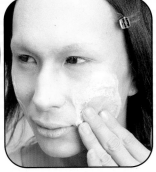

1 Put some MAKE UP FOR EVER SO DIVINE on your hand and apply it to your face in a circular motion, beginning with your cheeks.

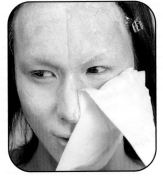

2 Press a tissue to your face and remove it carefully.

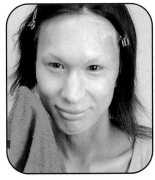

3 Wet a towel in hot water and wipe off the make-up. (If you don't have hot water, use a cleansing sheet.)

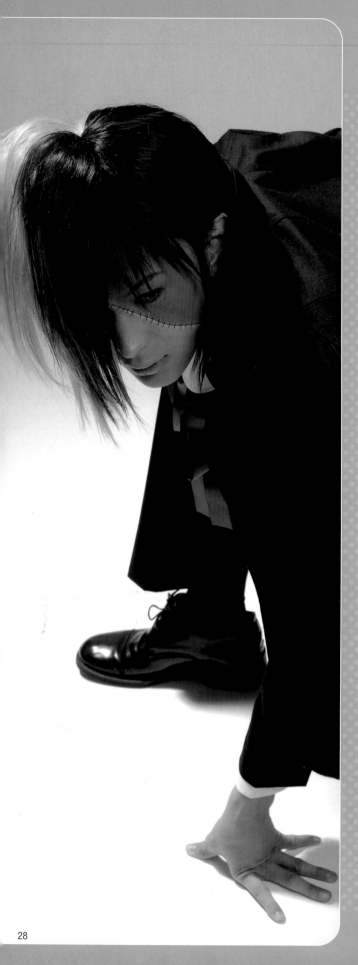

Chapter 2

Eyes, Eyebrows and Eyelashes

When you look at someone's face, the eyes always make the first and strongest impression. Even with magazine covers, for example, people don't select ones that don't have good eye energy.

It doesn't matter how beautiful your make-up is, if your eyes are indistinct, overall the look is a failure. Each character has his or her own eye shape and movement.

You can use eye make-up to change the appearance of your eyes drastically. Of course you can increase the energy, but you can also make slanted eyes droop, make droopy eyes elongated, and make small eyes larger, just to name a few tricks.

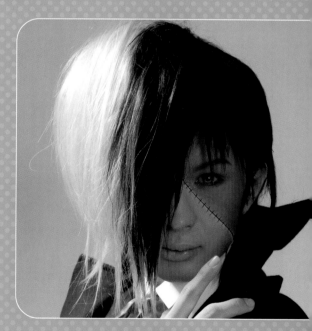

Eyebrows and eyelashes

1 Shaping your eyebrows

Just by changing the shape of the eyebrows, you can give your face a whole new look.

The techniques we'll discuss in this basic lecture – how to trim your brows, how to draw them in, and how to cover them up – can be used for any character.

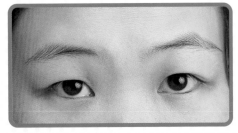

Before

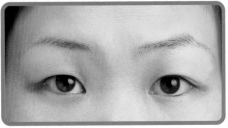

After

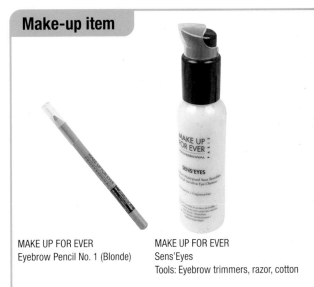
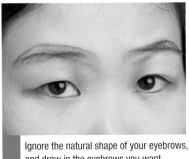

1 Ignore the natural shape of your eyebrows, and draw in the eyebrows you want.

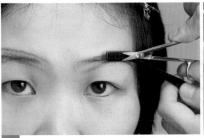

2 If you trim the eyebrows while they are flat, the results will not look natural; lift the hair of the eyebrows at a right angle and trim along the contour.

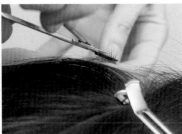

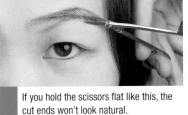

3 If you hold the scissors flat like this, the cut ends won't look natural.

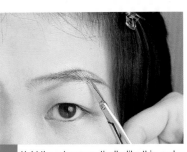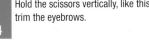

4 Hold the scissors vertically, like this, and trim the eyebrows.

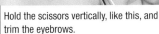

5 Use a razor to remove any extra hair, wipe of the contour line with make-up remover on a cotton pad, and you're done.

Drawing eyebrows

Make-up item

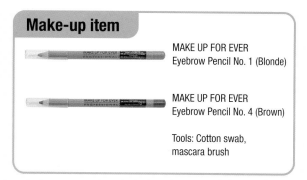

MAKE UP FOR EVER
Eyebrow Pencil No. 1 (Blonde)

MAKE UP FOR EVER
Eyebrow Pencil No. 4 (Brown)

Tools: Cotton swab,
mascara brush

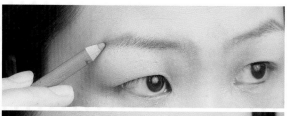

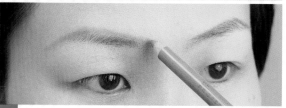

1 Starting at the top of the eyebrow arch, draw diagonal lines outwards on both eyebrows. You are drawing contour lines above the eyebrows. Next draw diagonal lines from the inner edge of the eyebrows up to the ends of the first diagonal lines.

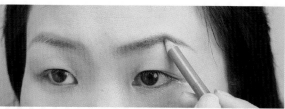

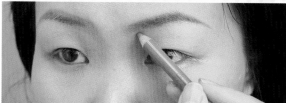

2 Draw in eyebrows underneath the contour lines. The line should be thicker at the inner edges, and grow thinner as you move outwards.

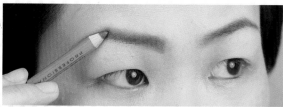

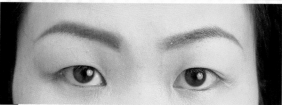

3 Look straight into a mirror to check that the left and right eyebrows are symmetrical.

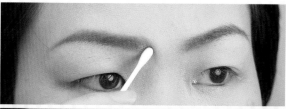

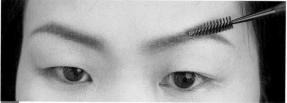

4 Smudge the inner edges of both eyebrows.
Use a mascara brush to slightly smudge the upper line of the eyebrow. If you smudge the entire eyebrow, it will look too blurry, so be careful (unless the character has eyebrows like that).

 Covering the eyebrows

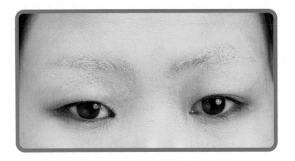

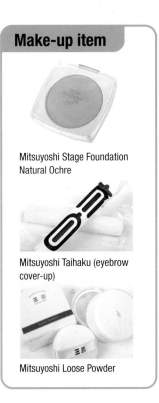
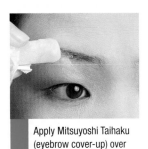

1 Apply Mitsuyoshi Taihaku (eyebrow cover-up) over the eyebrows.

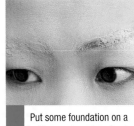

2 Put some foundation on a cotton swab and apply on top of the eyebrow cover-up.

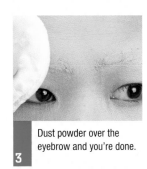

3 Dust powder over the eyebrow and you're done.

 How to put on false eyelashes

Putting false eyelashes on the right way is less important than creating the correct eye shape to match your costume. The first time you wear false eyelashes, you'll think, "My eyelids are so heavy!" – but you'll be used to them within 10 minutes.

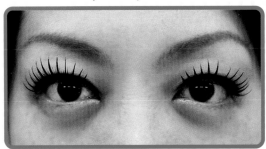

Before applying

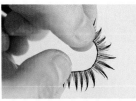

First, hold the false eyelashes between your thumb and forefinger and flex them to form a curve.

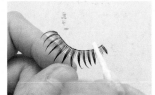

Apply the adhesive that comes with they eyelashes evenly. (You can also use Don Pishan cosmetic adhesive.)

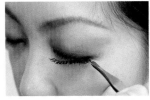 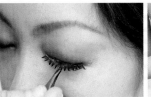 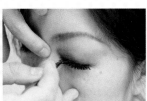

Attach beginning with the outer edge of the eye. Continue pressing on from the middle of the eye to the inner eye, and you're done.

To remove false eyelashes…

It's OK just to pull them off gently.
After a few uses, you can just roll off the glue that remains on the eyelashes, so don't worry about getting it all off. If you want to remove mascara or any other cosmetics you've applied to the eyelashes, just use some cleanser on a cotton swab.

1 Making both eyes look the same size

A face with perfect bilateral symmetry is beautiful, but while perfect symmetry may be possible in a manga or anime character, in reality, it is rarely seen. Here we're going to show you how to use make-up to make both eyes look the same size.

Before

To make it seem as if the left and right eyes are the same size, you'll use different amounts of make-up on each eye.

Make-up item

Sharena Face Color Pastel Green

MAKE UP FOR EVER
Mascara Volume No. 1

MAKE UP FOR EVER
Eyeshadow and Powder Blush
(No. 153, No. 121)

MAKE UP FOR EVER
Eye Pencil No. 3

Mitsuyoshi Pencil Liner Soft Black

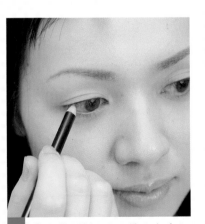

1 Start with whichever eye it's easier for you to work with. Use Mitsuyoshi Pencil Liner Soft Black to draw an eye line at the base of the eyelashes.

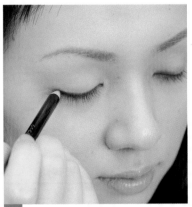

2 Use MAKE UP FOR EVER Eye Pencil No. 3 to draw a line under the eye.

When you've finished drawing the eye
you find it easiest to work with…

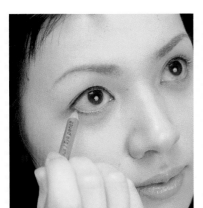

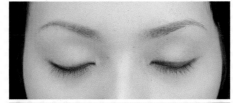

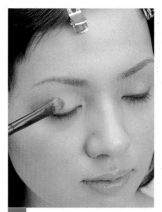

3 From the outer edge of the lower eyelid, draw an eye line about 1/3 across. The upper and lower lines should meet at the outer corner of the eye.

4 If that eye is the smaller eye, draw a thicker eye line on the other eye. If it is the larger eye, use a thinner eye line. Open both eyes and look straight into a mirror. Adjust the eye line until both eyes look like they are the same size. Draw in gradual stages until they appear the same.

5 Use MAKE UP FOR EVER Eyeshadow and Powder Blush No. 153 to cover the entire eyelid.

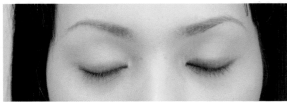

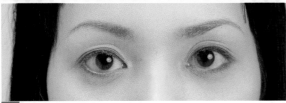

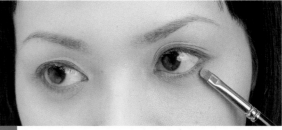

7 Add highlighting by applying Sharena Face Color Pastel Green along the bottom eyelid, about 1/3 the distance from the outer edge of the eye.

6 Just as you did with the eyeliner, start with the eye you're most comfortable working with, and apply eye shadow along the curve of the eye line, and then do the other eye, adding eye shadow until the eyes seem to be the same size. For this step, use MAKE UP FOR EVER Eye Shadow and Powder Blush No. 121.

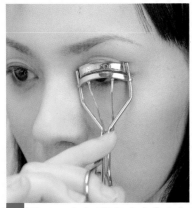

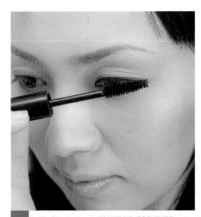

8 Use an eyelash curler to give both eyes the same degree of curl.

9 Apply mascara (MAKE UP FOR EVER Mascara Volume No. 1), and you're done.

2.2.2 Turning a double-fold eyelid into a single-fold eyelid

This is really a bigger job than turning a single-fold eyelid into a double-fold eyelid. Even without making a single-fold eyelid, you can make your eyes look long and narrow just with make-up.

Before

Use an eye shadow blush on the corner of the eyes.

Make-up item

Adhesive for double-fold eyelids Don Pichan

Sharena Face Color Black

MAKE UP FOR EVER Eye Shadow and Powder Blush No. 139

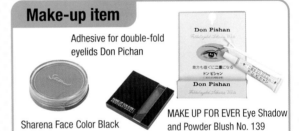

1 Use make-up remover to wipe off the foundation in the crease of the double fold.

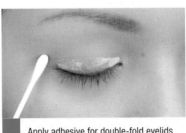

2 Apply adhesive for double-fold eyelids Don Pichan to the crease of the double fold.

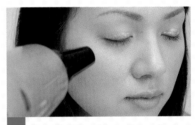

3 Dry with a blow dryer until the adhesive becomes transparent.

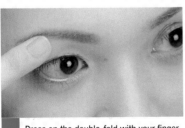

4 Press on the double-fold with your finger until the edges adhere to form a single fold.

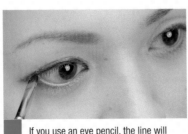

5 If you use an eye pencil, the line will crack, so use Sharena Face Color Black to draw an eye line.

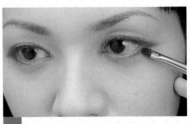

6 Apply MAKE UP FOR EVER Eye Shadow and Powder Blush No. 139 to follow along the eye line and, as in the photo, extend the outer corner of the eye, and you're done.

Turning a single-fold eyelid into the perfect double-fold eyelid

Rather than creating a double fold, it's actually more effective to use eye make-up to make the eye look bigger, but this is for those of you who just really want to make a double fold.

Before

Make-up item

VIVID Eye M

MAKE UP FOR EVER Eye Shadow and Powder Blush No. 126

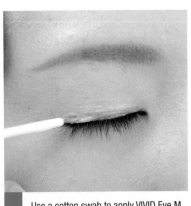

1 Use a cotton swab to apply VIVID Eye M from the edge of the eyelid to the line on the upper eyelid where you want the double fold to be.

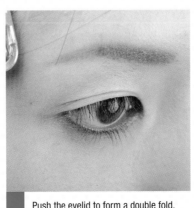

2 Push the eyelid to form a double fold.

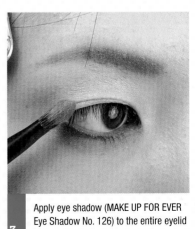

3 Apply eye shadow (MAKE UP FOR EVER Eye Shadow No. 126) to the entire eyelid and you're done.

2.2.4 Turning downward slanting eyes into long, narrow eyes

Single-fold eyelids are the focal point of "Asian Beauty."
By lifting the ends of the eyes and highlighting the inner corners of the eyes, you can change downward-slanting eyes into long, narrow eyes.

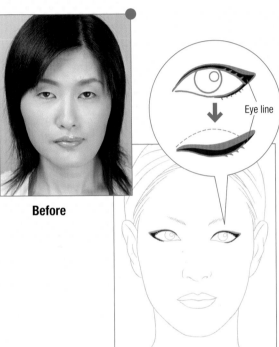

Before

Eye line

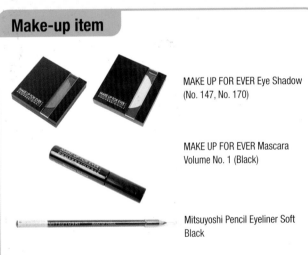

Make-up item

MAKE UP FOR EVER Eye Shadow
(No. 147, No. 170)

MAKE UP FOR EVER Mascara
Volume No. 1 (Black)

Mitsuyoshi Pencil Eyeliner Soft
Black

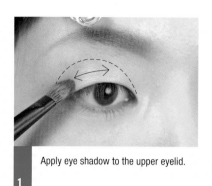

1 Apply eye shadow to the upper eyelid.

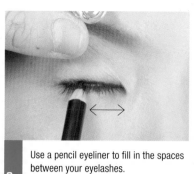

2 Use a pencil eyeliner to fill in the spaces between your eyelashes.

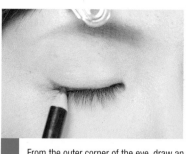

3 From the outer corner of the eye, draw an uninterrupted line across the edge of the upper eyelid.

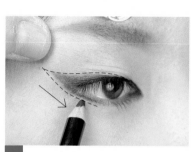

4 Draw an eye line from the outer edge of the line about 1/3 the way across the lower lid. The upper and lower eye lines should meet at the corner of the eye.

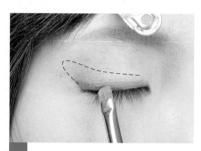

5 Apply a darker eye shadow (MAKE UP FOR EVER No.147) along the eye line, and smudge.

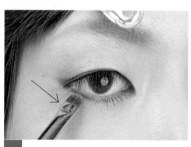

6 Do the same with the lower eyelid eye line.

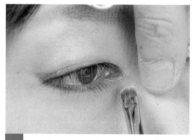

7 To highlight the inner corner of the eye, apply a whitish eye shadow (MAKE UP FOR EVER No.170).

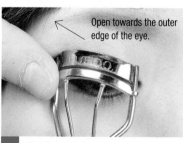

Open towards the outer edge of the eye.

8 Curl the eyelashes using an eyelash curler.

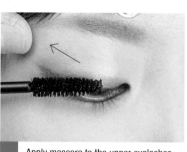

9 Apply mascara to the upper eyelashes, and you're done.

2.2.5 Making small eyes appear large!

If your eyes are on the small side, let's draw them larger! By giving the eyelashes lots of lift and drawing in 3-D gradation around the eyes, you can give your eyes much greater impact.

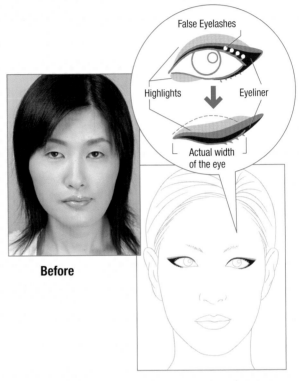

False Eyelashes

Highlights

Eyeliner

Actual width of the eye

Before

Make-up item

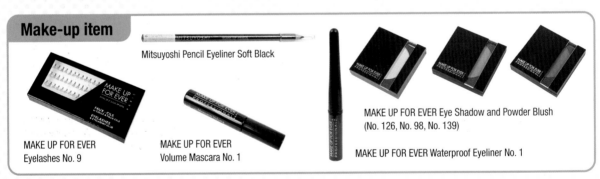

Mitsuyoshi Pencil Eyeliner Soft Black

MAKE UP FOR EVER
Eyelashes No. 9

MAKE UP FOR EVER
Volume Mascara No. 1

MAKE UP FOR EVER Eye Shadow and Powder Blush
(No. 126, No. 98, No. 139)

MAKE UP FOR EVER Waterproof Eyeliner No. 1

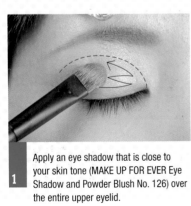

1 Apply an eye shadow that is close to your skin tone (MAKE UP FOR EVER Eye Shadow and Powder Blush No. 126) over the entire upper eyelid.

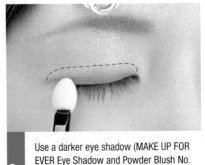

2 Use a darker eye shadow (MAKE UP FOR EVER Eye Shadow and Powder Blush No. 98) to draw a line from the edge of the upper eyelid to the double fold (to where you would like the double fold to be if you have single fold).

3 Use an even darker eye shadow (MAKE UP FOR EVER Eye Shadow and Powder Blush No. 139) to draw a triangle in the inner corner of the eye.

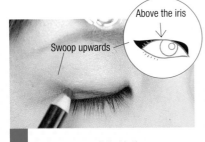

4 Use an eye pencil that is the same shade of black to draw a line on the upper eyelid from the outer corner about halfway across. The corner of the eye and the line across the upper eyelid should be joined together.

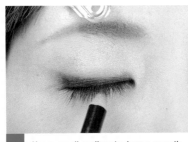

5 Use a pencil eyeliner to draw a smooth, unbroken line along the curve of the upper eyelid.

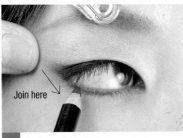

6 Draw an eye line from the outer corner of the lower eyelid about 1/3 of the way across.

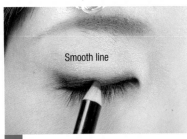

7 There should be one long, continuous smooth line from the inner corner to the outer corner of the upper eyelid.

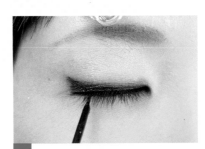

8 Use a black liquid eyeliner (MAKE UP FOR EVER Waterproof Eyeliner No. 1) to fill in the area marked out by the pencil eyeliner, making sure not to go over the lines.

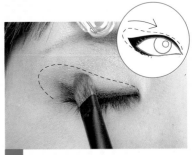

9 From above, lightly apply more of the eye shadow you used first (MAKE UP FOR EVER Eye Shadow and Powder Blush No. 98), and smudge it into the line to form gradations.

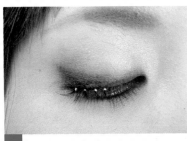

10 Use an eyelash curler on your upper eyelashes. Beginning at the outer corner of your eye, attach 4 false eyelashes. The white dots in the photo are where the eyelashes should be attached.

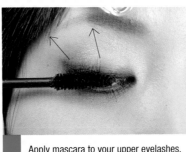

11 Apply mascara to your upper eyelashes.

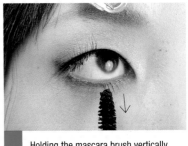

12 Holding the mascara brush vertically, apply mascara carefully to the lower eyelashes.

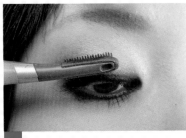

13 Use hot eyelash curlers on the upper eyelashes.

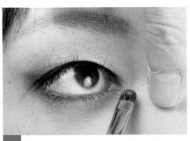

14 Highlight the inner corner of the eye. Use a whitish eye shadow (MAKE UP FOR EVER Eye Shadow and Powder Blush No. 126) on the inner corner of the lower eyelid.

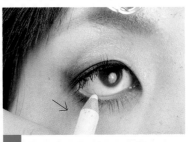

15 Use an ivory-toned eye pencil (any variation of white will do) on the inside of the lower eyelid, and you're done.

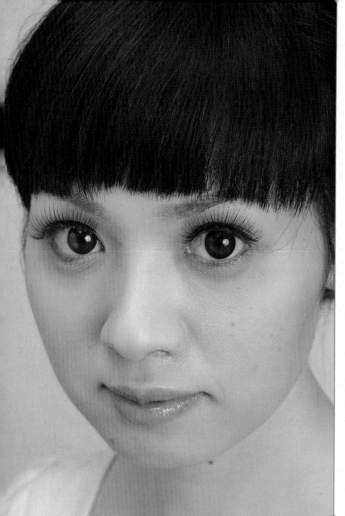

Making small eyes appear large!

In *sanpaku* eyes, the iris is small in comparison with the white of the eye, and white is visible between the iris and the lower eyelid. You can leave your eyes just like this, and they'll still look great and have lots of power, but this is a technique to use when you're doing a character whose eyes are large and liquid.

Before

If you draw an eye line in the inner corner of your eye, it makes your eyes look close set, and makes your expression look too severe. Leave the inner corner of the eye alone. Draw an eye line that makes the entire eye look round, and fill in with eye shadow to provide a stronger impression.

Make-up item

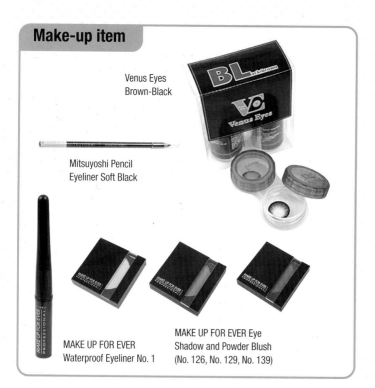

Venus Eyes
Brown-Black

Mitsuyoshi Pencil
Eyeliner Soft Black

MAKE UP FOR EVER
Waterproof Eyeliner No. 1

MAKE UP FOR EVER Eye
Shadow and Powder Blush
(No. 126, No. 129, No. 139)

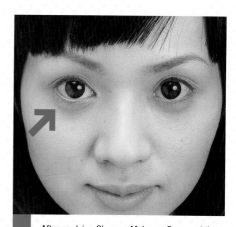

1 After applying Sharena Make-up Base and then Foundation, put in contact lenses that make your irises look larger (Venus Eyes Brown-Black).

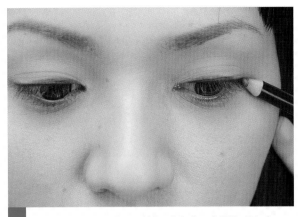

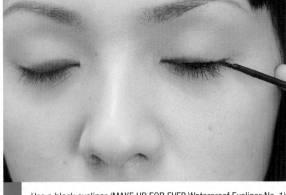

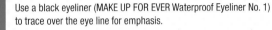

2 Use a black pencil (Mitsuyoshi Pencil Eyeliner Soft Black) to draw an eye line on the edge of the eyelid, filling in the eyelashes. Draw the line more rounded in the center of the eyelid.

3 Use a black eyeliner (MAKE UP FOR EVER Waterproof Eyeliner No. 1) to trace over the eye line for emphasis.

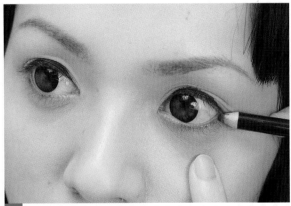

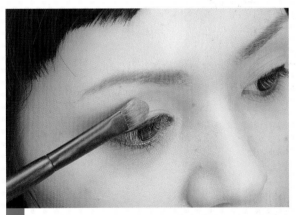

4 Use the Mitsuyoshi Pencil Eyeliner Soft Black to draw a line on the inside of the upper eyelid from the outer corner. The black line in the inner surface makes the white of the eye look smaller.

5 Apply a yellow-beige eye shadow (MAKE UP FOR EVER Eye Shadow and Powder Blush No. 126) over the entire eyelid.

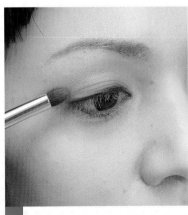

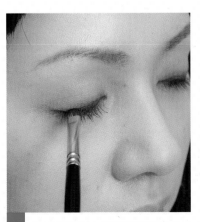

6 Use a darker eye shadow than that in Step 5 (MAKE UP FOR EVER Eye Shadow and Powder Blush No. 129) from the crease in the eyelid and above to create a gradation.

7 Use a darker eye shadow than that in Step 6 (MAKE UP FOR EVER Eye Shadow and Powder Blush No. 139) on the lid following the eye line, and you're done.

41

2.2.7 Turning almond-shaped eyes into downward-slanting eyes

The outer corner of the eye is higher than the inner corner in almond-shaped eyes. Using eye shadow, we're going to lower the outer corners.

To change the overall contour of the eye so that it seems to slant downwards, use an eye shadow brush on the outer corner of the lower eyelid.

Make-up item

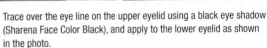

Mitsuyoshi Pencil Eyeliner Soft Black

MAKE UP FOR EVER Eye Blush No. 9

MAKE UP FOR EVER Volume Mascara

MAKE UP FOR EVER Waterproof Eyeliner No. 1

Sharena Face Color Black

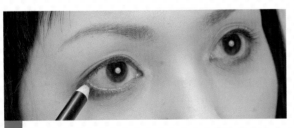

1 Use a black pencil (Mitsuyoshi Pencil Eyeliner Soft Black) to draw an eye line at the edge of the upper eyelid and between the lashes. Draw an eye line from the outer corner of the bottom eyelid about halfway across.

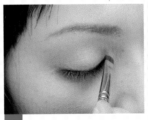

2 Trace over the eye line on the upper eyelid using a black eye shadow (Sharena Face Color Black), and apply to the lower eyelid as shown in the photo.

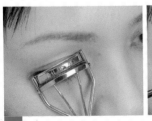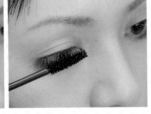

3 Use an eyelash curler on the upper eyelashes and apply MAKE UP FOR EVER Volume Mascara.

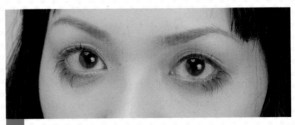

4 Attach about 5 point false eyelashes beginning at the outer corner of the eye, and you're finished.

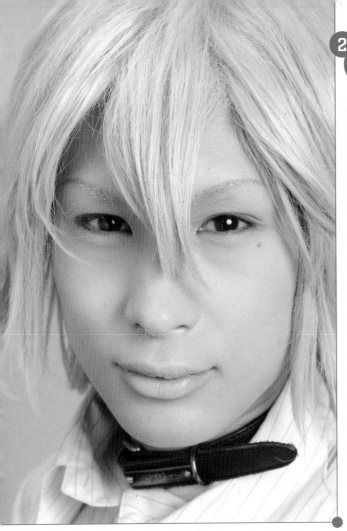

Characters

1 White hair and eyebrows

The color of the hair and eyebrows should match – this is a basic point. We'll use everyday tools to accomplish this.

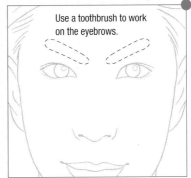

Use a toothbrush to work on the eyebrows.

Make-up item

Mitsuyoshi Hair Silver-White Mitsuyoshi Plus Color Gray

White wig

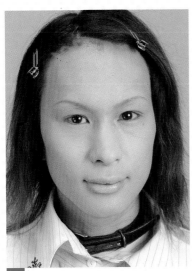

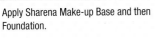

1 Apply Sharena Make-up Base and then Foundation.

2 Draw in eyebrows using Mitsuyoshi Plus Color Gray. With a toothbrush, use Mitsuyoshi Hair Silver-White to draw thicker brows in the direction of the eyebrow hair.

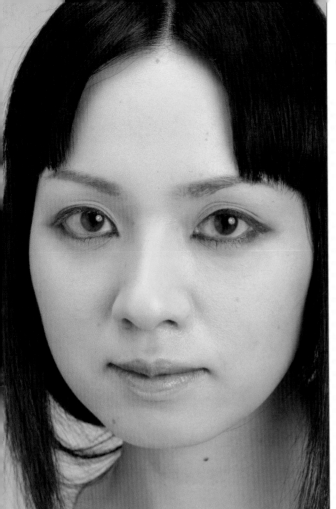

Straight eyebrows, almond-shaped eyes, the color red – these are standards of Japanese style.

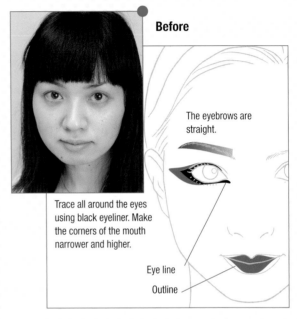

Before

The eyebrows are straight.

Trace all around the eyes using black eyeliner. Make the corners of the mouth narrower and higher.

Eye line

Outline

Make-up item

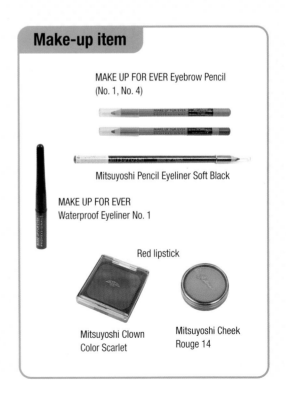

MAKE UP FOR EVER Eyebrow Pencil
(No. 1, No. 4)

Mitsuyoshi Pencil Eyeliner Soft Black

MAKE UP FOR EVER
Waterproof Eyeliner No. 1

Red lipstick

Mitsuyoshi Clown
Color Scarlet

Mitsuyoshi Cheek
Rouge 14

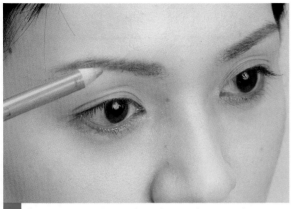

1 Draw straight eyebrows. Use a brown eyebrow pencil to draw the eyebrows.

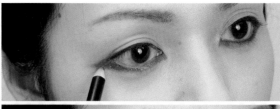

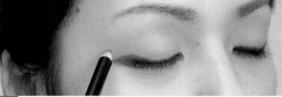

2 Use Mitsuyoshi Pencil Eyeliner Soft Black to draw a line from the middle of the lower eyelid to the outer corner of the eye. Extend the line as in the photo to form an almond shape and fill it in.

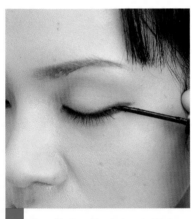

3 Use a black eyeliner to trace inside the eye line to emphasize the black.

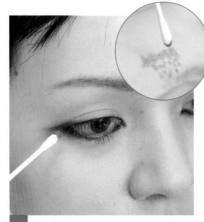

4 Apply red eye shadow. Put some Mitsuyoshi Clown Color Scarlet on the back of your hand and tap it until it powders. Use a cotton swab to apply red to the outer corner of the eye, as in the photo.

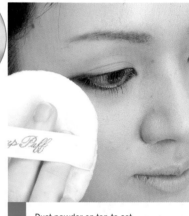

5 Dust powder on top to set.

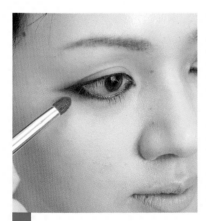

6 Use Mitsuyoshi Cheek Rouge 14 to dilute and extend the color and create a gradation.

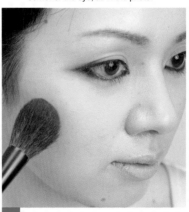

7 Use Mitsuyoshi Cheek Rouge 14 just under the cheekbone to soften the impact of the red color around the eyes.

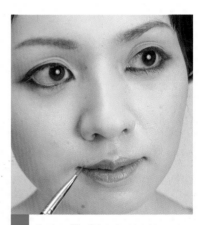

8 Apply red lipstick and you're done.

Chapter 3

Shadowing and Highlights

A slender, chiseled Western face, a doll-like face with a small chin…
A long, narrow Japanese face, a sharply pointed nose…
If only my face was a little narrower!
If only my nose was a little smaller!
Everyone dislikes something about his or her face.
Shadowing and highlighting are magical techniques that can change the very appearance of your bone structure.

Basic Methods: Shadowing and Highlights

Making the bridge of the nose look higher

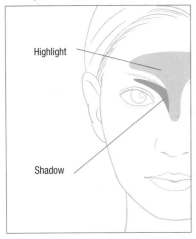

Highlight

Shadow

3-D effect

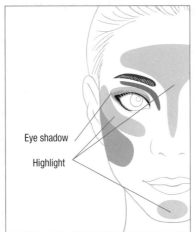

Eye shadow

Highlight

Adding definition to a round face

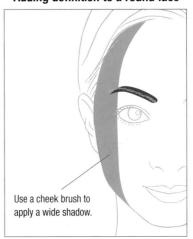

Use a cheek brush to apply a wide shadow.

Making the cheeks less conspicuous

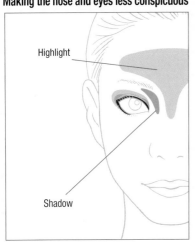

Cheek

Highlight

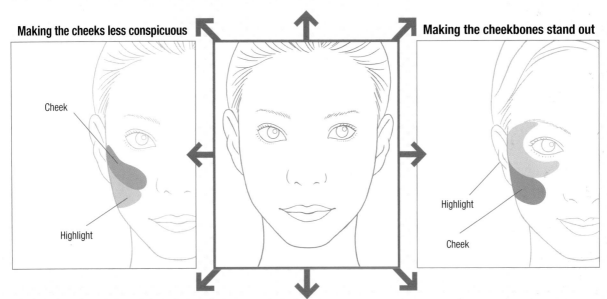

Making the cheekbones stand out

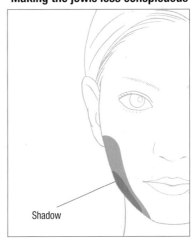

Highlight

Cheek

Making the nose and eyes less conspicuous

Highlight

Shadow

Inverted triangle shading

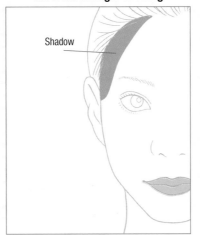

Shadow

Making the jowls less conspicuous

Shadow

 ## Nose with a high bridge

If you want your nose to look narrower, be sure not to use too much shadowing on it. The opposite is true if you want your nose to stand out. Use highlighting and shadowing between the eyebrows to make your nose more visible.

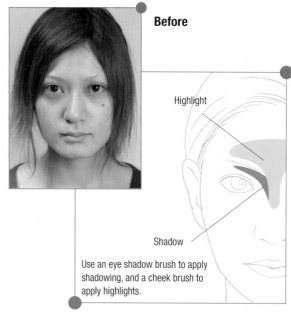

Before

Highlight

Shadow

Use an eye shadow brush to apply shadowing, and a cheek brush to apply highlights.

Make-up item

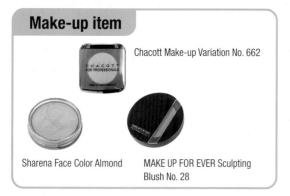

Chacott Make-up Variation No. 662

Sharena Face Color Almond

MAKE UP FOR EVER Sculpting Blush No. 28

1 First make a darker foundation that is close to the color of the shadowing on your skin. On the back of your hand, mix Sharena Face Color Almond and MAKE UP FOR EVER Sculpting Blush No. 28, using an eye shadow brush. Use the brush to press the mixture until it forms a very fine powder. (If it is not a very fine powder, the shadowing will not look natural.)

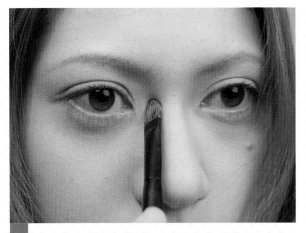

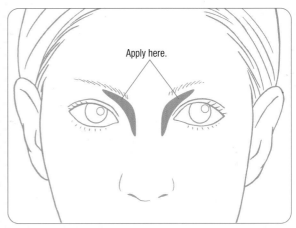

Apply here.

2 Apply the powder mixed in Step 1 along the line that connects the base of eyebrows and the bridge of the nose. Apply using the brush as shown in the photo.

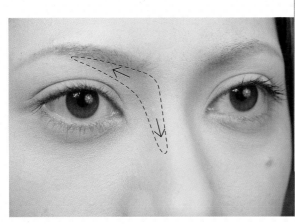

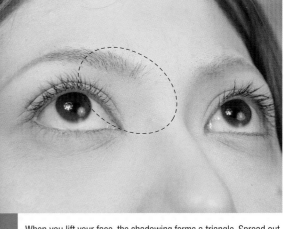

3 When you lift your face, the shadowing forms a triangle. Spread out the powder to form gradations in this triangular shape.

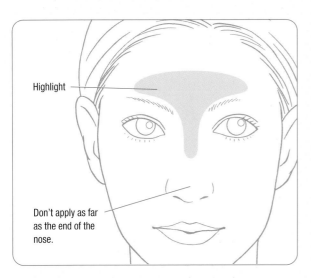

Highlight

Don't apply as far as the end of the nose.

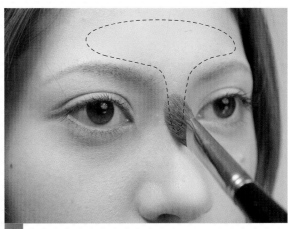

4 For the highlights, use Chacott Make-up Variation No. 662, in a brightness that suits your skin. Use a cheek brush to apply it from the forehead to the bridge of the nose. If you continue to the tip of the nose, it will look very long, so be careful.

49

Creating a 3-D (or western) face

The key to creating a 3-D, or western, face is to close the distance between the eyes and the eyebrows and to make the nose look narrower. If you overdo it, though, you'll end up with results that look like flashy stage make-up, so think of the balance.

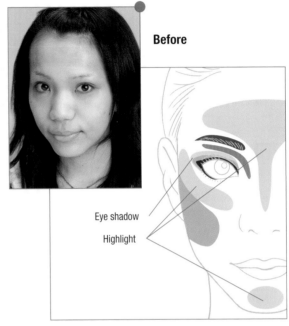

Before

Eye shadow

Highlight

Make-up item

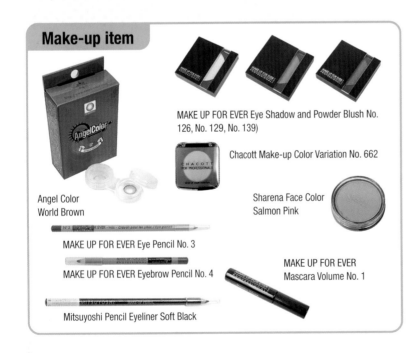

MAKE UP FOR EVER Eye Shadow and Powder Blush No. 126, No. 129, No. 139)

Chacott Make-up Color Variation No. 662

Angel Color World Brown

Sharena Face Color Salmon Pink

MAKE UP FOR EVER Eye Pencil No. 3

MAKE UP FOR EVER Eyebrow Pencil No. 4

MAKE UP FOR EVER Mascara Volume No. 1

Mitsuyoshi Pencil Eyeliner Soft Black

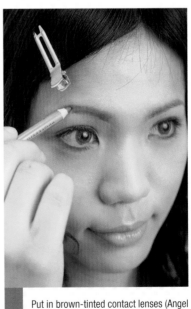

1 Put in brown-tinted contact lenses (Angel Color World Brown) and draw straight eyebrows in a color that matches your eyes (MAKE UP FOR EVER Eyebrow Pencil No. 4). Draw the eyebrows so that they look closer together.

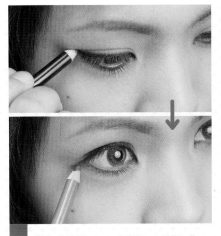

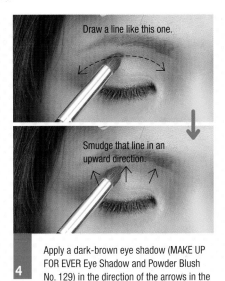

Draw a line like this one.

Apply an eye shadow that is lighter than your skin tone (MAKE UP FOR EVER Eye Shadow and Powder Blush No. 126) over the entire upper eyelid.

Smudge that line in an upward direction.

2 Use a black eye pencil (Mitsuyoshi Pencil Eyeliner Soft Black) to draw an eye line on the upper eyelid, filling in the spaces between the eyelashes. Use a brown eye pencil (MAKE UP FOR EVER Eye Pencil No. 3) to draw an eye line on the bottom eyelid, leaving out the inner corner of the eye.

4 Apply a dark-brown eye shadow (MAKE UP FOR EVER Eye Shadow and Powder Blush No. 129) in the direction of the arrows in the photos.

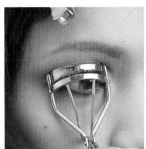
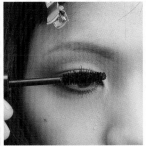

5 Apply an even darker eye shadow (MAKE UP FOR EVER Eye Shadow and Powder Blush No. 139) to draw a line approximating a double fold. Use the same color to draw a line along the lower eyelid from the outer corner of the eye, and smudge.

6 Use eye lash curlers on the upper eyelids, and apply a volumizing mascara.

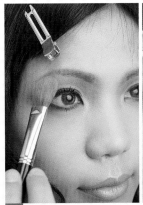
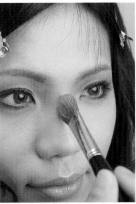
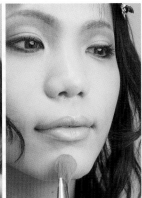
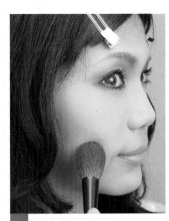

7 Apply Chacott Make-up Color Variation No. 662 from the brow to the cheekbones in a sideways "V". Apply highlights in four places; the forehead, the bridge of the nose, halfway between the two, and on the chin.

8 Don't use a dark color on your lips – a natural color is better. Add some color to the cheeks (Sharena Face Color Salmon Pink), and you're done.

 # Adding sharp planes to a round face

Adding shadowing to both sides of the face makes the front area look lighter and narrower.

Before

Use an angle to give an ascending impression.

Apply shadowing broadly, using a cheek brush.

Make-up item

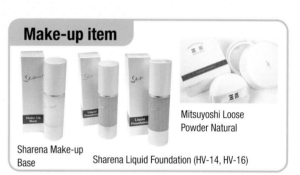

Sharena Make-up Base

Sharena Liquid Foundation (HV-14, HV-16)

Mitsuyoshi Loose Powder Natural

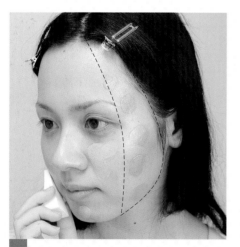

1 Sharena Make-up Base → Apply a foundation that matches your skin color, and then use a foundation about 2 shades darker for the shadowing.

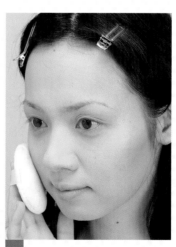

2 Apply powder to fix.

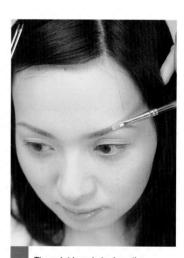

3 The point here is to draw the eyebrows at an angle; this makes the face look longer and narrower.

1.3.4 Making the cheekbones less obvious

If you use highlights instead of shadows on the cheekbones and other protruding areas of the face, it will make them stand out less.

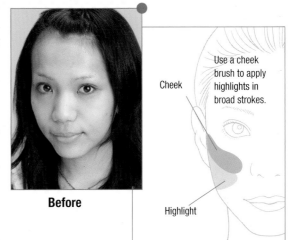

Before

Cheek

Use a cheek brush to apply highlights in broad strokes.

Highlight

Make-up item

Chacott Make-up Color Variation No. 662

MAKE UP FOR EVER Sculpting Blush No. 28

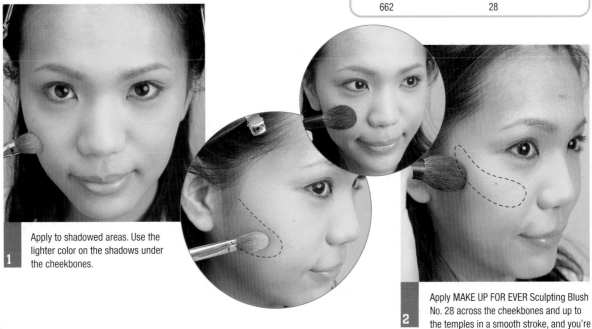

1 Apply to shadowed areas. Use the lighter color on the shadows under the cheekbones.

2 Apply MAKE UP FOR EVER Sculpting Blush No. 28 across the cheekbones and up to the temples in a smooth stroke, and you're done.

Making cheekbones stand out

Just by shortening your bangs and making your cheekbones stand out, you can look more like a smart, older woman.

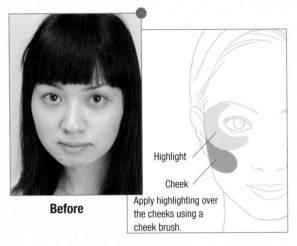

Before

Highlight

Cheek

Apply highlighting over the cheeks using a cheek brush.

Make-up item

Chacott Make-up Color Variation No. 662

Mitsuyoshi Cheek Color 14

1 Sharena Make-up Base → Start by applying foundation as usual.

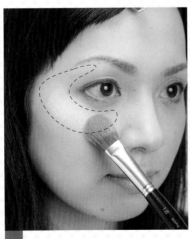

2 Apply Chacott Make-up Color Variation No. 662 to the area inside the dotted line.

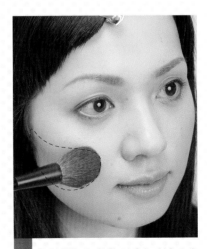

3 Apply Mitsuyoshi Cheek Color 14 from the top of the cheek as shown by the dotted line, and you're done.

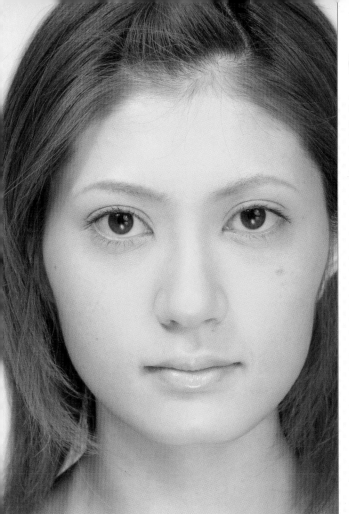

Making the jaw less prominent

You can't remove the bone, so use shadowing to make your jaw less obvious.

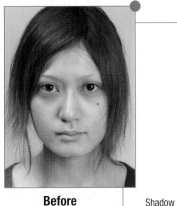

Before

Shadow

Make-up item

Sharena Face Color Almond

1 Use a cheek brush with a color slightly darker than your face (such as Sharena Face Color Almond) and tap the excess powder onto a tissue.

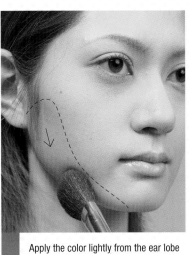

2 Apply the color lightly from the ear lobe to the chin.

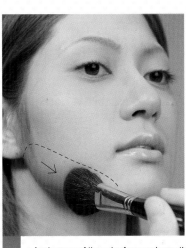

3 Apply more of the color from underneath that was applied in 2 to the top of the jaw.

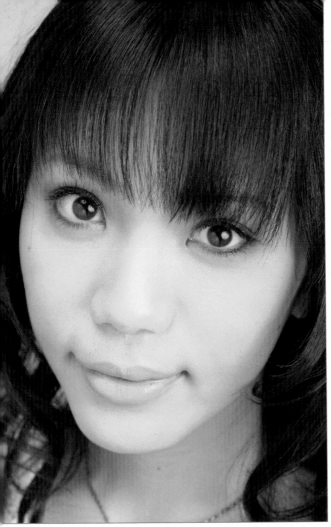

 ## Making the nose less prominent

You can't actually make your nose smaller (without surgery), but you can make it less prominent. The trick is to use highlighting to make the nostrils less obvious, and apply bolder eye make-up to draw the gaze to your eyes.

Before

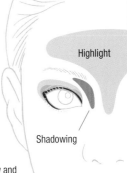

Highlight

Shadowing

Use eye shadow and a sponge applicator to emphasize your eyes, and apply highlights broadly using a cheek brush.

Make-up item

MAKE UP FOR EVER Eye Shadow and Powder Blush (No. 151, No. 121, No. 129, No. 131)

Chacott Make-up Color Variation No. 662

MAKE UP FOR EVER Eyelash No. 51

MAKE UP FOR EVER Mascara Volume 2

Mitsuyoshi Pencil Eyeliner Soft Black

Start after the steps on page 53, "Making the cheekbones less obvious."

Sharena Make-up Base → Start after using base make-up to lay a foundation.

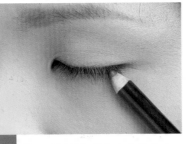

1 To emphasize the eyes, use a black eyeliner (Mitsuyoshi Pencil Eyeliner Soft Black) to darken the eyelashes and the spaces between lashes.

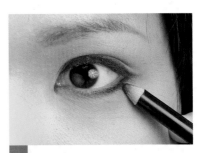

2 Use the pencil to elongate the outer corner of the eye, and darken the inner eyelid. Draw a line on the lower eyelid, except for the inner corner of the eye, and on the entire upper eyelid.

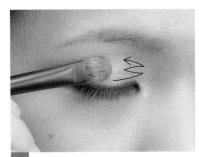

3 Apply a light-colored eye shadow (MAKE UP FOR EVER Eye Shadow and Powder Blush No.151) over the entire eyelid.

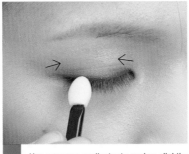

4 Use a sponge applicator to apply a slightly darker eye shadow than in 3 (MAKE UP FOR EVER Eye Shadow and Powder Blush No. 131), from the outer corner to the center and from the inner corner to the center.

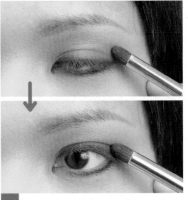

5 To emphasize the double-fold line, use a darker eye shadow (MAKE UP FOR EVER Eye Shadow and Powder Blush No. 121) to draw a curving line slightly above your natural double-fold line. Draw a thick line so that when your eye is open, the crease of the double fold doesn't conceal it.

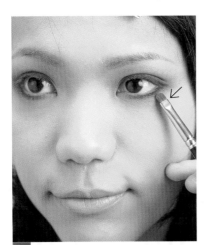

6 Apply the same MAKE UP FOR EVER Eye Shadow and Powder Blush No. 121 under the eye from the outer corner, smudging the eyeliner.

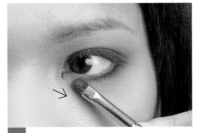

7 Use the same eye shadow as in 3 (Eye Shadow and Powder Blush No.151) and apply it from the inner corner of the eye, following the line of the lower eyelashes.

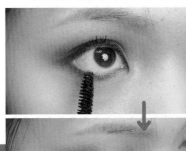

8 Increase the volume of the eyelashes use mascara. Apply MAKE UP FOR EVER Mascara Volume 2 to the upper and lower lashes.

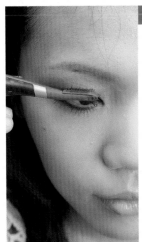

9 Affix false lashes with a lot of volume (MAKE UP FOR EVER Eyelash No. 51) to the upper lashes, and use a hot eyelash curler to give them a lot of lift.

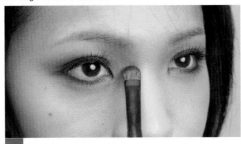

10 To make the bridge of the nose look smaller, apply shadowing to the nose. Select a color somewhere between that of your eyebrows and eye shadow (MAKE UP FOR EVER Eye Shadow and Powder Blush No. 129) and apply from the inner tip of the eyebrow, following the line of the nose. If you go all the way to the end of the nose, it will look bigger, so be careful!

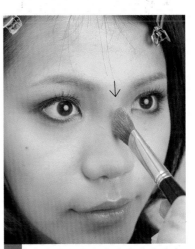

11 To finish the technique, apply white highlights. Use Chacott Make-up Color Variation No. 662 across the entire forehead and down the bridge of the nose.

 Inverted triangle shading

The point is to reduce the white areas of the face as much as possible. Try applying shadowing to the forehead (to the chin in people with long chins) to reduce the areas where light hits, and drawing a thicker lip line.

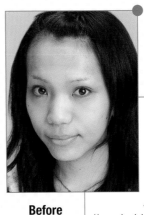

Before

Use a cheek brush to apply shadowing to the hairline.

Use a lip brush to draw a lip outline that is slightly larger than your own lips.

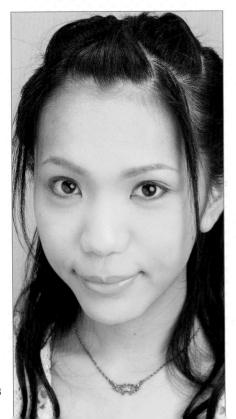

Make-up item

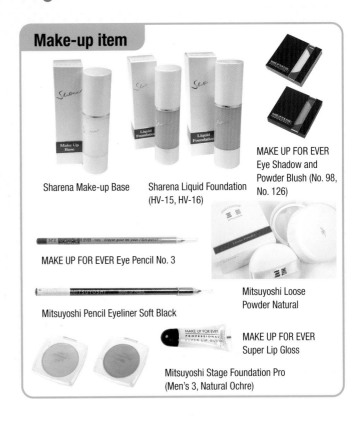

Sharena Make-up Base

Sharena Liquid Foundation (HV-15, HV-16)

MAKE UP FOR EVER Eye Shadow and Powder Blush (No. 98, No. 126)

MAKE UP FOR EVER Eye Pencil No. 3

Mitsuyoshi Loose Powder Natural

Mitsuyoshi Pencil Eyeliner Soft Black

MAKE UP FOR EVER Super Lip Gloss

Mitsuyoshi Stage Foundation Pro (Men's 3, Natural Ochre)

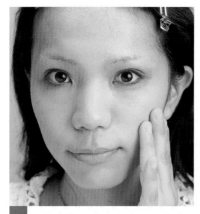

1 Sharena Make-up Base → Use Sharena Liquid Foundation (HV-15, HV-16) to prepare a base.

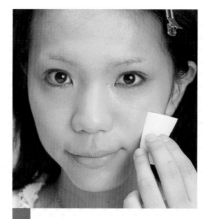

2 Using your finger, apply a cream foundation (Mitsuyoshi Stage Foundation Pro Men's 3, Natural Ochre) to areas that particularly bother you, and blot with a sponge.

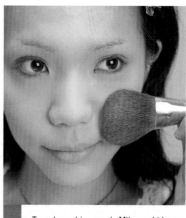

3 To reduce shine, apply Mitsuyoshi Loose Powder Natural all over.

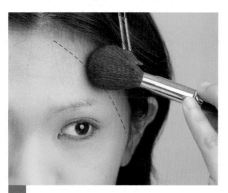

4 Shadow both sides of the forehead. Apply a slightly dark color (MAKE UP FOR EVER Eye Shadow and Powder Blush No. 98) inside the dotted line as shown, using a cheek brush from the top of the forehead to the temples.

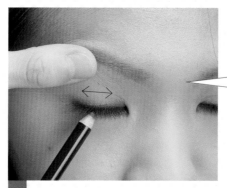

Entire upper eyelid

From the outer corner, 1/3 the length of the lower eyelid

5 Use an eye pencil to darken the lashes and the spaces between lashes. Use black eyeliner on the upper lid (Mitsuyoshi Pencil Eyeliner Soft Black) and a brown one on the lower lid (MAKE UP FOR EVER Eye Pencil No. 3).

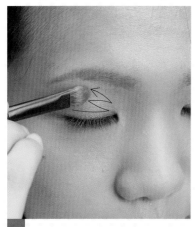

6 Apply an eye shadow lighter than your skin (MAKE UP FOR EVER Eye Shadow and Powder Blush No.126) over the entire eyelid.

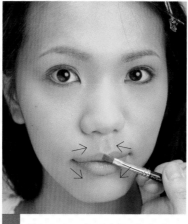

7 Use an expansive pink lip color to draw in lips slightly larger than your own.

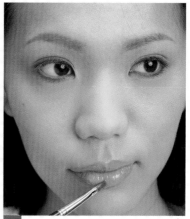

8 Use lip gloss to add overall shine. Apply MAKE UP FOR EVER Super Lip Gloss and you're done.

Make-up Patterns

1 A character with a pale complexion

The trick to creating "beautifully pathological" characters is the shadowing around the eyes and on the cheeks; other than that, the complexion should be a pale bluish-white. Even if you do the eye make-up beautifully, if the skin looks patchy, your character will look more like a vagrant.

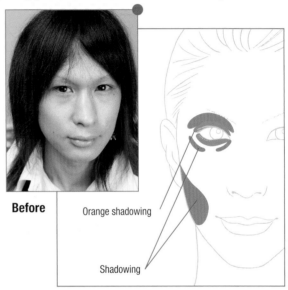

Before

Orange shadowing

Shadowing

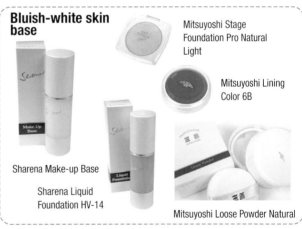

Bluish-white skin base

Sharena Make-up Base

Sharena Liquid Foundation HV-14

Mitsuyoshi Stage Foundation Pro Natural Light

Mitsuyoshi Lining Color 6B

Mitsuyoshi Loose Powder Natural

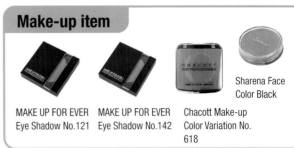

Make-up item

MAKE UP FOR EVER Eye Shadow No.121

MAKE UP FOR EVER Eye Shadow No.142

Chacott Make-up Color Variation No. 618

Sharena Face Color Black

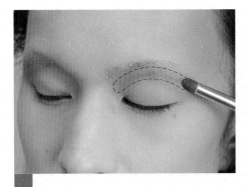

1 To make the eyes look sunken, create shadows under the eyebrows. Mix MAKE UP FOR EVER Eye Shadow and Powder Blush No. 142 and Sharena Face Color Black in the palm of your hand, and apply to the area inside the dotted line using an eye shadow brush.

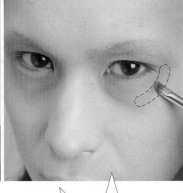

2 Apply the same color to the area that would be the rim of the eyes in a skull.

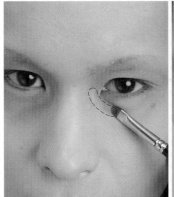

This area

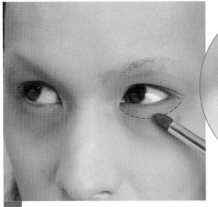

3 Apply orange shadow (Chacott Make-up Color Variation No. 618) inside the ring drawn in 2, and in the area inside the dotted line, making it darker the farther away you get from the eye.

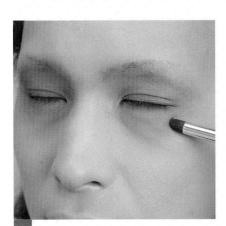

4 To darken the gradation from 3, use Sharena Face Color Black.

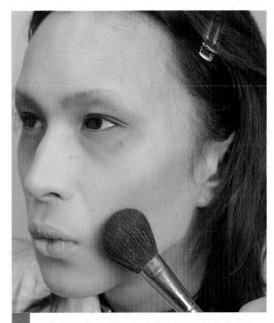

5 Purse your lips as if saying "ooh" and create shadows in the hollow (or maybe straight) area that forms underneath the cheekbones. Lightly dust with MAKE UP FOR EVER Eye Shadow and Powder Blush No. 121 (Metallic Grape), and you're done.

Make-up Changes
Natural → White coating

This comes in handy when you're going from one event to another, and you want to change your character. This is a quick-change technique that allows you to finish in 15 minutes.

Make-up item

Mitsuyoshi Face Cake White

Mitsuyoshi Face Powder White

Sponge Puffs

Mitsuyoshi Itabake 60 (Wooden-handled brush)

Tools to carry with you: Water (portable), sponge

1 Start with a cream foundation base. This make-up can stain your costume, so cover it with a towel or something similar beforehand.

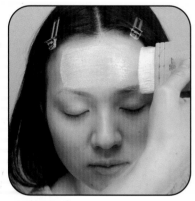

2 Mix Mitsuyoshi Face Powder White with water, and apply with an Itabake, starting with the forehead.

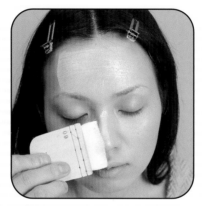

3 Apply to the bridge of the nose, and sweep down the sides of the nose.

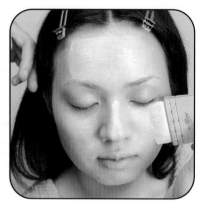

4 Apply to the cheeks from the inside outward.

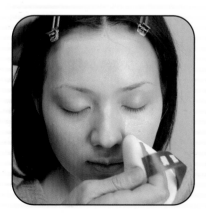

5 When you have covered the face, blot with a sponge puff to remove excess moisture.

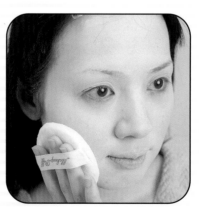

6 Apply Mitsuyoshi Face Powder White with a puff to fix the make-up, and you're done.

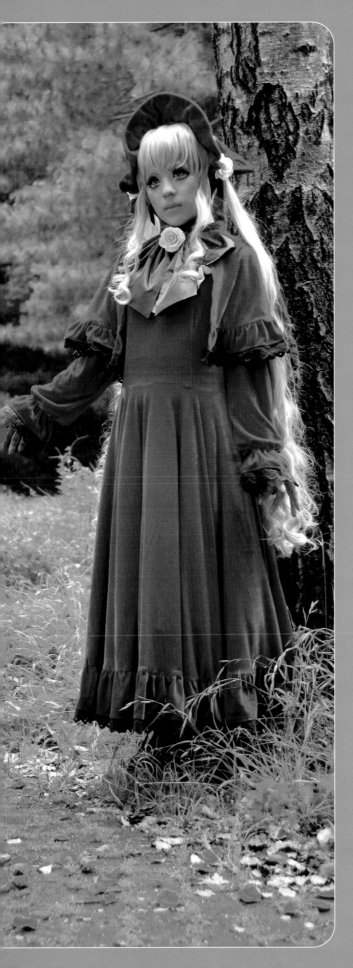

Chapter 4

Basics of Male and Female Costumes

Gallant men, sadistic youths, women whose beauty evokes sighs….
No matter the era, women adore the charm of androgyny. Using these techniques, you can become many different characters. Here we'll introduce some secrets to dressing as male or female characters, no matter your own gender.

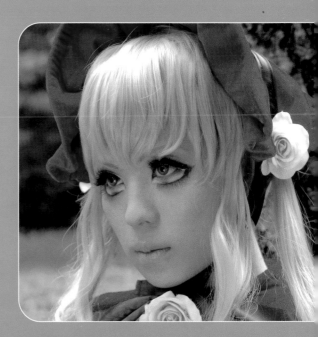

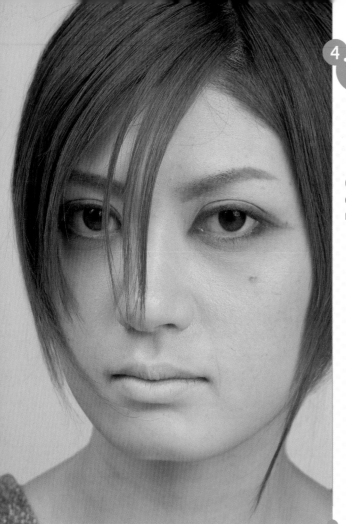

4.1 Eye and Eyebrow Patterns: Male Costumes

1 A youth with long, narrow eyes

One point to dressing as a male is the space between the eyes and the eyebrows. If you can narrow this down, you can really appear to be male.

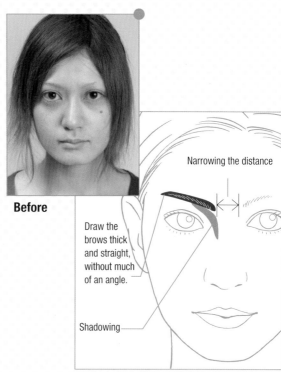

Before

Narrowing the distance

Draw the brows thick and straight, without much of an angle.

Shadowing

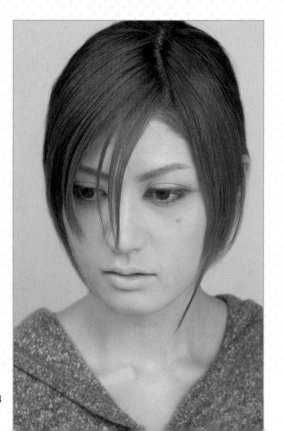

Make-up item

MAKE UP FOR EVER Eyebrow No. 4

MAKE UP FOR EVER Eye Pencil No. 3

MAKE UP FOR EVER Eye Shadow and Powder Blush No.139

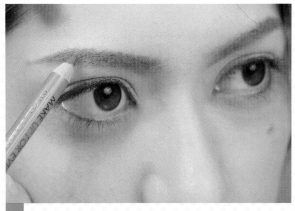

1 Use the same basic foundation as for woman's make-up. Use a slightly dark eyebrow pencil (MAKE UP FOR EVER Eyebrow No. 4) to draw straight eyebrows. Extend them past the inner corners of your eyes to narrow the distance between them.

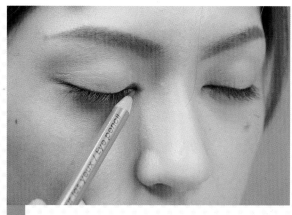

2 Use a dark brown eye pencil (MAKE UP FOR EVER Eye Pencil No. 3) to draw a triangle in the inner corner of the eye and extend the line past the outer corner of the eye. Make sure the line doesn't go up at the outer corner.

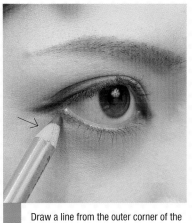

3 Draw a line from the outer corner of the eye to the edge under the eye.

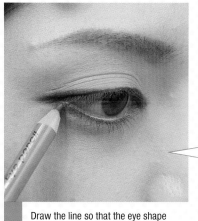

4 Draw the line so that the eye shape seems elongated.

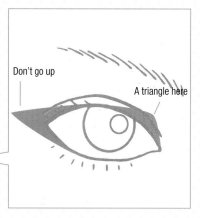

Don't go up

A triangle here

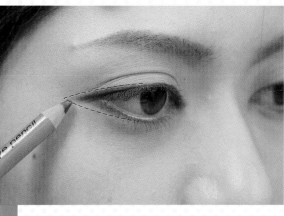

5 Fill in the entire space at the outer corner of the eye.

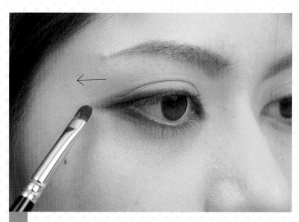

6 Use an eye pencil and a similarly colored eye shadow (MAKE UP FOR EVER Eye Shadow and Powder Blush No. 139) to smudge the line and fill in spaces that are not yet filled in. Use foundation on the lips so that they blend in with the color of your skin.

Average youth

When doing make-up for a male character in his early teens, the point is translucent-looking skin and large, round eyes. You're also going for as natural a look as possible. No matter how round your cheeks are, don't use cheek blush to add shadowing. Focus on the look in your eyes.

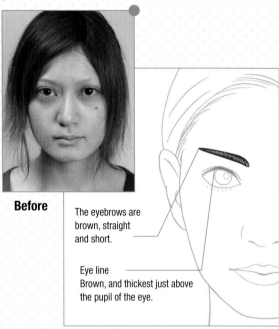

Before

The eyebrows are brown, straight and short.

Eye line
Brown, and thickest just above the pupil of the eye.

Make-up item

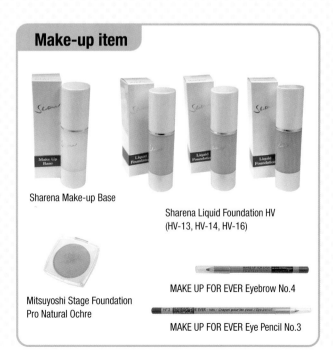

Sharena Make-up Base

Sharena Liquid Foundation HV
(HV-13, HV-14, HV-16)

Mitsuyoshi Stage Foundation
Pro Natural Ochre

MAKE UP FOR EVER Eyebrow No.4

MAKE UP FOR EVER Eye Pencil No.3

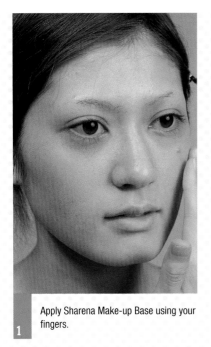

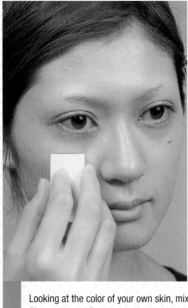

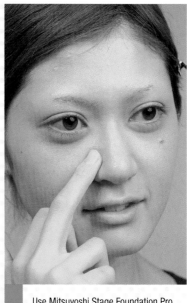

1 Apply Sharena Make-up Base using your fingers.

2 Looking at the color of your own skin, mix Sharena Liquid Foundation HV-13, HV-14, HV-16 until the shade matches, and then apply smoothly with a sponge.

3 Use Mitsuyoshi Stage Foundation Pro Natural Ochre to cover any blemishes or red areas and make the complexion flawless.

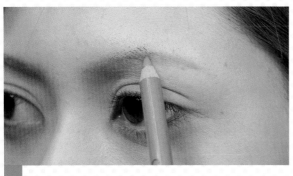

4 Use an eyebrow pencil slightly darker than your own eyebrows (MAKE UP FOR EVER Eyebrow No.4) to draw in thick, straight brows.

Draw the line very round here

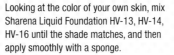

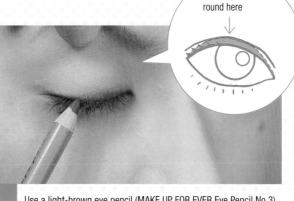

5 Use a light-brown eye pencil (MAKE UP FOR EVER Eye Pencil No.3) to draw a round contour for the eyelid.

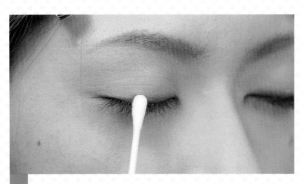

6 Use a cotton swab to smudge the contour line, apply foundation to your lips to tone down their color, and you're done.

 Sexy young man with downward-turning eyes

The mistake that most people make in trying to create downward-turning or droopy eyes (*tare-me*), is that they use eye shadow only underneath the eyes. To do it right, draw an eye line above the eye and fill in the entire contour with eye shadow. But if you use too much, it will look like something out of a horror movie, so be careful.

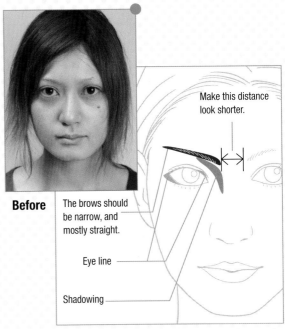

Before

The brows should be narrow, and mostly straight.

Make this distance look shorter.

Eye line

Shadowing

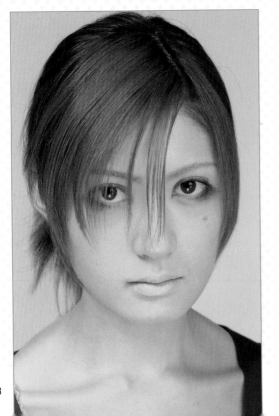

Make-up item

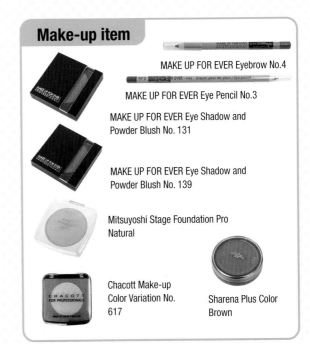

MAKE UP FOR EVER Eyebrow No.4

MAKE UP FOR EVER Eye Pencil No.3

MAKE UP FOR EVER Eye Shadow and Powder Blush No. 131

MAKE UP FOR EVER Eye Shadow and Powder Blush No. 139

Mitsuyoshi Stage Foundation Pro Natural

Chacott Make-up Color Variation No. 617

Sharena Plus Color Brown

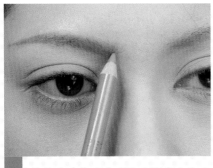

1 Apply a basic foundation. Draw straight eyebrows using MAKE UP FOR EVER Eyebrow No.4. They may be called droopy eyes, but the eyebrows should definitely not droop.

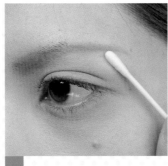

2 Use a cotton swab to clean up the end of the eyebrow and stretch the color for an elegant look.

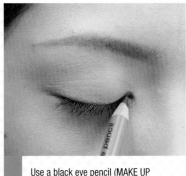

3 Use a black eye pencil (MAKE UP FOR EVER Eye Pencil No.3) to draw a triangle in the inner corner of the eye.

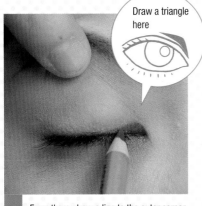

Draw a triangle here

4 From there, draw a line to the outer corner of the eye, coloring in the spaces between lashes. At the outer corner, extend the line of the upper eyelid down farther than your natural line.

613

617

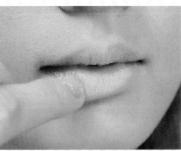

5 Apply a red color (Chacott Make-up Color Variation No. 617) from the outer corner to the middle of your eye. Use eye shadow on the lower lid.

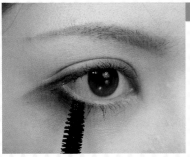

6 To conceal the eye line, apply black eye shadow (MAKE UP FOR EVER Eye Shadow and Powder Blush No. 139, Mitsuyoshi Plus Color Brown) in gradations from the outer corner of the eye, and then use mascara on the lower eyelashes from the outer corner about 1/3 of the way across.

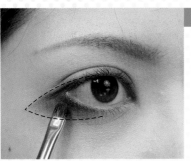

7 Increase the gradation effect by using another color (MAKE UP FOR EVER Eye Shadow and Powder Blush No. 131) on the corner of the eye; smudge.

8 Apply foundation the same color as your skin (Mitsuyoshi Stage Foundation Pro Natural Ochre) to your lips, fix with powder and you're done.

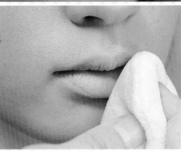

 1.4.4 Boy with upward-slanting eyes

The opposite of *tare-me* are *tsuri-me*, eyes that turn up at the outer corners. If you don't draw in the gradations correctly, it will look like you have terrible bags under your eyes, so smudge away!

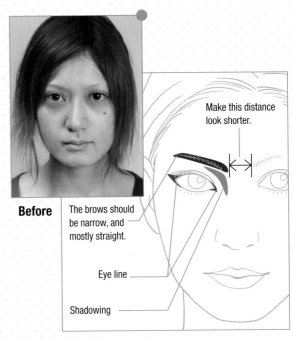

Before

Make this distance look shorter.

The brows should be narrow, and mostly straight.

Eye line

Shadowing

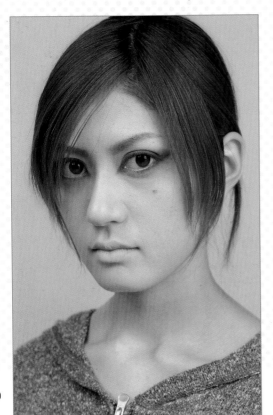

Make-up item

MAKE UP FOR EVER Eyebrow No.4

MAKE UP FOR EVER Eye Pencil No.3

MAKE UP FOR EVER Eye Shadow and Powder Blush No. 139

Sharena Face Color Almond

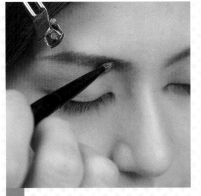

Point

If you're unable to draw symmetrical eyebrows, it's probably because you're bending your head and looking down. If you want to achieve bilateral symmetry, face the mirror directly and look ahead while you draw the eyebrows.

Start with Normal Youth make-up from page 66.

The steps are the same after Sharena Make-up Base → Applying basic foundation.

1 Draw straight eyebrows that are basically the same thickness as they are at the inner edge. When you reach the outer corner of the eyes, draw in a lift in the eyebrow, and after that, narrow the eyebrow. Use MAKE UP FOR EVER Eyebrow No.4 to make the inner edges of the brows and the eyes themselves look closer together. Apply Sharena Face Color Almond below the brows to create shadows from the brows. Doing this narrows the distance between the brow and the eye for a more western look.

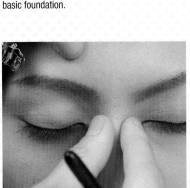

2 Use your fingers as in the photo to apply eye shadow along the bridge of the nose to lengthen the shadowing.

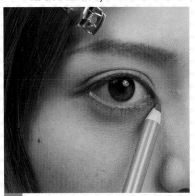

3 Use MAKE UP FOR EVER Eye Pencil No. 3 to draw a line from the inner corner of the eye, while your eye is open.

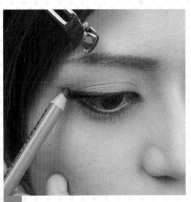

4 Draw the line past the natural line at the outer corner of your eye, and extend it upward. Image a point where the line from your brow and the one from the outer corner of your eye meet – but don't draw it just yet.

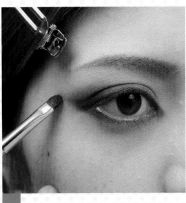

5 Use brown eye shadow (MAKE UP FOR EVER Eye Shadow and Powder Blush No. 139) to trace over and smudge the line from the outer corner.

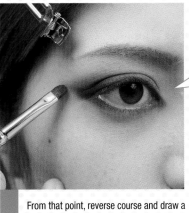

6 From that point, reverse course and draw a large triangle from the outer corner of the eye across the upper eyelid.

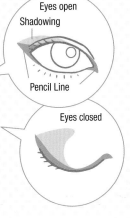

Eyes open
Shadowing

Pencil Line

Eyes closed

"Visual" make-up

Basically the make-up will be the same as for long, narrow eyes; the exceptions are the colored contact lenses, lighter, thinner eyebrows and blue eye shadow.

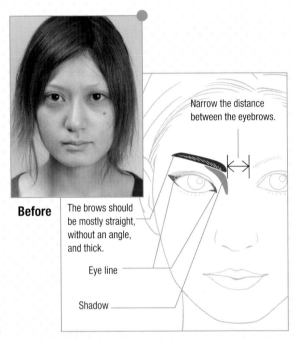

Before

The brows should be mostly straight, without an angle, and thick.

Narrow the distance between the eyebrows.

Eye line

Shadow

Make-up item

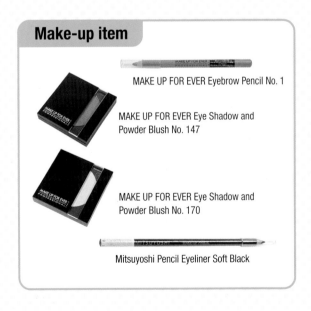

MAKE UP FOR EVER Eyebrow Pencil No. 1

MAKE UP FOR EVER Eye Shadow and Powder Blush No. 147

MAKE UP FOR EVER Eye Shadow and Powder Blush No. 170

Mitsuyoshi Pencil Eyeliner Soft Black

Start with the eye make-up for long, narrow eyes on page 64.

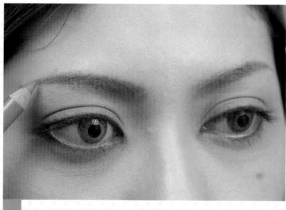

1 Draw the brows in a narrow, straight line as far as the outer corner of the eye. Use a brown color, and make sure the brows are symmetrical. Put in gray-colored contact lenses.

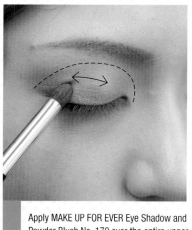

2 Apply MAKE UP FOR EVER Eye Shadow and Powder Blush No. 170 over the entire upper eyelid.

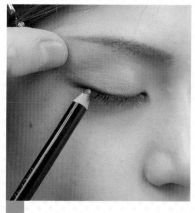

3 Use Mitsuyoshi Pencil Eyeliner Soft Black to fill in the spaces between eyelashes, and extend the outer corner of the eye slightly upward.

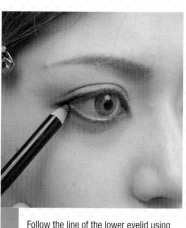

4 Follow the line of the lower eyelid using Mitsuyoshi Pencil Eyeliner Soft Black.

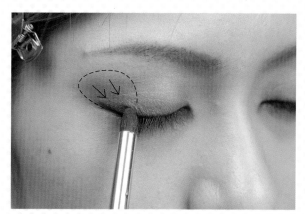

5 Apply MAKE UP FOR EVER Eye Shadow and Powder Blush No. 147 as shown by the arrows in the photo.

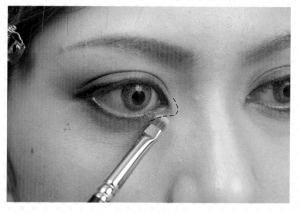

6 Use MAKE UP FOR EVER Eye Shadow and Powder Blush No. 170 to apply highlights to the inner corner of the eye in the shape of the Japanese syllable "＜" as shown by the dotted lines. Use MAKE UP FOR EVER Eye Shadow and Powder Blush No. 147 along the line of the upper eyelid and smudge, and you're done.

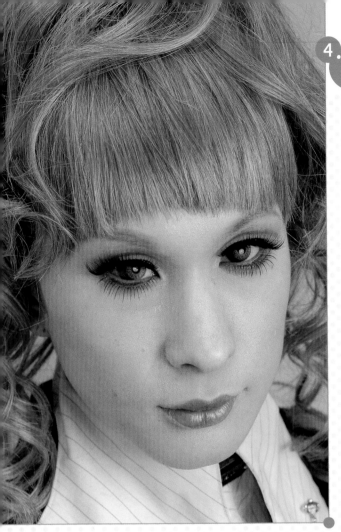

4.2 Eye and Eyebrow Patterns: Female Costumes

1 Female dolls

To create the plump face of a doll, the points to focus on are to use a whitish, translucent foundation and to use color on the cheeks to make them look rounder.

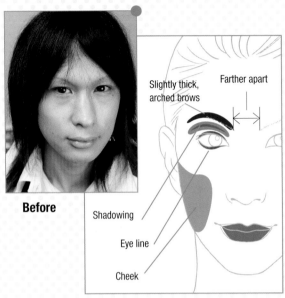

Before

Slightly thick, arched brows

Farther apart

Shadowing

Eye line

Cheek

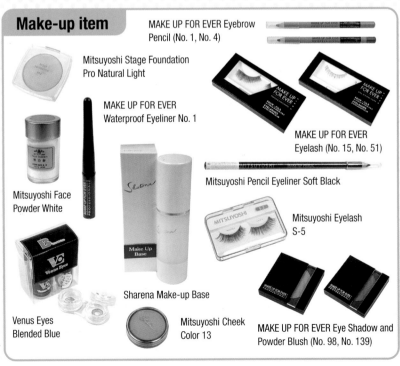

Make-up item

MAKE UP FOR EVER Eyebrow Pencil (No. 1, No. 4)

Mitsuyoshi Stage Foundation Pro Natural Light

MAKE UP FOR EVER Waterproof Eyeliner No. 1

MAKE UP FOR EVER Eyelash (No. 15, No. 51)

Mitsuyoshi Pencil Eyeliner Soft Black

Mitsuyoshi Face Powder White

Mitsuyoshi Eyelash S-5

Venus Eyes Blended Blue

Sharena Make-up Base

Mitsuyoshi Cheek Color 13

MAKE UP FOR EVER Eye Shadow and Powder Blush (No. 98, No. 139)

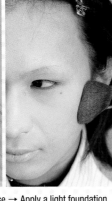

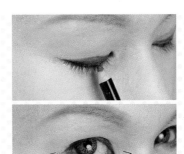

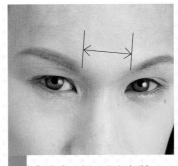

1 Sharena Make-up Base → Apply a light foundation (Mitsuyoshi Stage Foundation Pro Natural Light) using your fingers and spread it using a sponge. Cover everything with Mitsuyoshi Face Powder White.

2 Put in the color contacts. In this case, we're using a blue color as in western eyes (Venus Eyes Blended Blue). Use a light brown for the eyebrows, and draw a thickish arch. Draw it so that the brows seem farther apart (this is more feminine).

3 Draw a thick eye line using Mitsuyoshi Pencil Eyeliner Soft Black. Draw an eye line on the bottom line, from the middle to the inner corner and from the middle to the outer corner.

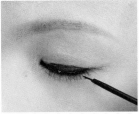

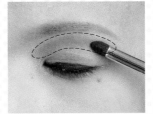

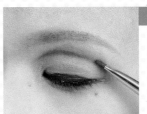

6 Draw a double line using MAKE UP FOR EVER Eye Shadow and Powder Blush No. 139. Drawing a double line on the eye line by following the line of the eyeball makes the eye look bigger.

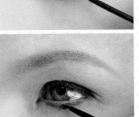

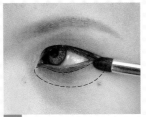

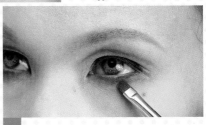

4 Emphasize the eye line by tracing over the eye pencil line using MAKE UP FOR EVER Waterproof Eyeliner No. 1.

5 Apply brown eye shadow (MAKE UP FOR EVER Eye Shadow and Powder Blush No. 98) to the upper lid where the rim of the eyehole in a skull would be, as shown by the dotted lines. Trace the line of the lower eyelid as in the photo.

7 Use a dark brown eye shadow (MAKE UP FOR EVER Eye Shadow and Powder Blush No. 139 to draw a line on the upper eyelid. Smudge the eye line on the lower eyelid to create a gradation.

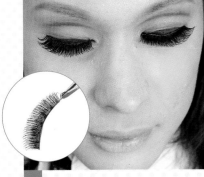
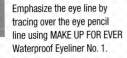

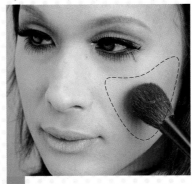

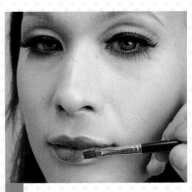

8 Darken your own lashes before affixing long, fluttering eyelashes to your upper eyelid.

9 Use MAKE UP FOR EVER Eyelash No. 51 on the lower eyelashes. Apply Mitsuyoshi Cheek Color 13 lightly to the area inside the dotted lines.

10 Apply a rose or pink lip gloss inside a lip line, and you're done.

 Sexy older woman

The key to a creating the look of a sophisticated older woman is long, narrow eyes, long eyelashes and an elegant mouth. If you're off just a little, you'll look gaudy, so stay away from bright red lipstick, gaudy cheeks and curly, light-brown hair.

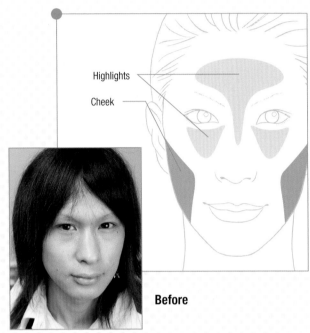

Highlights

Cheek

Before

Make-up item

MAKE UP FOR EVER Eye Pencil (No. 1, No. 4)

Mitsuyoshi Pencil Eyeliner Soft Black

Angel Color World Brown

Chacott Make-up Color Variation No. 616

MAKE UP FOR EVER Waterproof Eyeliner No. 1

Chacott Point Eyelashes

MAKE UP FOR EVER Eyelashes M51

MAKE UP FOR EVER Eye Shadow and Powder Blush (No. 131, No. 170, No. 147)

MAKE UP FOR EVER Mascara Volume 1

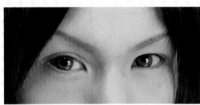

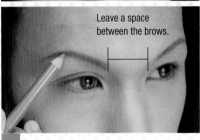

Leave a space between the brows.

1 For a softer look, put in brown contacts (Angel Color World Brown). Use a matching light-brown color (a mix of MAKE UP FOR EVER Eye Pencil No. 1 and No. 4) to draw arched brows. For guys who want to dress up as women or for women with severe faces, extend brows past the outer edge of the eyes. Widen the distance between the brows as much as possible without making it seem unnatural – this is one point to making a face more feminine.

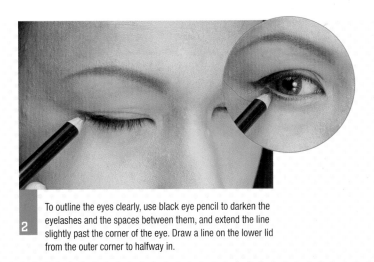

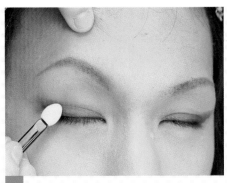

2 To outline the eyes clearly, use black eye pencil to darken the eyelashes and the spaces between them, and extend the line slightly past the corner of the eye. Draw a line on the lower lid from the outer corner to halfway in.

3 Apply blue eye shadow. First use a darker shade (MAKE UP FOR EVER Eye Shadow and Powder Blush No. 147) to slightly widen the double fold to the edge of the eyelid. Work from the inner corner in, and then from the outer corner in.

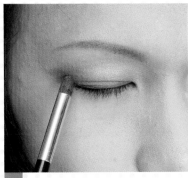

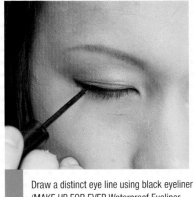

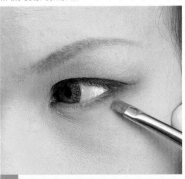

4 Apply a lighter blue than 3 (MAKE UP FOR EVER Eye Shadow and Powder Blush No. 170) over the entire upper eyelid in gradations.

5 Draw a distinct eye line using black eyeliner (MAKE UP FOR EVER Waterproof Eyeliner No. 1).

6 Apply a reddish color (MAKE UP FOR EVER Eye Shadow and Powder Blush No. 131) at the outer corner of the eye. This is a key point for sexiness.

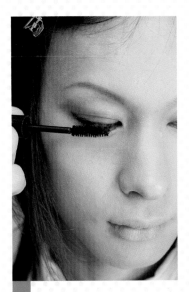

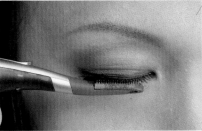

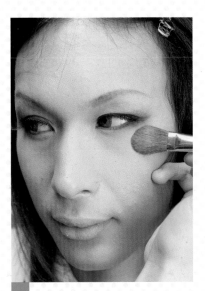

7 Apply black mascara to the upper eyelashes.

8 For even more powerful eyes, affix a double layer of false eyelashes. With MAKE UP FOR EVER Eyelashes M51 as a base, add Chacott Point Eyelashes and curl with a hot eyelash curler.

9 Use a cheek brush to lightly apply Chacott Make-up Color Variation No. 616 above the cheekbones, and you're done. (Skip this step if you have prominent cheekbones.)

Female college student

This type of make-up is meant to portray a basically beautiful woman who is perfectly made up. Use basic colors, and work on highlights and translucency. It should look as natural as possible, but base make-up should cover any flaws.

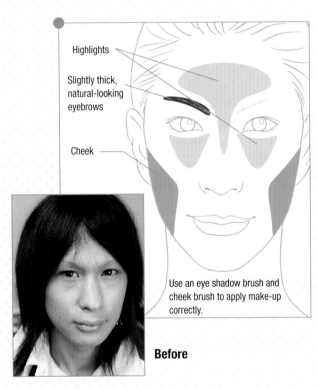

Highlights

Slightly thick, natural-looking eyebrows

Cheek

Use an eye shadow brush and cheek brush to apply make-up correctly.

Before

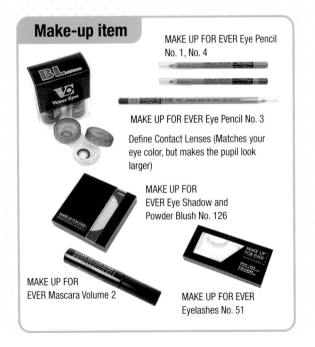

Make-up item

MAKE UP FOR EVER Eye Pencil No. 1, No. 4

MAKE UP FOR EVER Eye Pencil No. 3

Define Contact Lenses (Matches your eye color, but makes the pupil look larger)

MAKE UP FOR EVER Eye Shadow and Powder Blush No. 126

MAKE UP FOR EVER Mascara Volume 2

MAKE UP FOR EVER Eyelashes No. 51

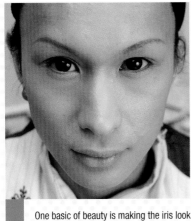

1 One basic of beauty is making the iris look larger. Use Define Contact Lenses that match your own eye color.

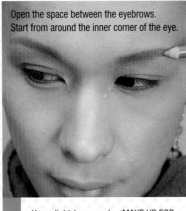

Open the space between the eyebrows. Start from around the inner corner of the eye.

2 Use a light-brown color (MAKE UP FOR EVER Eye Pencil No 1, No. 4) to draw natural-looking thick brows.

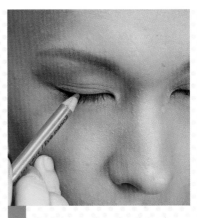

3 Don't draw eye lines, since that makes them look less natural. Just use a thin black eye pencil (MAKE UP FOR EVER Eye Pencil No. 3) to fill in the spaces between lashes. Use the pencil to lightly fill in the spaces.

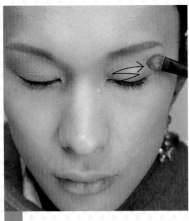

4 Apply eye shadow (MAKE UP FOR EVER Eye Shadow and Powder Blush No. 126) to the entire upper eyelid as a highlight.

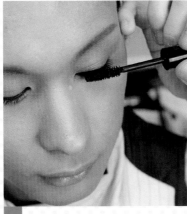

5 Apply lots of volumizing mascara (MAKE UP FOR EVER Mascara Volume 2).

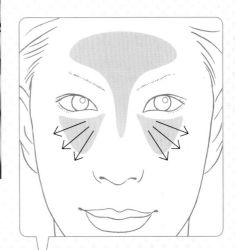

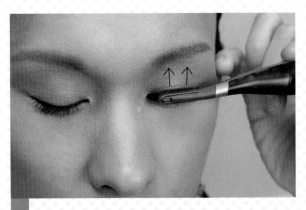

6 To give the impression of long eyelashes, affix false eyelashes (MAKE UP FOR EVER Eyelashes No. 51), and use a hot eyelash curler to give them lift. This is the one part where it's OK not to go for a natural look.

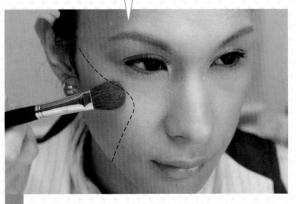

7 Use a cheek color slightly lighter than your own skin to apply highlights to your forehead and cheeks, as shown in the photo.

 2.⁴4

Fresh-faced woman

For make-up that doesn't look like make-up, the key points are white skin with plenty of highlights, and natural-looking eye make-up.

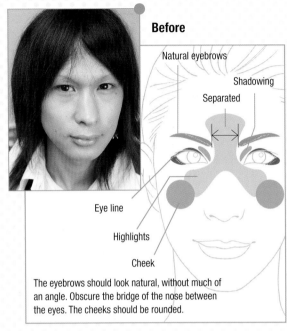

Before

Natural eyebrows

Shadowing

Separated

Eye line

Highlights

Cheek

The eyebrows should look natural, without much of an angle. Obscure the bridge of the nose between the eyes. The cheeks should be rounded.

Make-up item

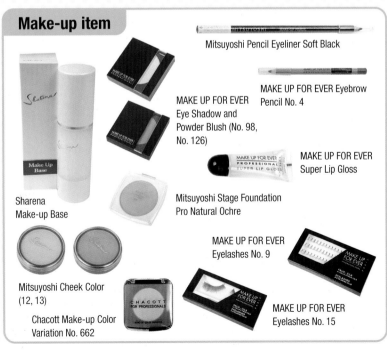

Mitsuyoshi Pencil Eyeliner Soft Black

MAKE UP FOR EVER Eyebrow Pencil No. 4

MAKE UP FOR EVER Eye Shadow and Powder Blush (No. 98, No. 126)

MAKE UP FOR EVER Super Lip Gloss

Sharena Make-up Base

Mitsuyoshi Stage Foundation Pro Natural Ochre

MAKE UP FOR EVER Eyelashes No. 9

Mitsuyoshi Cheek Color (12, 13)

Chacott Make-up Color Variation No. 662

MAKE UP FOR EVER Eyelashes No. 15

Start from white eyebrows, on page 43

Sharena Make-up Base → Apply Mitsuyoshi Stage Foundation Pro Ochre using a sponge, and cover with powder.

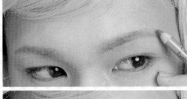
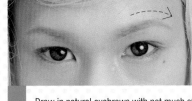

1 Draw in natural eyebrows with not much of an angle. Smudge the ends with a cotton swab.

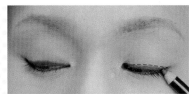
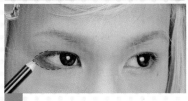

2 Draw a round spot in the center of the eyelid using Mitsuyoshi Pencil Eyeliner Soft Black, and draw a thin eye line to the inner and outer corners of the eye. The eye line for the bottom eyelid should be moderately bold.

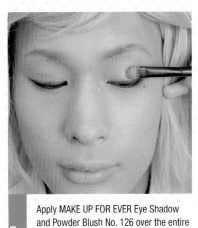

3 Apply MAKE UP FOR EVER Eye Shadow and Powder Blush No. 126 over the entire eyelid.

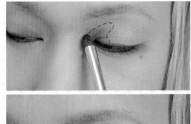
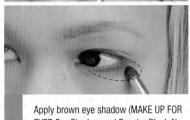

4 Apply brown eye shadow (MAKE UP FOR EVER Eye Shadow and Powder Blush No. 98) in the corners of the eyes as shown by the dotted lines.

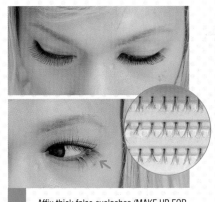

5 Affix thick false eyelashes (MAKE UP FOR EVER Eyelashes No. 15) to the upper eyelid, and then add point eyelashes (MAKE UP FOR EVER Eyelashes No. 9) to the lower eyelid. Use about 4 per eye, beginning with the outer corner.

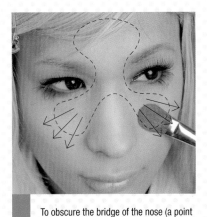

6 To obscure the bridge of the nose (a point for a younger look), add highlights to the areas inside the dotted lines. Apply Chacott Make-up Color Variation No. 662 from the forehead to the nose and cheeks, in the direction of the arrows, using a cheek brush.

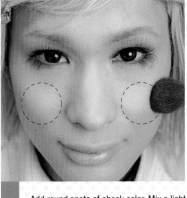

7 Add round spots of cheek color. Mix a light pink color using Mitsuyoshi Cheek Color No. 12 and 13, and apply it to the areas in side the dotted lines, using a cheek brush in a circular motion. (The area is the part that is most prominent when you smile.)

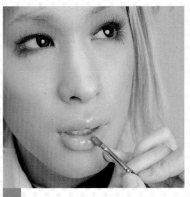

8 Don't apply color to the lips – just use gloss. Apply MAKE UP FOR EVER Super Lip Gloss using a lip brush.

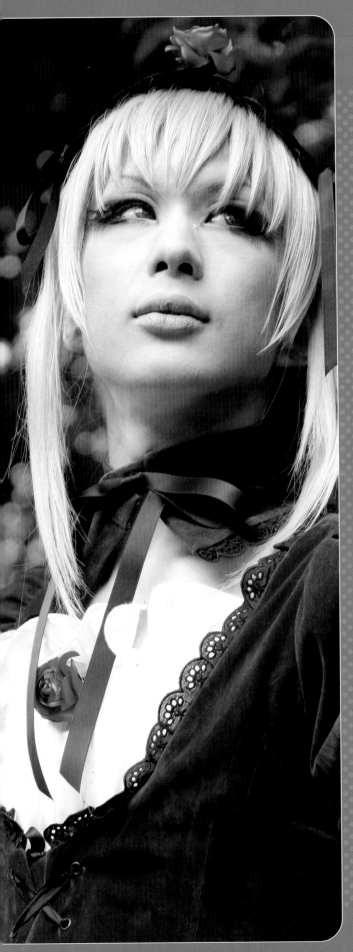

Chapter 5

Comprehensive Guide to Greasepaint

The porcelain skin of a china doll, the translucent blue-white skin of a vampire, the cocoa-brown skin of a girl from the southern isles – by changing the color of your skin, you can change your appearance so completely that people will wonder if you are even the same person. There are many different greasepaint products, but here we'll explain the basics of how to apply greasepaint and how to be sure that it won't stain your costume.

5.1 Basics of Greasepaint

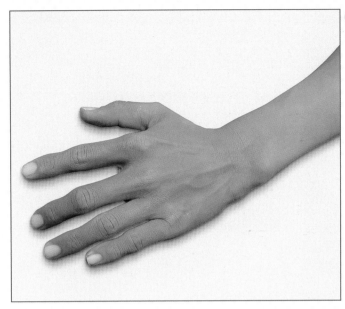

1 Applying theatrical make-up

This is the easiest way to apply greasepaint. If the color you want to use is included in the line-up of theatrical make-up, it's simple to use, and doesn't come off easily on your costume.

Mitsuyoshi Face Powder White

MAKE UP FOR EVER Wet Make-up (Royal Blue)

Recommended product
MAKE UP FOR EVER Wet Make-up
This stage make-up is a favorite of professionals. There are 31 colors in all, including such unique colors as turquoise, silver and copper, and this greasepaint is vivid and easy to apply. It's also very durable, and won't flake easily, so even at a crowded event, it will maintain its color for a long time. This paint is oil-free; it has a glycerin base that is gentle on the skin. The colors can be mixed as you please, and because a little bit covers a large area, it's very economical!

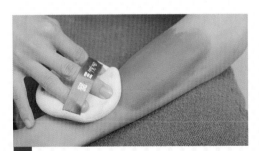

1 Start by wiping off sweat and any oil from the skin to be painted. Moisten a sponge in water, and then take up a tiny bit of MAKE UP FOR EVER Wet Make-up and apply to the skin.

2 After applying the paint once, dust thoroughly with powder.

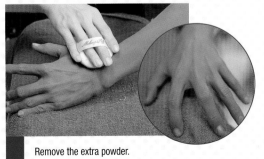

3 Remove the extra powder.

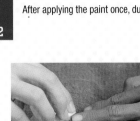

4 If you're going to apply false fingernails or do a manicure, remove the paint simply using a cleansing sheet.

To remove

Use either soap and warm water or cleansing milk to remove the paint easily.

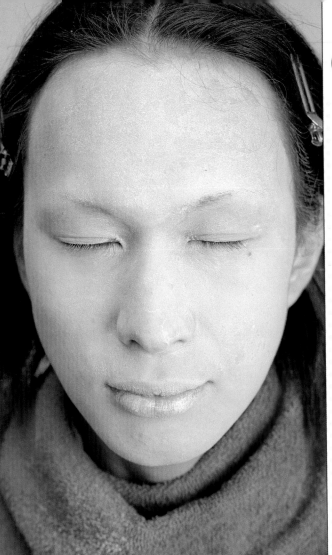

 Applying white paint evenly

Use white foundation to achieve a smooth white base.

Start at the point where you've applied cream foundation and dusted it with powder.

Point

Prepare water in a container, and dip an itabake (wooden-handled brush) into the water, and then into the Mitsuyoshi Face Cake White.

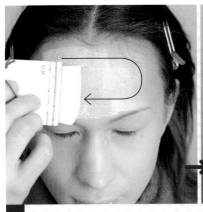
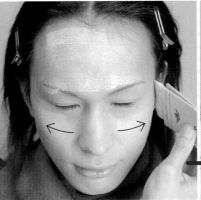
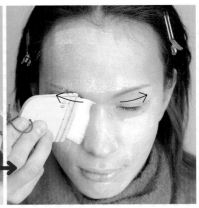

1 Apply liberally to your forehead, and to the cheeks in an outward sweep. With your eyes closed, apply across the eye, from the inner corner outward.

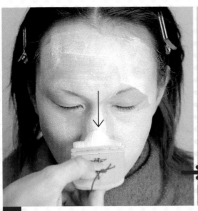
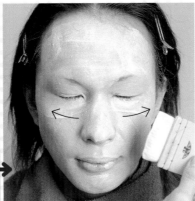

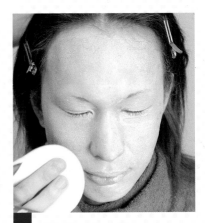

2 Apply down the nose, and again across the cheeks.

3 Blot with a cotton puff to remove any excess moisture. Continue this process until you achieve the degree of color you want.

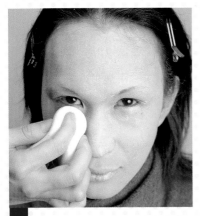
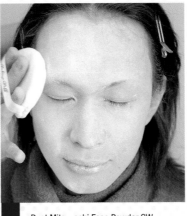

4 Use a cotton puff to apply Face Cake to small and hard-to-reach areas.

5 Dust Mitsuyoshi Face Powder SW (translucent) over the area.

6 Use a brush to remove any excess powder, and you're done.

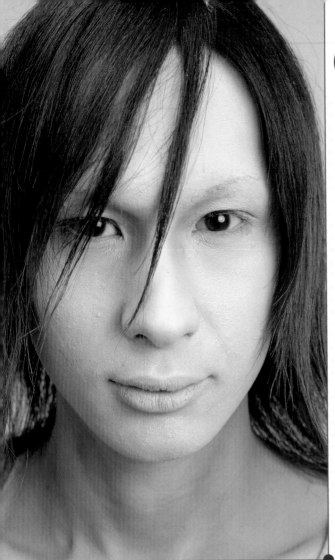

Applying gray paint

When the color you want isn't available, you may have to mix it yourself. If the materials you're mixing are all oil-based, they should blend nicely.

Start with no make-up on.

Make-up item

Mitsuyoshi Lining Color 1 (Black)

Mitsuyoshi Greasepaint White

Mitsuyoshi Face Cake White

Mitsuyoshi Face Powder

Sharena Face Color Black

Recommended product

Mitsuyoshi Greasepaint
Commonly known as *Dohran*, this is the representative stage make-up. It's an oil-based cream, and is fixed using powder.

Mitsuyoshi Lining Color
This oil-based pigment is a stage make-up used for areas such as the eyes and mouth.

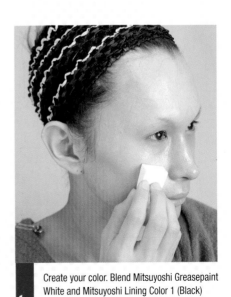

1 Create your color. Blend Mitsuyoshi Greasepaint White and Mitsuyoshi Lining Color 1 (Black) on a palette to make a shade of gray that you like. Put some on a sponge and spread on your (washed) face.

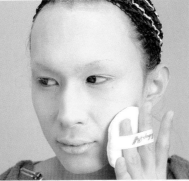

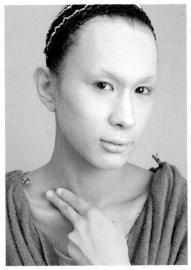

2 When you've covered your face, without missing any spots, dust with Mitsuyoshi Face Powder SW. After that, as when applying white foundation, spread Mitsuyoshi Face Cake White using an itabake, blot with a sponge puff to remove moisture, and dust with Mitsuyoshi Face Powder SW.

For the body, apply gray first in the same manner.

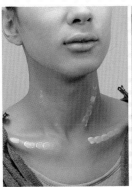
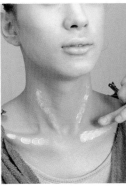
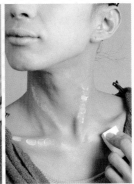

3 Apply highlights to the collarbone and other protruding parts using Mitsuyoshi Greasepaint White, dotted along protruding areas. Spread it with your fingers and then use a sponge to add gradations.

Point

Follow this pattern: Mix and apply two colors of greasepaint (oil-based) → Apply Mitsuyoshi Face Cake White (water-based) → Apply powder.
If you do it in this order, the make-up will last a long time.

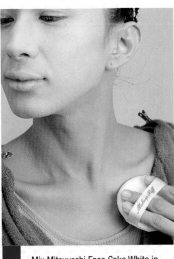
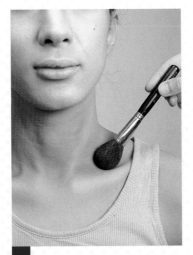

4 Mix Mitsuyoshi Face Cake White in water and apply using an itabake, as with applying white foundation. Blot with a sponge. Dust with Mitsuyoshi Face Powder SW (translucent).

5 Use Sharena Face Color Black to add shadowing.

Character Make-up

1 Vampire make-up

A slightly bluish-white complexion, red eyes, shadowy eyelids and lips dyed with blood – the marks of a vampire! To create the effect that your skin actually looks like this without make-up, pay attention to the shadowy gradations at the eyes and forehead.

Before

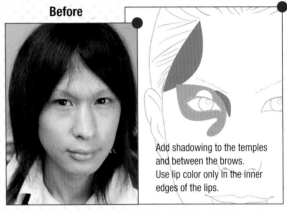

Add shadowing to the temples and between the brows. Use lip color only in the inner edges of the lips.

Bluish-white skin base
(a rehearsal for abnormal make-up)

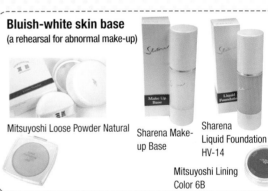

Mitsuyoshi Loose Powder Natural

Sharena Make-up Base

Sharena Liquid Foundation HV-14

Mitsuyoshi Lining Color 6B

Make-up item

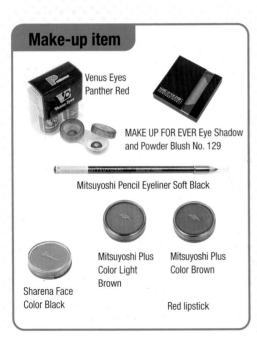

Venus Eyes Panther Red

MAKE UP FOR EVER Eye Shadow and Powder Blush No. 129

Mitsuyoshi Pencil Eyeliner Soft Black

Sharena Face Color Black

Mitsuyoshi Plus Color Light Brown

Mitsuyoshi Plus Color Brown

Red lipstick

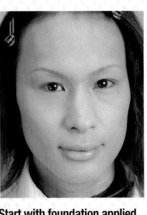

Start with foundation applied.

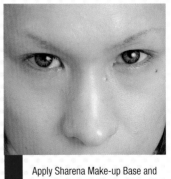

1 Apply Sharena Make-up Base and put in red contact lenses (Venus Eyes Panther Red).

2 Make a bluish-white base. As with abnormal make-up, start with Sharena Liquid Foundation HV-14 (pale skin color) as the base, and add Mitsuyoshi Lining Color 6B (blue) to get a pale blue-white color. Apply with your fingers, starting with the cheeks.

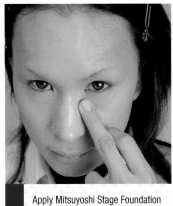

3 Apply Mitsuyoshi Stage Foundation Pro Natural Light (pale matte skin color) smoothly to areas of particular concern.

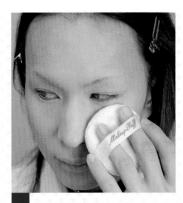

4 Dust Mitsuyoshi Loose Powder with a powder puff.

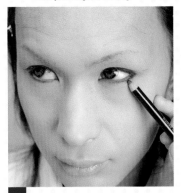

5 Use a black eye pencil (Mitsuyoshi Pencil Eyeliner Soft Black) to boldly outline the upper eyelid and particularly the outer corner of the eye. Outline the lower eyelid as well, but don't draw the line as far as the inner corner.

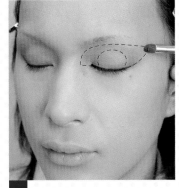

6 Apply shadowing to the hollows of the eye. The point here is not to use black (if you do, it looks more like stage make-up). Use Mitsuyoshi Plus Color Brown in the areas shown by the dotted lines.

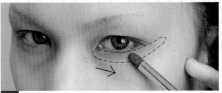

7 Create heavy shadows under the eyes. Apply Mitsuyoshi Plus Color Light Brown in the direction of the arrows in the photo, using an eye shadow brush. Smudge the eye line under the lower lid, and apply shadowing broadly. Apply MAKE UP FOR EVER Eye Shadow and Powder Blush No. 129 in the areas shown by the dotted lines.

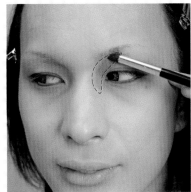

8 As accents, use Sharena Face Color Black on the darkest part of the shadows. Apply Sharena Face Color Black within the dotted lines, but don't use too boldly. Use different levels for a gradation effect.

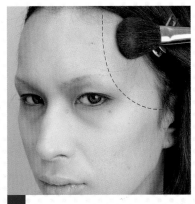

9 Use shadowing on the cheeks to make your face look thin. Apply the same shade used around the eyes (MAKE UP FOR EVER Eye Shadow and Powder Blush No. 129) from the temples to the cheeks, including the outer corners of the eyes. Use a cheek brush to create neat gradations.

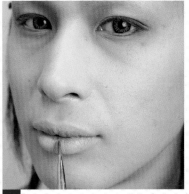

10 Don't use color on the entire lip. First apply foundation to the lips to cover up your natural color, and then, holding it vertically, use a lip brush to apply a crimson red color just to the inner vertical lines.

Healthy, tanned skin

When making yourself up as a beautiful tanned character, the important thing is to make sure that your eye and lip make-up is bold enough to complement your darker skin. To fix your make-up so that it won't wear off, you'll use a translucent face powder, but it you try to reapply make-up over the powder, it will look truly bad, so make sure that everything is ready before you apply the powder.

Before

Make-up item

Mitsuyoshi
Face Cake S10

Mitsuyoshi Face Powder SW

Mitsuyoshi Stage Foundation Pro
(Cream, Natural Light, Ochre)

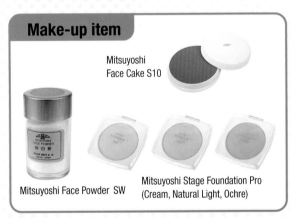

1 Create the color to be applied using a cream foundation. Check whether your skin has yellow or red tones (you can also have this checked at the store when you buy the foundation) and mix Mitsuyoshi Stage Foundation Pro Cream, Natural Light and Ochre to get a color that matches your skin tone. Apply the foundation and dust with powder (Mitsuyoshi Face Powder SW).

2 Dissolve Mitsuyoshi Face Cake S10 in water and following the line of the muscles, apply from the inside to the outside using an itabake, making sure that the application is smooth.

3 Blot with a sponge puff to remove excess moisture.

4 Once your face is completely covered, fix with powder and apply a lipstick that is redder than your usual color. Use a darker eyeliner to make your eyes stand out too.

5 With your face color as a reference, apply the same color to your neck and under the chin, using an itabake.

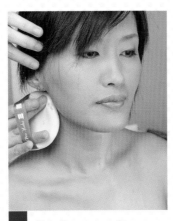

6 Blot with a sponge puff to remove excess moisture.

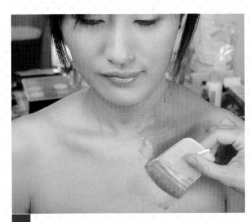

7 Follow the same procedure for the rest of the body. Don't forget the hollows of the collarbone or under your arms.

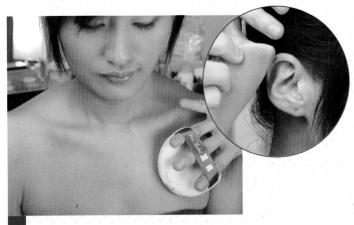

8 Pat with a sponge puff to remove excess moisture. It's easy to forget the earlobes and the back of the ears. It's difficult to do these areas with the itabake, so dip a sponge in water and then in Mitsuyoshi Face Cake S10 and cover the ears.

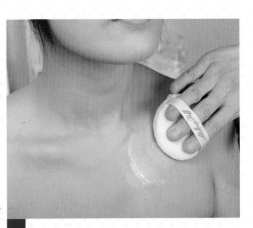

9 Finally, apply Mitsuyoshi Face Powder SW all over, and you're finished. (It's translucent, so it won't be white.) If you try to add color on top if this, the itabake will damage the layer that's already there, so this should be the absolutely final step.

Chapter 6

Introduction to Special Effects Make-up!

If your wounds and tattoos make people wonder "Are those real?", this adds infinitely to the effectiveness of your costume.

When it comes to special effects make-up, there are all kinds, from the very simple to the extremely realistic.

In this section, professional make-up artists will explain how to create wounds, burns, bruises, tattoos and other effects that can help bring a character to life, using everyday materials.

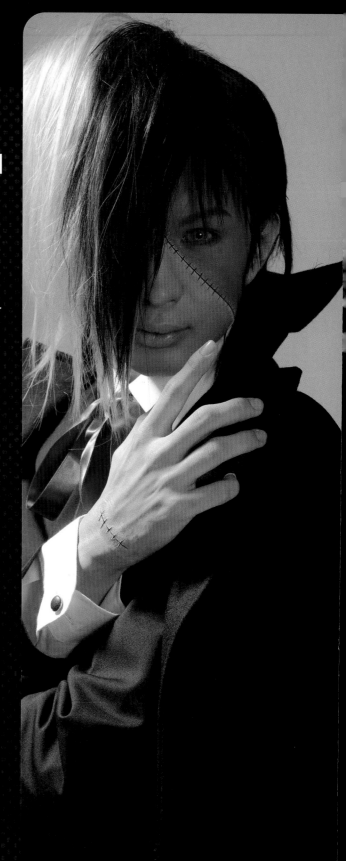

Blood-stained bandages

Here we'll show you how to do two versions – one using "blood clots" (you can make this at home, dry it and go to your event), and one using acrylic paints.

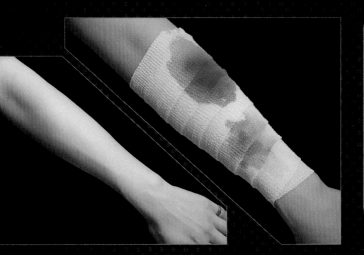

Make-up item

Blood paste (Laitier Dressy Red) and water or Acrylic paint (water-based); (Clear Red, Clear Orange)
Tools: Flat brush, narrow brush, paper cups

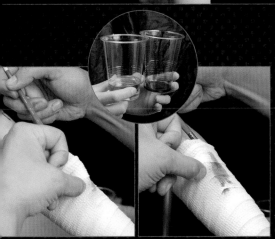

If possible, wrap the bandages around a straight part of your anatomy. Bandages around the joints can slip, so be careful.
Wrap the bandages tightly, and use surgical tape on the inner side to fasten loose parts securely.

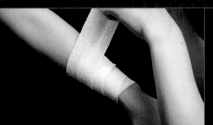

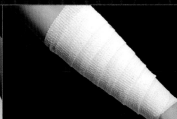

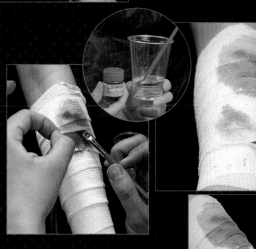

Making the blood paste

Mix water and blood paste in a ratio of 2:1.

Scoop up blood paste on one side only of the brush, insert the brush inside the bandages and press the blood against the bandage from the inside.

Dip a different brush in water and in the blood mixture. When it dries, use the blood to make fine adjustments. For a realistic touch, the dark blood and light blood should be mottled.

Acrylic paints

Prepare water-based acrylic paint in Clear Red, and water.

Wrap bandages as with the first method.

If you use just Clear Red, the effect will look fake, so for a more realistic look, mix with Clear Orange.

Faded Battle Scars

The scars of sword cuts received on the field of battle – in this section we'll discuss raised scars, which are made using latex, and puckered scars, made with Keloskin.

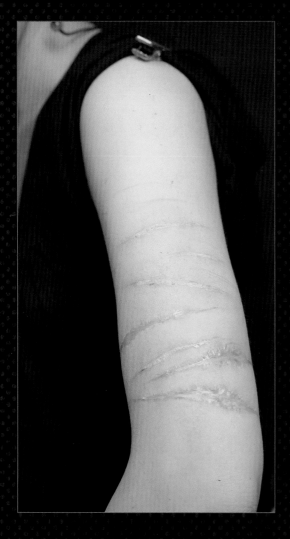

The trick to making scars look real is to first imagine how the wounds would have been made, and to think about the design and placement. This time, we imagined someone wearing the type of armor that exposes the arms, receiving multiple cuts from a sword on the battlefield, leading to multiple thin scars on the outside edge of the arm.

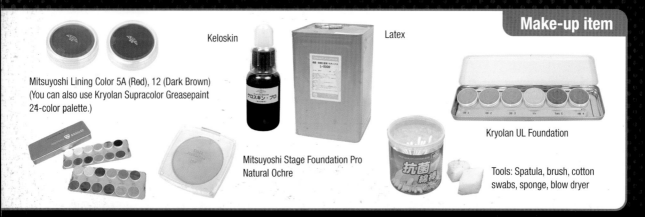

Make-up item

Keloskin

Latex

Mitsuyoshi Lining Color 5A (Red), 12 (Dark Brown)
(You can also use Kryolan Supracolor Greasepaint 24-color palette.)

Mitsuyoshi Stage Foundation Pro Natural Ochre

Kryolan UL Foundation

Tools: Spatula, brush, cotton swabs, sponge, blow dryer

Raised scars

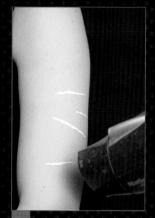

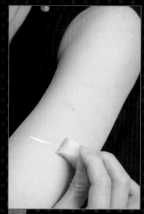

1 First use a spatula to draw thin lines across the arm with the latex in the shape of the scars.

2 Dry the latex with a blow dryer (low heat is fine) until it turns translucent.

3 Apply Mitsuyoshi Stage Foundation Pro Natural Ochre using a sponge.

Puckered Scars

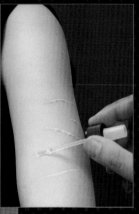

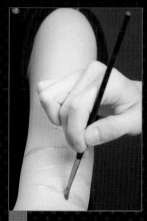

1 Draw scars using the Keloskin Pro.

2 Dry the Keloskin Pro until the skin begins to pucker.

3 Mix Mitsuyoshi Lining Color 5A (Red) and 12 (Dark Brown) to make a reddish-brown color, and apply using a brush.

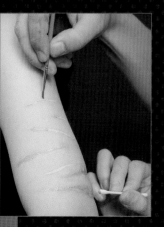

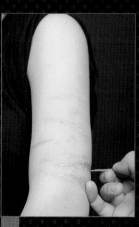

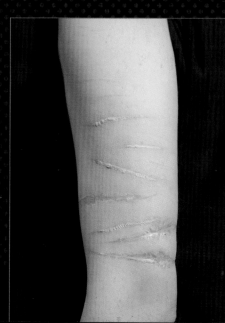

4 Using cotton swabs and a small brush, apply darker red color to the center of the scar. Mix white with the red to create a lighter color, and apply to the edges of the scars.

5 In the space between scars, use a small brush to apply red color, as if inflamed.

95

6·3 Fresh Wounds

Use greasepaint to draw the wound, and blood paste for the blood pouring from the wound.

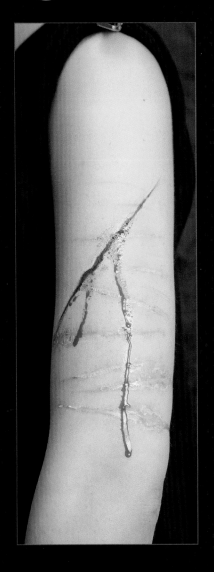

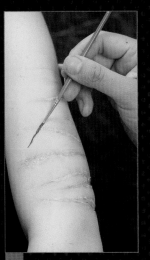

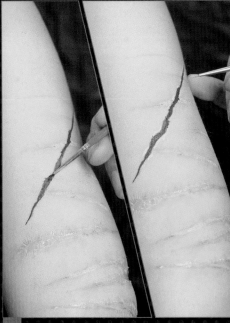

1 Blend Mitsuyoshi Greasepaint Red and Black to make the color of blood, and use a small brush to draw the line of the wound. Once you start drawing, draw a thin straight line to the end and then lift the brush.

2 Add details, such as widening gouged areas and making the wound crooked. The edge of the wound should be raised, so use Mitsuyoshi Stage Foundation Pro Natural Ochre to add highlights.

3 Next use the blood paste.

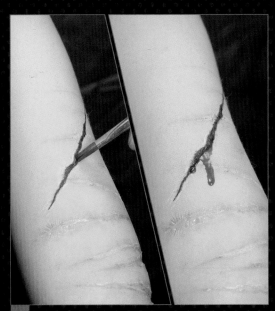

Make-up item

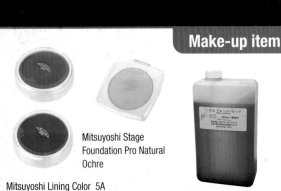

Mitsuyoshi Stage Foundation Pro Natural Ochre

Mitsuyoshi Lining Color 5A (Red), 12 (Dark Brown)

Blood paste (Laitier Dressy Red)
Tools: Brush

4 Don't thin with water; apply as is using a brush. Where blood will be dripping, lightly press in to form a blood clot. Add realistic-looking blood flows and you're done.

Painted-on Stitched Wounds

Stitched wounds that look real and can be finished in 5 minutes.

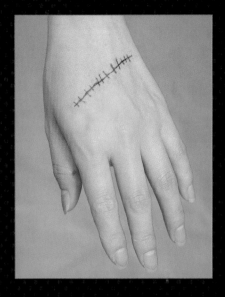

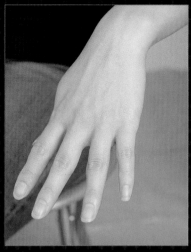

Draw this on the hand opposite to your dominant hand.

Make-up item

Acrylic paints (water-based):
(Black, Dark Brown)
Tool: Fine-tipped brush

1 Dip the brush in water and then in the Dark Brown acrylic paint and lightly draw a scar.

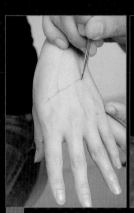

2 Add horizontal stitching lines. The dark brown line will become the edge of the scar.

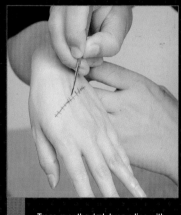

3 Trace over the dark brown line with black acrylic paint. The point here is to draw a black line that's thinner than the dark brown line.

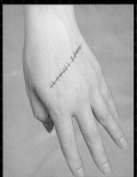

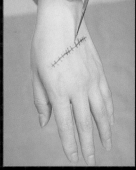

4 Add shadowing using dark brown color mixed with water. First dab color on both ends of the horizontal stitch lines to add color. This makes it look like the ends of the stitches are disappearing into the skin.

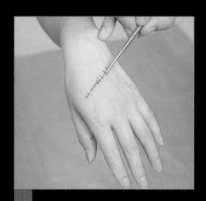

5 Using the same dark brown, add shadows to show the puckering in the center. Add color where the horizontal and vertical lines cross, and you're done.

Bullet holes

Old bullet holes in the chest, as well as slightly less faded scars – here we'll explain how to make them using both putty (Plus Art) and tissue paper.

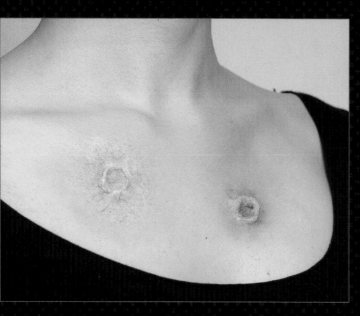

Make-up item

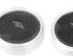

Mitsuyoshi Lining Color 5A (Red), 12 (Dark Brown) (You can also use Kryolan Supracolor Greasepaint 24-color palette.)

Mitsuyoshi Stage Foundation Pro Natural Ochre

Plus Art (nose-and-scar wax)

Tools: Brush, cotton swabs, sponge, blow dryer

Tissue paper

Using putty

1 Apply latex to make a thin membrane where the bullet hole will go. This will allow the Plus Art to stick to your skin better.

2 Use a blow dryer to dry the latex until it turns translucent.

3 Create the raised part of the bullet hole using Plus Art (Mitsuyoshi Taihaku Eyebrow cover-up is also OK), and use the opposite end of the brush to hollow out the center.

4 Coat the Plus Art using latex.

5 Apply latex to the skin around the bullet hole, and dry the entire thing using a blow dryer.

6 Blend Mitsuyoshi Lining Color 5A (Red) and 12 (Dark Brown) to make a reddish-brown color, and use a brush to apply it to the center of the bullet hole.

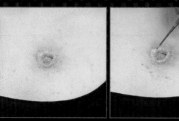
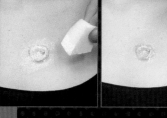

7 Apply color around the bullet hole in a gradated pattern, use Mitsuyoshi Stage Foundation Pro Natural Ochre to highlight the highest part of the bullet hole scar, and you're done.

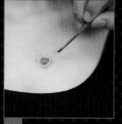

sing tissue paper

1 Prepare the tissue paper to be used. Separate double-ply tissues into separate sheets.

2 Gather the tissue paper into a ball at one end. The ball should be slightly larger than the bullet hole you are creating. Shred the tail of the tissue and spread it out.

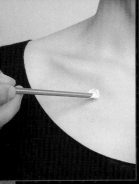

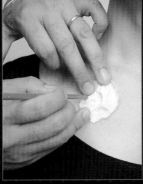

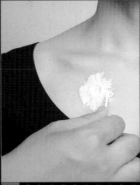

3 Apply latex where the center of the bullet hole will be, and place the center of the tissue ball on top of it.

4 After covering the whole thing with latex, use a cotton swab to make a crater in the center of the tissue paper, and when it looks right, use a blow dryer to dry it.

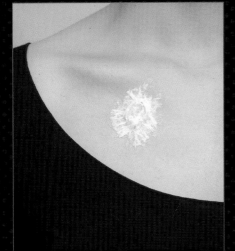

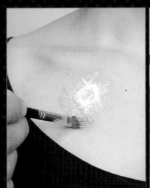

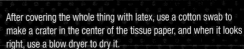

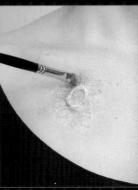

5 Color it the same way you did the Plus Art bullet hole. Apply reddish-brown color to the center of the bullet hole and in a gradation

6·6 Facial Blood Vessels

Use Plus Art to create the raised segments, and a fine-tipped brush to paint in the capillaries. In just 10 minutes you can create bulging facial blood vessels.

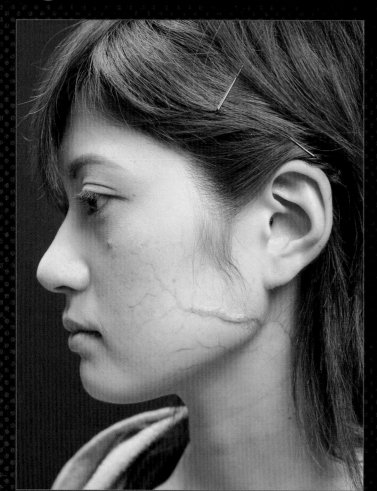

Make-up item

Mitsuyoshi Lining Color 5A (Red), 3A (Blue) (You can also use Kryolan Supracolor Greasepaint 24-color palette.)

Mitsuyoshi Stage Foundation Pro Natural Ochre

Latex

Plus Art (nose-and-scar wax)
Tools: Brush, fine-tipped brush, sponge

Before

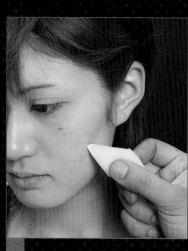

Apply latex where the raised veins will be.

1

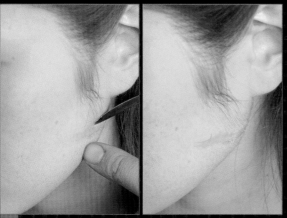

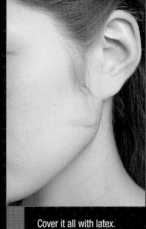

2 Create raised veins using Plus Art on top of the latex.

3 Cover it all with latex.

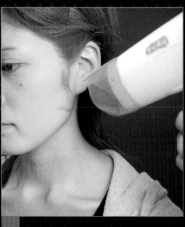

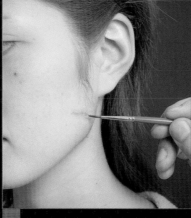

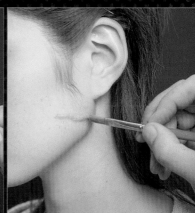

4 Dry with a blow dryer until the latex turns transparent.

5 Apply Mitsuyoshi Lining Color 5A (Red) on top of the putty.

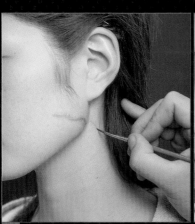

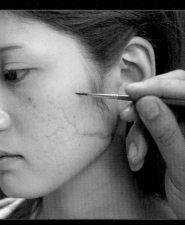

6 Mix Mitsuyoshi Lining Color 5A (Red) and 3A (Blue), draw in the capillaries with a fine-tipped brush, and you're done.

7 If you draw the capillaries even where they're not usually visible, such as under the chin, the make-up will be effective from every angle.

Facial bruises

Create facial bruises (fresh wounds and old bruises) using latex and greasepaint.

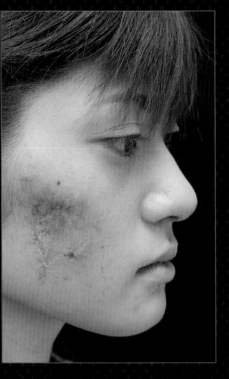

Before

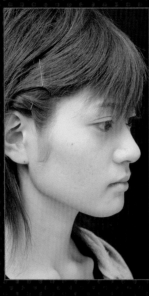

Make-up item

Kryolan Supracolor (Blue, Red),
(You can also use Mitsuyoshi Lining Color 5A, 3A)

Tools: Brush,
sponge

Latex

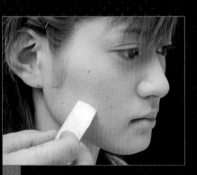

Wipe your face thoroughly to remove oil.

1

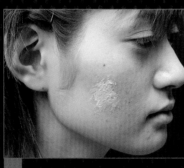

Apply latex to give the skin a rough look.

2

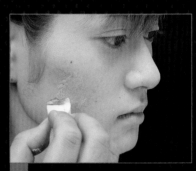

Put Kryolan Supracolor (Red) on a sponge and dab it on to provide texture and color.

3

Adjust the color with a brush in a patchy, mottled pattern.

4

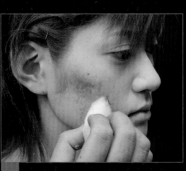

Put Kryolan Supracolor (Blue) on a sponge and apply in patches. Use the blue sparingly.

5

6.8 Tattoo on the Nape of the Neck

Design and create a pattern of the tattoo first, and apply it to the skin and trace around it.

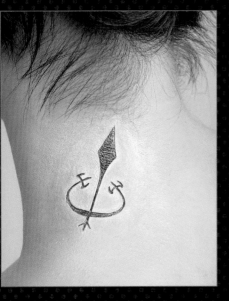

Make-up item

Oil-based Clay

Kryolan UL Foundation

Latex

Plaster

Kryolan Supracolor Greasepaint

Baby Powder

In addition, you'll need cardboard, tape, cotton swabs, a sponge, and Pros Aid (glue for special effects make-up).

The plaster mold is completed.

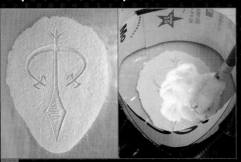

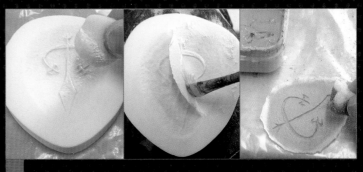

1 After designing your tattoo, engrave it into the oil-based clay. On a flat surface, make a thin layer with the design on it. Use plaster to make a cast of the design. Use cardboard to make a wall around the mold; tape the bottom so the plaster can't leak. To prevent bubbles on top of the clay, use a brush to apply plaster over the design, and then pour in more plaster until it is about 1cm thick. When the plaster is hard, turn over the cast and remove the cardboard. Remove the clay, and the cast is finished.

2 Use latex to make a mold of the tattoo with thin edges and a center that is thick enough not to tear. First use a sponge to apply the first layer of latex to the cast, and let it dry. Apply the second layer of latex. Start about 1 cm from the edge when applying the second layer – don't apply to the edges. Apply a third layer the same way, and repeat for another 7 ~ 10 layers.
When the last layer of latex has dried, remove the latex from the plaster cast. The latex tears easily, so use baby powder and a brush to gently remove it.
Apply color. Place the tattoo mold on a flat surface and use Kryolan Supracolor 24-color palette to paint it the colors you want.

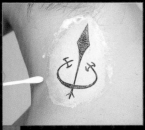

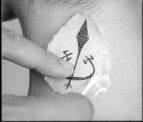

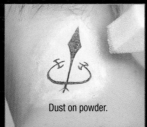

Dust on powder.

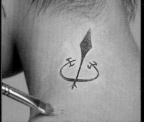

3 Use Pros Aid (a glue for use with special effects prosthetics) to attach the tattoo. Apply to the center, stick to your skin, and when the location is set, apply Pros Aid to the edges using a cotton swab and stick down.

4 Apply Pros Aid to the edges from above, and blend in.
Apply Kryolan UL Foundation to the skin and latex, blend in, and you're done.

Wrinkles and Blood Vessels on the Hand

Using everyday items like tissue paper and string, transform your hand in an instant to that of an old man with raised veins!

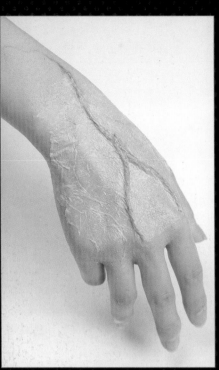

Make-up item

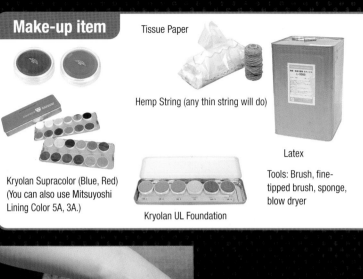

Tissue Paper

Hemp String (any thin string will do)

Latex

Kryolan Supracolor (Blue, Red)
(You can also use Mitsuyoshi
Lining Color 5A, 3A.)

Kryolan UL Foundation

Tools: Brush, fine-tipped brush, sponge, blow dryer

Before

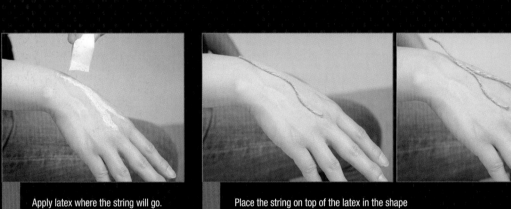

1 Apply latex where the string will go.

2 Place the string on top of the latex in the shape of a blood vessel.

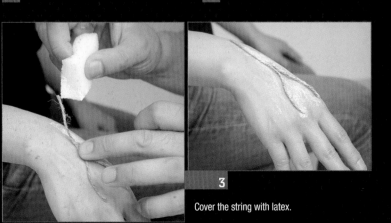

3 Cover the string with latex.

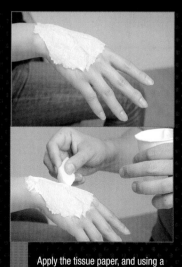

4 Tear the tissue paper by hand to the size of the area to be covered by wrinkles. Separate the 2 layers.

5 Apply the tissue paper, and using a sponge in a daubing motion, coat with more latex.

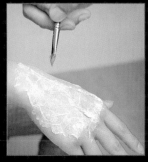
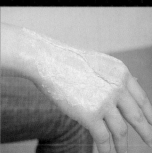

6 Apply latex to the skin as well, and dry it with a blow dryer until the latex turns transparent.

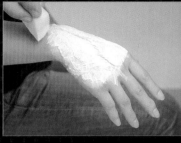
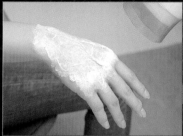
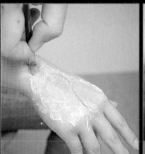
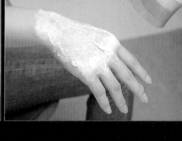

7 Apply dry Kryolan Ultra Foundation with a brush (it's easier to apply on top of latex than other foundations), pressing down to make the color stick. You can also use greasepaint.

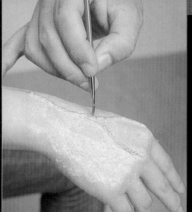

8 Use Kryolan Supracolor Red on the string to make it look like a blood vessel. If you want to create a more wrinkled vein, you can also use Lining Color Red.

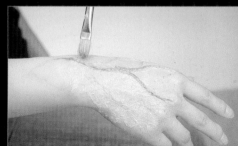

9 Use Kryolan Supracolor Kryolan Red and Blue to color the parts aside from the vein, and you're done.

Webbing

Create translucent webbing for your hands using paper towels and latex. Because of the latex covering, the webbing doesn't tear even if you clench your hands.

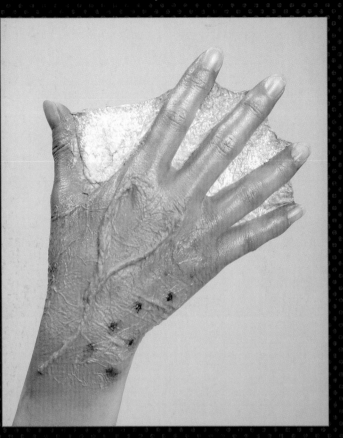

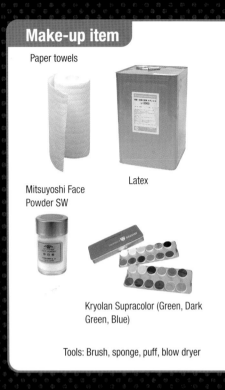

Make-up item

Paper towels

Latex

Mitsuyoshi Face Powder SW

Kryolan Supracolor (Green, Dark Green, Blue)

Tools: Brush, sponge, puff, blow dryer

Start from page 104 "Wrinkles and Blood Vessels on the Hand"

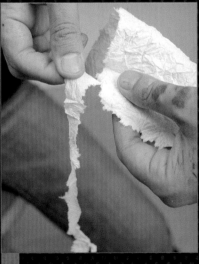

1 Crumple up the paper towel tightly into a ball, and then straighten it out. Tear a piece that's the size of the space between your thumb and index finger when they are spread out. If you cut it with scissors, the line will be too straight, and won't look natural.

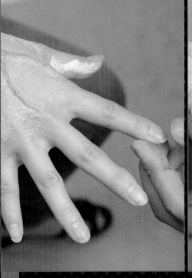

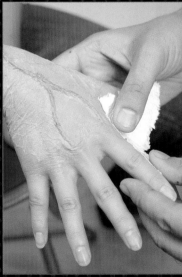

2 Apply latex to the sides of the thumb and index finger. Stick the paper towel piece to the latex.

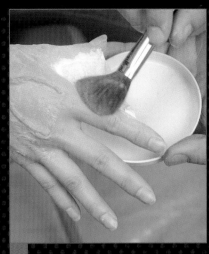

Coat the paper towel with latex and clean up the edges.

3

4 The latex will be sticky even after it dries, so before moving your hand, dust with Mitsuyoshi Face Powder SW (Transparent).

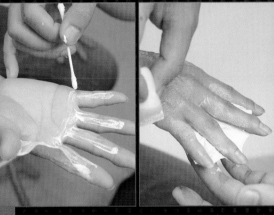

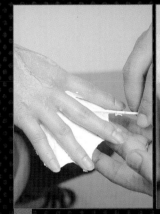

Do the webbing for the next three fingers all at the same time. Apply latex to the edge of the palm and the fingers, and stick a torn piece of paper towel to them.

5

6 Using a cotton swab, fill the spaces between the fingers and the webbing with latex. When you're finished with that, give the webbing and fingers a final coating of latex and blow dry.

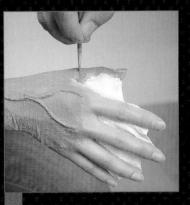

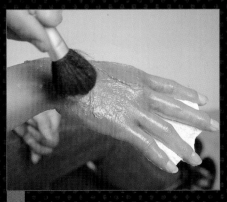

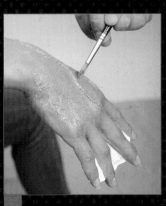

Paint the entire hand with Kryolan Supracolor (Green).

7

Dust all over with Mitsuyoshi Face Powder SW (Transparent).

8

Use Kryolan Supracolor to paint your desired pattern (in this case the mottling of frog skin), and you're done.

9

6. 11 Scales on the Back

Stick false fingernails to your back carefully and paint them, and you can create weird and beautiful scales.

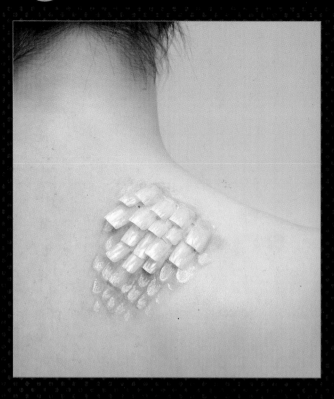

Make-up item

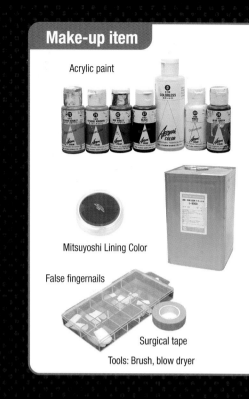

Acrylic paint

Mitsuyoshi Lining Color

False fingernails

Surgical tape

Tools: Brush, blow dryer

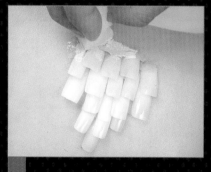

1 Stick the nails one by one to your skin using surgical tape.

2 For reinforcement, apply latex to the top layer of nails only.

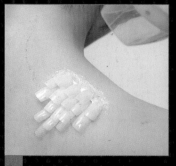

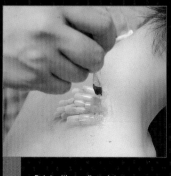

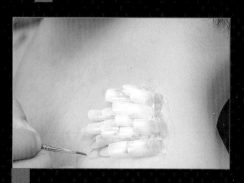

3 Blow dry.

4 Paint with acrylic paints.

5 If you're drawing scales on the skin, first draw an outline using Mitsuyoshi Lining Color or a similar product. Apply white to the tip of the scale and then add highlights for a 3-D effect.

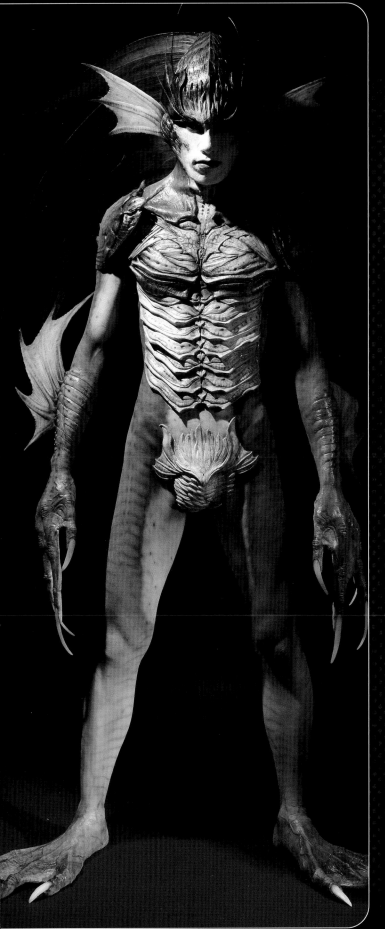

Chapter 7

"Making of" the Opening Photographs

In this section we'll explain how to recreate the costumes seen in the opening color photographs – Suigintou, from Rozen Maiden; Black Jack; and Aulbath from Vampire Hunter. Here we'll put the lessons from the previous chapters to practical use.

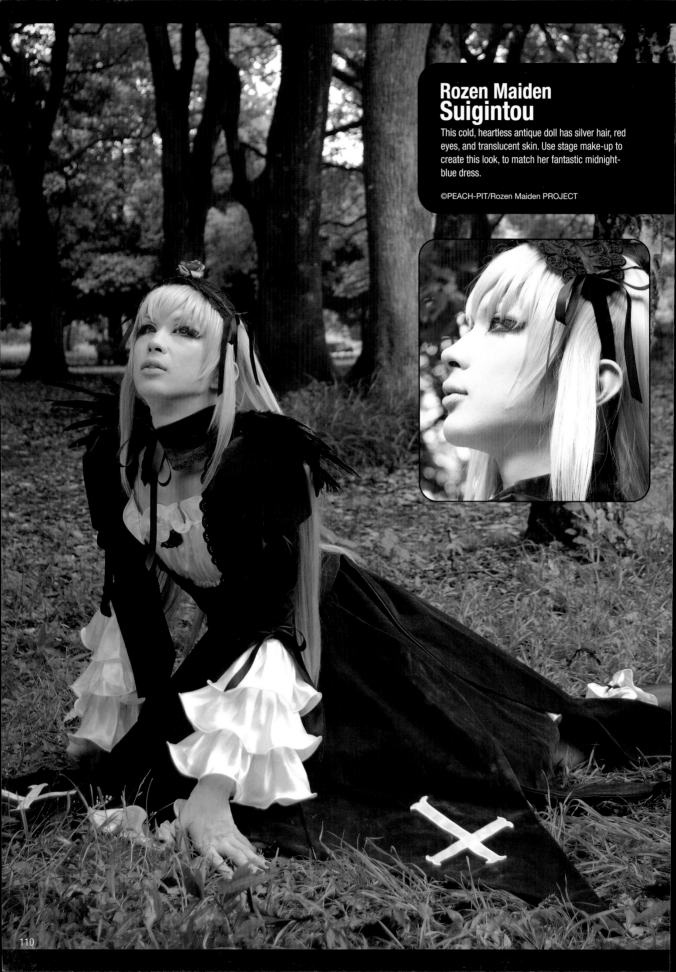

Rozen Maiden
Suigintou

This cold, heartless antique doll has silver hair, red eyes, and translucent skin. Use stage make-up to create this look, to match her fantastic midnight-blue dress.

©PEACH-PIT/Rozen Maiden PROJECT

Create the impression of more distance between the eyes

Eye line

Eye shadow

Make-up item

Mitsuyoshi Stage Foundation Pro Natural Light

Mitsuyoshi Stage Foundation Pro Ochre

Red color contacts

MAKE UP FOR EVER Waterproof Eyeliner No. 1

Sharena Make-up Base

Mitsuyoshi Face Cake White

Mitsuyoshi Face Powder SW

Mitsuyoshi Face Color Brown

Sharena Face Color Almond

Sharena Face Color Black

Mitsuyoshi Eyebrow Pencil Medium Gray

Mitsuyoshi Eyebrow Pencil Soft Black

1 Create a base for the face. Apply Sharena Make-up Base → Mitsuyoshi Stage Foundation Pro Ochre evenly all over the face. In the areas marked by the oblique lines, apply Mitsuyoshi Stage Foundation Pro Natural Light as highlighting, and dust with Mitsuyoshi Face Powder SW (Transparent). Put in red contact lenses (Red Fleck).

2 Apply white greasepaint to the parts of the body that are not covered by clothing. Mix Mitsuyoshi Face Cake White with water, spread it with an itabake, pat with a sponge puff, and dust with face powder.

3 Draw the eyebrows. Imagine a doll or young girl and draw the inner edges of the eyebrows far apart. (If your natural brows are already separated, leave them as they are.) Draw narrow, straight, rising lines. Use a color that doesn't stand out too much (Mitsuyoshi Eyebrow Pencil Medium Gray).

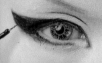

4 Use black on the outer corner of the eye. With your eye open wide, draw the same design as in the photo using black eyeliner (MAKE UP FOR EVER Waterproof Eyeliner No. 1). If you make a mistake, you'll have to start over from the beginning (starting with the foundation), so draw an outline first using an eye pencil, and then fill it in with eyeliner. Using the same eyeliner, draw in a double-fold line on the upper eyelid.

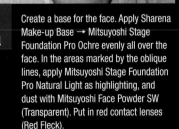

5 Use eye shadow in the shape of the Japanese character "く" around the inner corner of the eye. Mix Sharena Face Color Almond and Mitsuyoshi Face Cake Black and use as eye shadow. Also use it to blur the double-fold line you drew in 4.

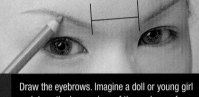

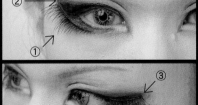

6 Put on false lashes. To create the gorgeousness of the doll, use 4 Chacott Point Eyelashes on each eye (a total of 8). First apply 2 at the outer corner of the eyes in locations ① and ② (not the natural corner, but the one you drew in 4). For ②, if the lash is too long, cut it before affixing it. The distance between ② on the lower eyelid and ④ on the upper eyelid is very large, so also put lashes at ③, lying flat. Apply the lashes at ④ so

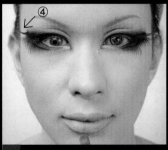

7 Do not use a lip line for the lips. To cover up most of the red, apply Sharena Face Color Almond to the lips using an eye shadow brush. To highlight the lips, apply Mitsuyoshi Plus Color Brown to the center

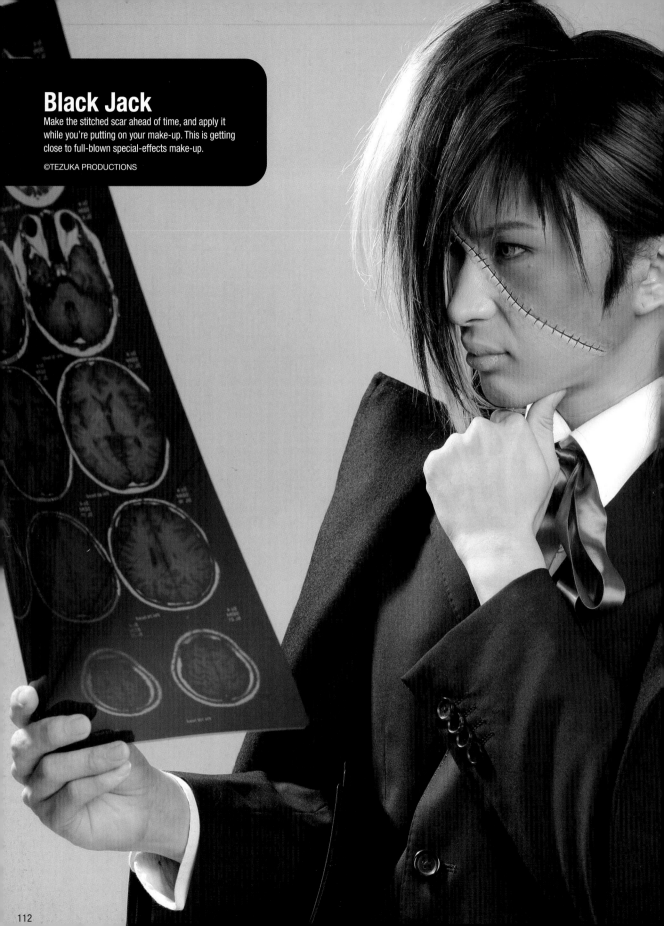

Black Jack

Make the stitched scar ahead of time, and apply it while you're putting on your make-up. This is getting close to full-blown special-effects make-up.

Make-up item

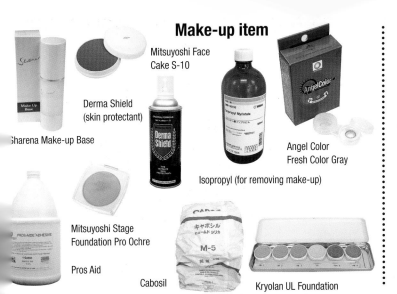

Sharena Make-up Base

Derma Shield (skin protectant)

Mitsuyoshi Face Cake S-10

Isopropyl (for removing make-up)

Angel Color Fresh Color Gray

Mitsuyoshi Stage Foundation Pro Ochre

Pros Aid

Cabosil

Kryolan UL Foundation

Items for prosthetics

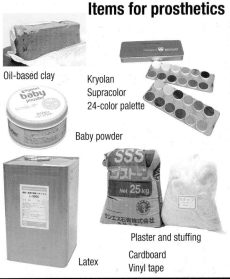

Oil-based clay

Kryolan Supracolor 24-color palette

Baby powder

Latex

Plaster and stuffing
Cardboard
Vinyl tape

1 Measure the length of your face to establish how long the scar should be, and then mold a scar out of clay. On a flat surface, sculpt the part to be affixed to your skin and impress the marks of a scar on it. The long one is for the facial scar, and the short one for the scar on your hand.

2 Use plaster to make a mold. Use cardboard to construct a wall around the clay and tape the bottom down so that the plaster can't leak out. Use a brush to apply plaster over the clay so that bubbles don't form. Then pour plaster in to a depth of about 1 cm. When the plaster has hardened, flip it over and remove the cardboard wall and the clay. The mold is complete.

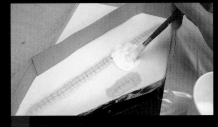

3 To blend in with the skin, apply latex to the mold so that the edges of the scar are thin while the scar itself is thicker so as not to tear. First apply a thin layer of latex over the entire mold using a sponge, and let it dry. (This is the first layer.) The

4 When the last layer has hardened, remove the latex from the plaster mold. Use baby powder and a brush to remove the latex carefully so that you don't tear it.
Add color. Place the latex on a flat surface, use Kryolan Supracolor Greasepaint 24-color Palette to paint the scar, and you're done.

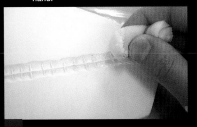
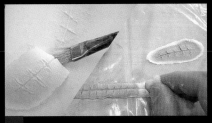

add a second layer, beginning about 5 mm inside the edge. (Don't apply again to the edge.) Then do a third layer. Repeat the process until you

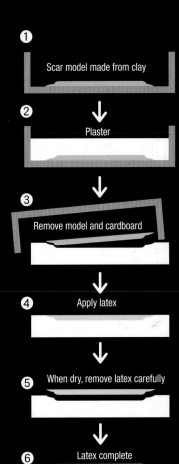

① Scar model made from clay

② Plaster

③ Remove model and cardboard

④ Apply latex

⑤ When dry, remove latex carefully

⑥ Latex complete

Point

When building the latex scar

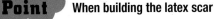

10 layers

The edges are where you'll stick the scar to your skin, so only use one layer of latex.

Sticking the scar to your face

You'll stick the scar on with Pros Aid, a glue used for special-effects make-up. To remove it, use a special cleanser, isopropyl.

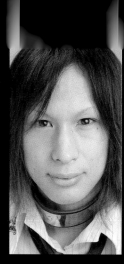

First wash your face thoroughly to remove all traces of oil.

1

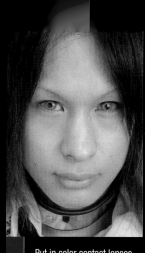

Put in color contact lenses (Angel Color Fresh Color Gray).

2

Apply Derma Shield to the areas of the skin where you'll be sticking the scar.

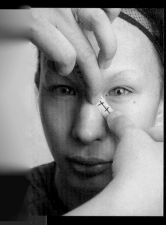
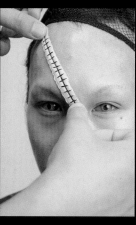
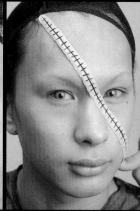

Apply a thin layer of Pros Aid to the back of the scar. Decide where the center of the scar will be located, and work towards the chin and forehead to temporarily affix it.

3

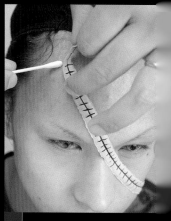

Apply Pros Aid directly to the skin under the scar, and fix the scar firmly to the skin.

4

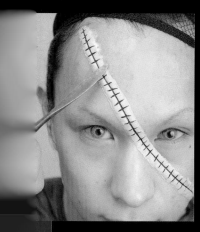

Spread more Pros Aid on top of the edges of the scar.

5

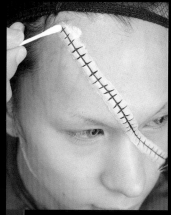

Mix Pros Aid and cabosil until it thickens. (This mixture is called Cabopatch.) Apply this mixture to the edges as well.

6

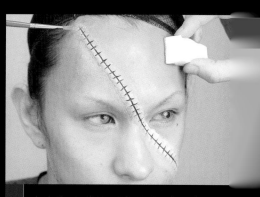

7

Apply Kryolan UL Foundation to the edges of the scar so that the scar blends with your own skin. (Other greasepaints won't adhere.)
To create the right side of Black Jack's face (the darker side), mix Mitsuyoshi Face Cake S-10 with water and apply to the skin using a sponge. For the

Adding sideburns

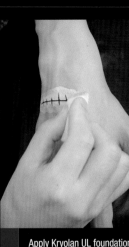

Gather the ends of a wig together and cut them off.

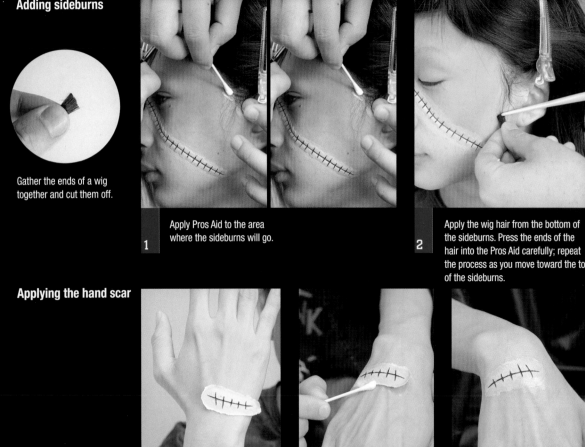

1 Apply Pros Aid to the area where the sideburns will go.

2 Apply the wig hair from the bottom of the sideburns. Press the ends of the hair into the Pros Aid carefully; repeat the process as you move toward the top of the sideburns.

Applying the hand scar

1 Stick the center of the scar lightly to the back of your hand.

2 Use Pros Aid to stick down the edges of the scar.

3 Apply Cabopatch over the edges.

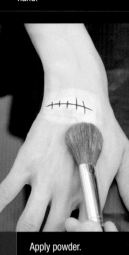

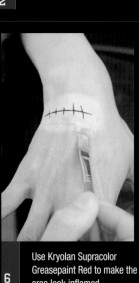

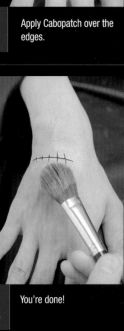

4 Apply Kryolan UL foundation to match the color of your skin

5 Apply powder.

6 Use Kryolan Supracolor Greasepaint Red to make the area look inflamed.

7 You're done!

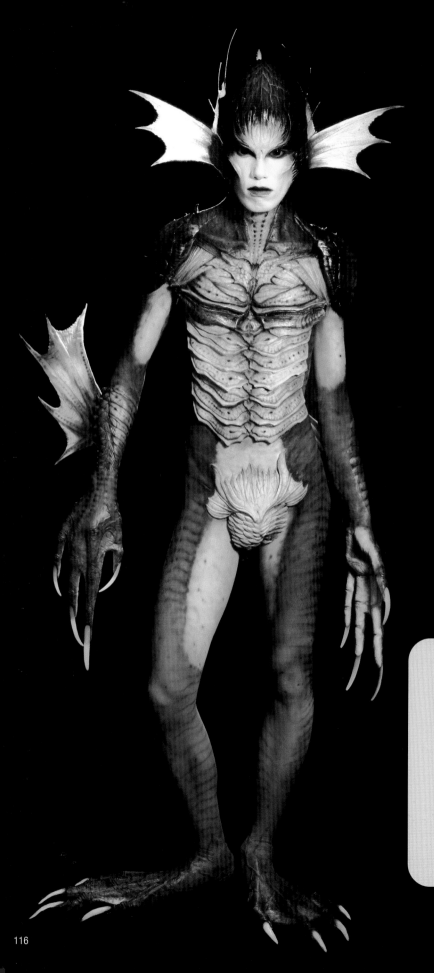

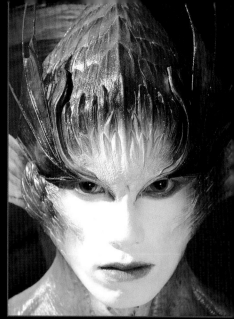

VAMPIRE HUNTER
AULBATH

Let's take a brief look at how to apply professional-grade special-effects make-up. Molds are taken of the entire body, and different materials are used to make separate parts to be worn. These are advanced techniques, but we'll explain the feet and foam parts, which even a beginner can do. If you want to know more, check out "*A Complete Guide to Special Effects Make-up*", advertised on the cover flap!

Make-up item

Cabosil

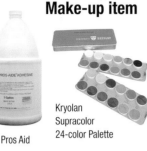
Pros Aid

Kryolan Supracolor 24-color Palette

flexible urethane foam

Latex

Items from Prosthetics

Water-based clay

Plaster and stuffing

Baby powder

Making the feet

These are prosthetic feet that can be worn like shoes. The skin is made using latex, and the flesh is made using flexible urethane foam.

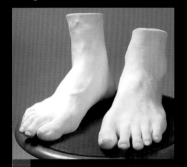

1 First make an impression of your feet (make the impression using alginate and then make a mold using plaster). At this time, be sure to make a key at the ankle.

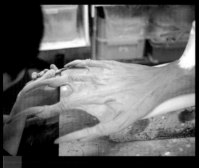

2 Sculpt the desired foot shape over the plaster cast, using water-based clay. Be sure not to cover over the key!

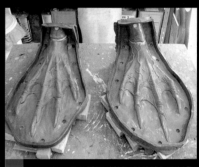

3 Build a "wall" using water-based clay around both sculpted feet, and make a mold using plaster.

1

Key

C: Upper plaster mold

Mold-release coating

Clay

B: Mold of your foot

A: Water-based clay "wall" (For plaster mold)

Key

If you cover the entire foot at one time, you won't be able to get the foot cast out, so do the top of the foot and the bottom of the foot separately. First do the top. Mold a wall (A) around the clay sculpt (B) using water-based clay. Spray Clear Spray or a similar mold releasing agent on the clay sculpt, and pour plaster to cover it (C). When doing this, be sure that (C) covers the keys in (B).

Cover with latex.
Apply about 14 layers of latex to B, C, and D as shown in the diagram. Don't cover the keys!

4

D

B

C

2

Clear Spray mold-release agent

When the plaster has hardened, turn the cast over and do the bottom. Remove (A) and cover with plaster (D). If you add straw to the plaster, the plaster will be strengthened.

5 When the latex dries, flexible urethane foam, pour over D, and immediately set B into D. Pour Soft Core over that and immediately place C on top. The keys are vital at this point in joining the two halves firmly.

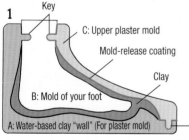

3

C: Upper plaster cast

D: Bottom plaster cast

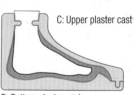

When the plaster hardens, separate C and D.

6

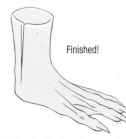

Finished!

When the Soft Core has hardened, remove the outer plaster cast and paint. Cut a slit from the ankle on the inside, where it can't be seen, and before wearing at an event, remove the inside plaster cast.

Making the arms

These are glove-type arms, and they will be made by baking foam latex. An explanation of the steps involved follows.

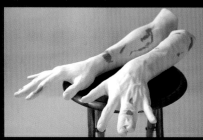

1 First make a mold of your arms and hands. (Use alginate to make a mold, and then cover with plaster to make the cast of your arms and hands.) Be sure to make keys when you are doing this.

2 Because this will be a glove-type prosthesis, saw the fingers of the plaster cast off at the base.

3 The fingers will be elongated, so use a drill to drill holes in the tips of the fingers, insert wires, and use instant glue to set. This creates the bone structure. Heat up polyvinyl chloride and press onto the arm part of the plaster cast (where the fin will go). Make a thin, tough layer of "skin." Cut out a fin shape, and attach it to the arm using small braces and screws. Set the arms on a base and sculpt the details using oil-based clay.

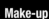

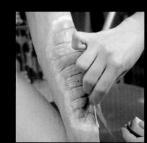

4 Make plaster casts of the back and palm of the hands.

5 Beat the foam using a beater, and pour into the casts made in 4. Sand the casts to match the actual hands, and put the two casts together. Clamp them together and bake in an oven for 2 ~ 2.5 hours at 90 degrees C.
When the baking is complete, use PAX (a mix of Pros Aid and acrylic paint) to paint the arms, and you're done.

Make-up

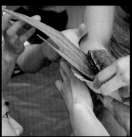

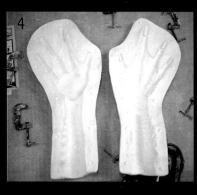

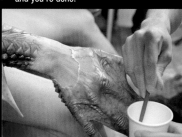

1 Stick the inside of the skin to your arm using surgical tape.

2 Use Pros Aid to fasten the foam to your skin.

3 Reinforce the edge adhesion using Cabopatch.

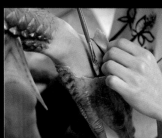

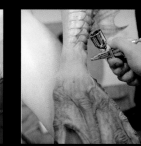

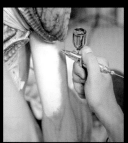

4 Put your hand into the prosthetic like a glove, and apply Pros Aid inside the prosthetic. Reinforce with Cabopatch. For the green of the skin, use blends of MAKE UP FOR EVER Color Cream Pale Green, Bright Green and Pine Green.

5 For the border between the skin and the prosthetic, use Aeroflash (acrylic paints for use with air brushes) to apply gradations in color.

6 For the white parts, use Mitsuyoshi Face Cake. Use an air brush on the borders with the green areas, and you're finished.

All-body make-up

Let's take a look at the process involved in putting parts on the upper body (naked).

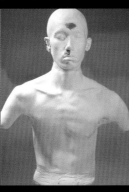

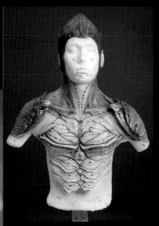

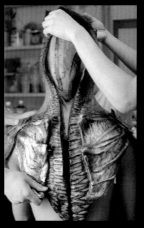

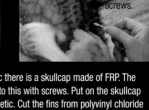

Stick on the pieces that cover the screws.

1 These are prosthetics that will be affixed to the head, upper torso and abdomen.

2 Inside the head of the prosthetic there is a skullcap made of FRP. The head and ear fins are attached to this with screws. Put on the skullcap and then the upper torso prosthetic. Cut the fins from polyvinyl chloride sheets and paint. Attach to the skullcap with small brackets and screws.

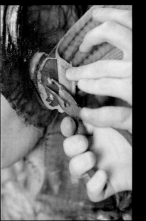

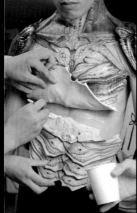

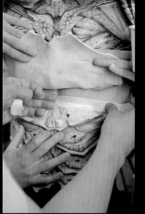

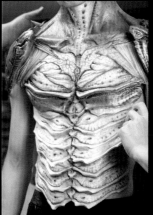

**Sengoku Basara
(Devil Kings)**

**Code Geass:
Lelouch of
the Rebellion**

Cosplayer's name: Ayaka
Character name: Date Masamune
Time to make: 1 month
Cost to make: 20,000 yen
Best point: The handmade sword

Left
Cosplayer's name: Seigo
Character name: Ashlaf Ali Ibrahim
Time to make: 2 days
Cost to make: About 10,000 yen
Best point: The way the scarf is
decorated

Cosplayer's name: Kanoko
Character name: C.C.
Cost to make: 17,800 yen
Best point: The legs extending
from the shorts, which you can
see through the slit in the skirt

**Zettai Fukuju Meirei
(Absolute Obedience)**
Left
Character name: Kia Welbehenna
Cost to make: 20,000 yen
Best point: Gives impression of someone
who obeys

**Zettai Fukuju Meirei
(Absolute Obedience)**
Right
Cosplayer's name: Choda Ito
Character name: Louis
Hardwich
Time to make: 1 day
Cost to make: 20,000 yen
Best point: Gives impression of
someone to be obeyed

Right
Cosplayer's name: Tou-u
Character name: Kia
Welbehenna
Time to make: About 3
days
Cost to make: About
10,000 yen

Left
Cosplayer's name:
Shiira Ahya
Character name: Atem
Time to make: 3 – 5
days
Cost to make: 30,000
yen
Best point: Ancient
times and modern days

Right
Cosplayer's name:
Shikkoku Hime
Character name: Mutoh
Yugioh
Time to make: 3 days
Cost to make: 20,000
yen
Best point: Ancient times
and modern days

Event Report 2008.4.20
Cosplay Heaven in Harumi

Organization: Cosplay Heaven Committee
Our first report is from spring in Harumi! The day was a bit chilly, but
there was plenty of heat inside! Everyone was really full of energy,
but we managed to get them to stand still long enough to take some
photos. Some costumes took a month to make, or cost over
100,000 yen…it really is a labor of love.

**Heart no kuni no Alice
~Wonderful Wonder World~**

**Sengoku Basara
(Devil Kings)**

Cosplayer's name: Ryohiryu
Character name: Imagawa
Yoshimoto
Time to make: I did it in a real
hurry, so it's a mess
Cost to make: A little less
than 20,000 yen
Best point: I worked really
hard on the fan.

Cosplayer's name: Yae
Character name: Boris Ellay
Cost to make: About 10,000 yen
Best point: Boris' fluffiness

**Yugioh Duel
Masters**

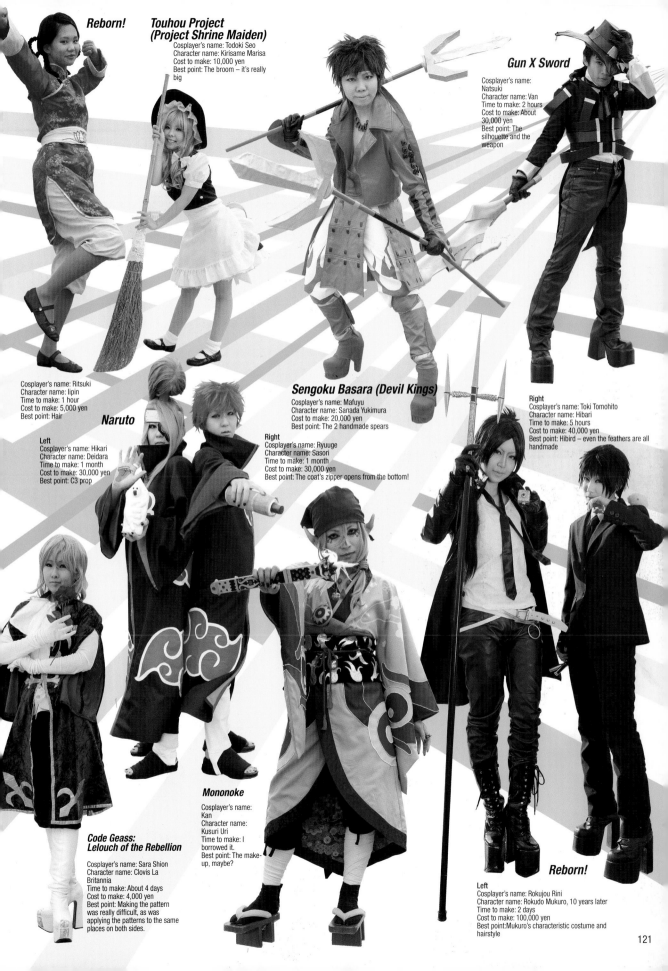

Reborn!

Touhou Project (Project Shrine Maiden)

Cosplayer's name: Todoki Seo
Character name: Kirisame Marisa
Cost to make: 10,000 yen
Best point: The broom – it's really big

Gun X Sword

Cosplayer's name: Natsuki
Character name: Van
Time to make: 2 hours
Cost to make: About 30,000 yen
Best point: The silhouette and the weapon

Cosplayer's name: Ritsuki
Character name: Iipin
Time to make: 1 hour
Cost to make: 5,000 yen
Best point: Hair

Naruto

Left
Cosplayer's name: Hikari
Character name: Deidara
Time to make: 1 month
Cost to make: 30,000 yen
Best point: C3 prop

Sengoku Basara (Devil Kings)

Cosplayer's name: Mafuyu
Character name: Sanada Yukimura
Cost to make: 20,000 yen
Best point: The 2 handmade spears

Right
Cosplayer's name: Ryuuge
Character name: Sasori
Time to make: 1 month
Cost to make: 30,000 yen
Best point: The coat's zipper opens from the bottom!

Right
Cosplayer's name: Toki Tomohito
Character name: Hibari
Time to make: 5 hours
Cost to make: 40,000 yen
Best point: Hibird – even the feathers are all handmade

Code Geass: Lelouch of the Rebellion

Cosplayer's name: Sara Shion
Character name: Clovis La Britannia
Time to make: About 4 days
Cost to make: 4,000 yen
Best point: Making the pattern was really difficult, as was applying the patterns to the same places on both sides.

Mononoke

Cosplayer's name: Kan
Character name: Kusuri Uri
Time to make: I borrowed it.
Best point: The make-up, maybe?

Reborn!

Left
Cosplayer's name: Rokujou Rini
Character name: Rokudo Mukuro, 10 years later
Time to make: 2 days
Cost to make: 100,000 yen
Best point: Mukuro's characteristic costume and hairstyle

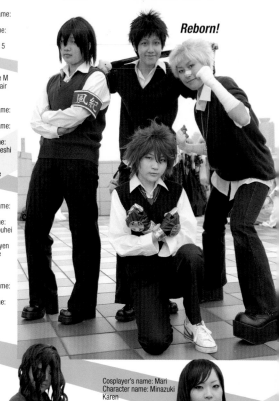

Left
Cosplayer's name: Raiba Aoha
Character name: Hibari Kyoya
Time to make: 5 hours
Cost to make: 5,000 yen
Best point: The M shape of the hair

Middle
Cosplayer's name: Izayoi Tsuki
Cosplayer's name: Hinata Rui
Character name: Yamamoto Takeshi
Cost to make: 5,000 yen
Best point: The sword!

Right
Cosplayer's name: Akimiya Mani
Character name: Sasagawa Ryouhei
Cost to make: About 10,000 yen
Best point: The group

Front
Cosplayer's name: Riku
Character name: Tsuna

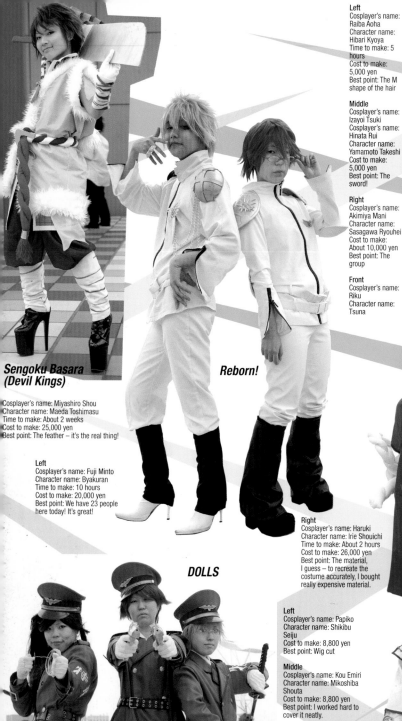

Sengoku Basara (Devil Kings)

Cosplayer's name: Miyashiro Shou
Character name: Maeda Toshimasu
Time to make: About 2 weeks
Cost to make: 25,000 yen
Best point: The feather – it's the real thing!

Left
Cosplayer's name: Fuji Minto
Character name: Byakuran
Time to make: 10 hours
Cost to make: 20,000 yen
Best point: We have 23 people here today! It's great!

Reborn!

Right
Cosplayer's name: Haruki
Character name: Irie Shouichi
Time to make: About 2 hours
Cost to make: 26,000 yen
Best point: The material, I guess – to recreate the costume accurately, I bought really expensive material.

DOLLS

Left
Cosplayer's name: Papiko
Character name: Shikibu Seiju
Cost to make: 8,800 yen
Best point: Wig cut

Middle
Cosplayer's name: Kou Emiri
Character name: Mikoshiba Shouta
Cost to make: 8,800 yen
Best point: I worked hard to cover it neatly.

Right
Cosplayer's name: Tooru
Character name: Toudou Usaki
Cost to make: 8,800 yen
Best point: The glasses – I had to look hard to find the right ones.

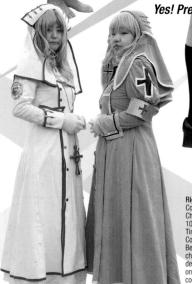

Cosplayer's name: Mari
Character name: Minazuki Karen
Cost to make: About 10,000 yen
Best point: The wig I bought and fixed

Mononoke

Cosplayer's name: Notto
Character name: Sasaki Hyoue
Time to make: 1 month
Cost to make: 30,000 yen
Best point: The rose pattern and the medicine obi

Yes! Pretty Cure 5 GoGo!

Left
Cosplayer's name: Yasaka Akito
Character name: Kate Scott
Time to make: 1 month
Cost to make: 20,000 yen
Best point: I put love into the pants and the character.

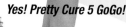

Right
Cosplayer's name: Kanon
Character name: Kate Scott, 10 years ago
Time to make: 2 hours
Cost to make: 17,000 yen
Best point: Doing the same character separated by a decade. We worked hard on the different parts of the costume.

Trinity Blood

Cosplay Heaven in Jack no Tou

Organization: Cosplay Heaven Committee

The event was held at the Yokohama Port Memorial Hall, Jack no Tou. With this important cultural property as the setting, spirits were even higher than usual! To match the occasion, there were some interesting costumes and interactions! Which one do you prefer?

Heart no Kuni no Alice ~Wonderful Wonder World~

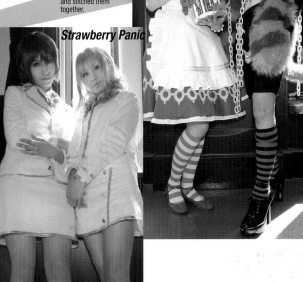

Left
Cosplayer's name: Kishitaka Hideya
Character name: Alice Liddel
Cost to make: 18,000 yen
Best point: The global props

Right
Cosplayer's name: Shiki
Character name: Boris Ellay
Time to make: 1 week
Cost to make: About 10,000 yen
Best point: The giant muffler. I took two different colors of fur and stitched them together.

Rozen Maiden

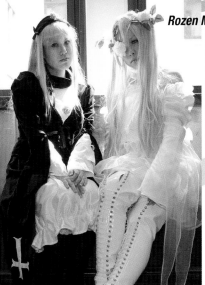

Left
Cosplayer's name: Shiki
Character name: Suigintou
Time to make: 8 hours
Cost to make: 10,000 yen
Best point: All of it, because I make all of it by hand. It's the first time I had ever made girl's clothes.

Right
Cosplayer's name: Yoshida
Character name: Kiraki Shou
Cost to make: 25,000 yen
Best point: It's all white.

Strawberry Panic

Left
Cosplayer's name: Sakichi
Character name: Ootori Amane
Time to make: 2 days
Cost to make: 8,000 yen
Best point: The matching girls' school uniforms.

Right
Cosplayer's name: Eikai
Character name: Konohana Hikari
Time to make: 2 days
Cost to make: 8,000 yen
Best point: The pure white uniforms. The combination of white and gold give them a very high-quality feel.

Nodame Cantabile

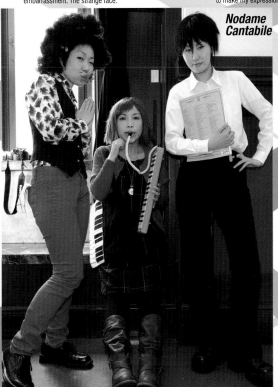

Left
Cosplayer's name: Tsukikai Hiromi
Character name: Masami
Time to make: They're all my own clothes.
Cost to make: Wig - 4,000 yen
Best point: The Afro hair style. I became the character, without embarrassment. The strange face.

Middle
Cosplayer's name: Ringo
Character name: Noda Megumi
Time to make: 30 minutes (the piano bag)
Cost to make: 3,990 yen
Best point: The strange face. Or maybe Noda's weird hair.

Right
Cosplayer's name: Seiji
Character name: Chiaki Shinichi
Time to make: 30 minutes (setting the wig)
Cost to make: 3,800 yen
Best point: People understand that we're doing Nodame. Working hard to make my expression cold.

Code Geass: Lelouch of the Rebellion

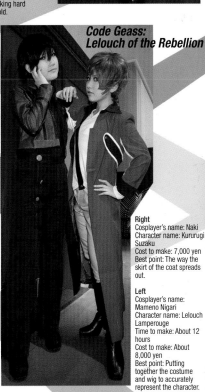

Right
Cosplayer's name: Naki
Character name: Kururugi Suzaku
Cost to make: 7,000 yen
Best point: The way the skirt of the coat spreads out.

Left
Cosplayer's name: Mameno Nigari
Character name: Lelouch Lamperouge
Time to make: About 12 hours
Cost to make: About 8,000 yen
Best point: Putting together the costume and wig to accurately represent the character.

Sailor Moon

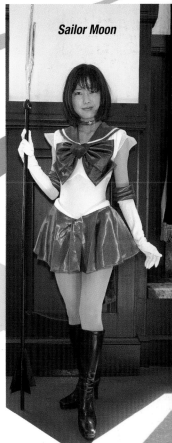

Cosplayer's name: Minoru
Character name: Super Sailor Saturn
Time to make: 3 hours to make the Silence Glaive
Cost to make: 30,000 yen
Best point: The overall balance of the entire costume and the Silence Glaive

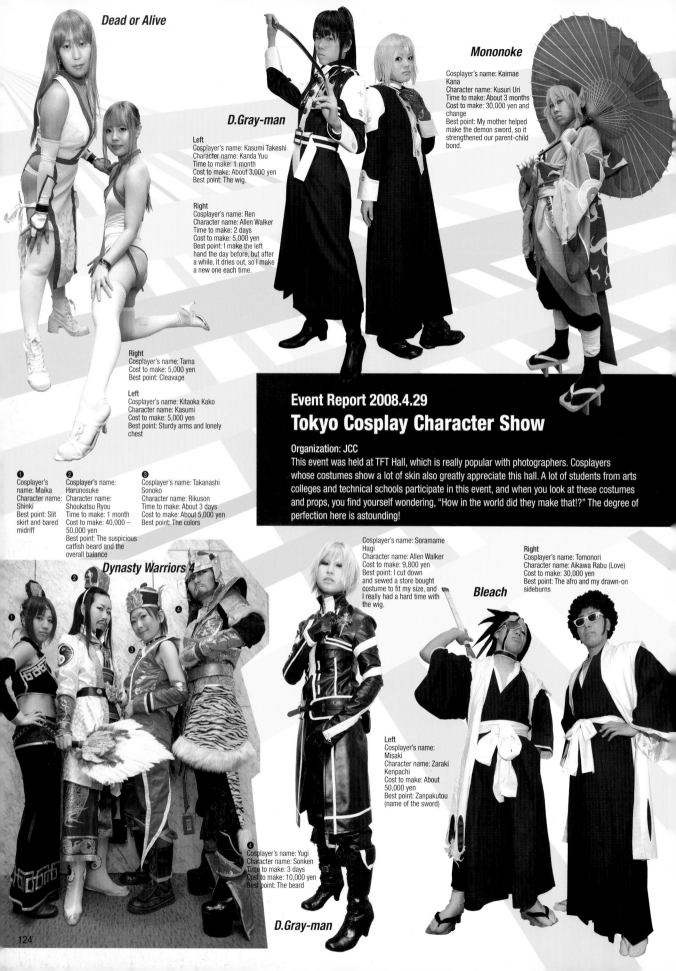

Dead or Alive

D.Gray-man

Left
Cosplayer's name: Kasumi Takeshi
Character name: Kanda Yuu
Time to make: 1 month
Cost to make: About 3,000 yen
Best point: The wig.

Right
Cosplayer's name: Ren
Character name: Allen Walker
Time to make: 2 days
Cost to make: 5,000 yen
Best point: I make the left hand the day before, but after a while, it dries out, so I make a new one each time.

Mononoke

Cosplayer's name: Kaimae Kana
Character name: Kusuri Uri
Time to make: About 3 months
Cost to make: 30,000 yen and change
Best point: My mother helped make the demon sword, so it strengthened our parent-child bond.

Right
Cosplayer's name: Tama
Cost to make: 5,000 yen
Best point: Cleavage

Left
Cosplayer's name: Kitaoka Kako
Character name: Kasumi
Cost to make: 5,000 yen
Best point: Sturdy arms and lonely chest

❶ Cosplayer's name: Maika
Character name: Shinki
Best point: Slit skirt and bared midriff

❷ Cosplayer's name: Harunosuke
Character name: Shoukatsu Ryou
Time to make: 1 month
Cost to make: 40,000 – 50,000 yen
Best point: The suspicious catfish beard and the overall balance

❸ Cosplayer's name: Takanashi Sonoko
Character name: Rikuson
Time to make: About 3 days
Cost to make: About 5,000 yen
Best point: The colors

Event Report 2008.4.29
Tokyo Cosplay Character Show

Organization: JCC
This event was held at TFT Hall, which is really popular with photographers. Cosplayers whose costumes show a lot of skin also greatly appreciate this hall. A lot of students from arts colleges and technical schools participate in this event, and when you look at these costumes and props, you find yourself wondering, "How in the world did they make that!?" The degree of perfection here is astounding!

Dynasty Warriors 4

Cosplayer's name: Soramame Hagi
Character name: Allen Walker
Cost to make: 9,800 yen
Best point: I cut down and sewed a store bought costume to fit my size, and I really had a hard time with the wig.

Right
Cosplayer's name: Tomonori
Character name: Aikawa Rabu (Love)
Cost to make: 30,000 yen
Best point: The afro and my drawn-on sideburns

Bleach

Left
Cosplayer's name: Misaki
Character name: Zaraki Kenpachi
Cost to make: About 50,000 yen
Best point: Zanpakutou (name of the sword)

❹ Cosplayer's name: Yugi
Character name: Sonken
Time to make: 3 days
Cost to make: 10,000 yen
Best point: The beard

D.Gray-man

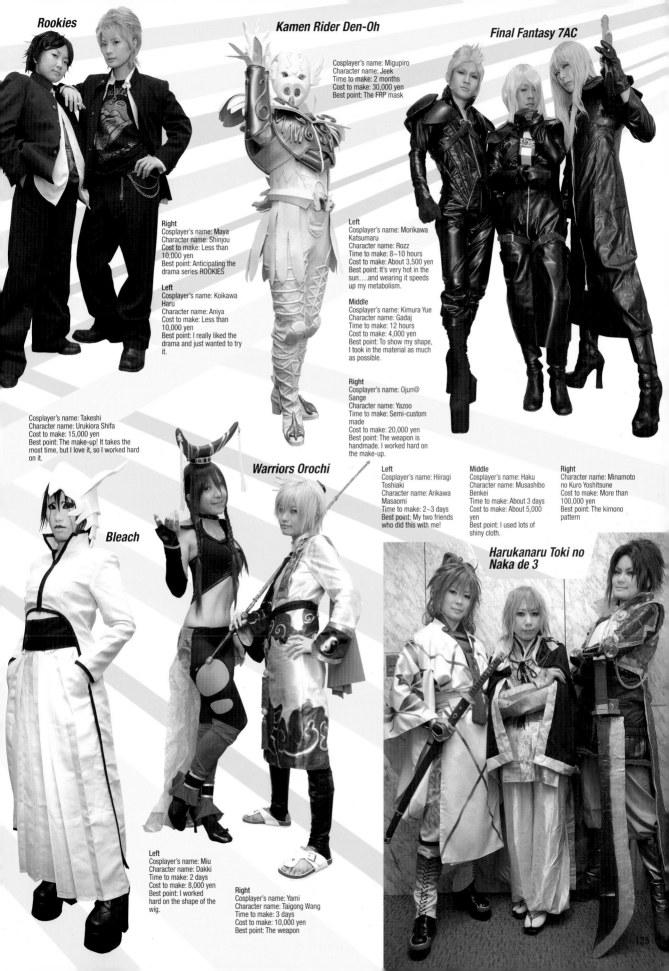

Rookies

Right
Cosplayer's name: Maya
Character name: Shinjou
Cost to make: Less than 10,000 yen
Best point: Anticipating the drama series ROOKIES

Left
Cosplayer's name: Koikawa Haru
Character name: Aniya
Cost to make: Less than 10,000 yen
Best point: I really liked the drama and just wanted to try it.

Cosplayer's name: Takeshi
Character name: Urukiora Shifa
Cost to make: 15,000 yen
Best point: The make-up! It takes the most time, but I love it, so I worked hard on it.

Bleach

Warriors Orochi

Left
Cosplayer's name: Miu
Character name: Dakki
Time to make: 2 days
Cost to make: 8,000 yen
Best point: I worked hard on the shape of the wig.

Right
Cosplayer's name: Yami
Character name: Taigong Wang
Time to make: 3 days
Cost to make: 10,000 yen
Best point: The weapon

Kamen Rider Den-Oh

Cosplayer's name: Migupiro
Character name: Jeek
Time to make: 2 months
Cost to make: 30,000 yen
Best point: The FRP mask

Final Fantasy 7AC

Left
Cosplayer's name: Morikawa Katsumaru
Character name: Rozz
Time to make: 8~10 hours
Cost to make: About 3,500 yen
Best point: It's very hot in the sun….and wearing it speeds up my metabolism.

Middle
Cosplayer's name: Kimura Yue
Character name: Gadaj
Time to make: 12 hours
Cost to make: 4,000 yen
Best point: To show my shape, I took in the material as much as possible.

Right
Cosplayer's name: Ojun@ Sange
Character name: Yazoo
Time to make: Semi-custom made
Cost to make: 20,000 yen
Best point: The weapon is handmade. I worked hard on the make-up.

Left
Cosplayer's name: Hiiragi Toshiaki
Character name: Arikawa Masaomi
Time to make: 2~3 days
Best point: My two friends who did this with me!

Middle
Cosplayer's name: Haku
Character name: Musashibo Benkei
Time to make: About 3 days
Cost to make: About 5,000 yen
Best point: I used lots of shiny cloth.

Right
Character name: Minamoto no Kuro Yoshitsune
Cost to make: More than 100,000 yen
Best point: The kimono pattern

Harukanaru Toki no Naka de 3

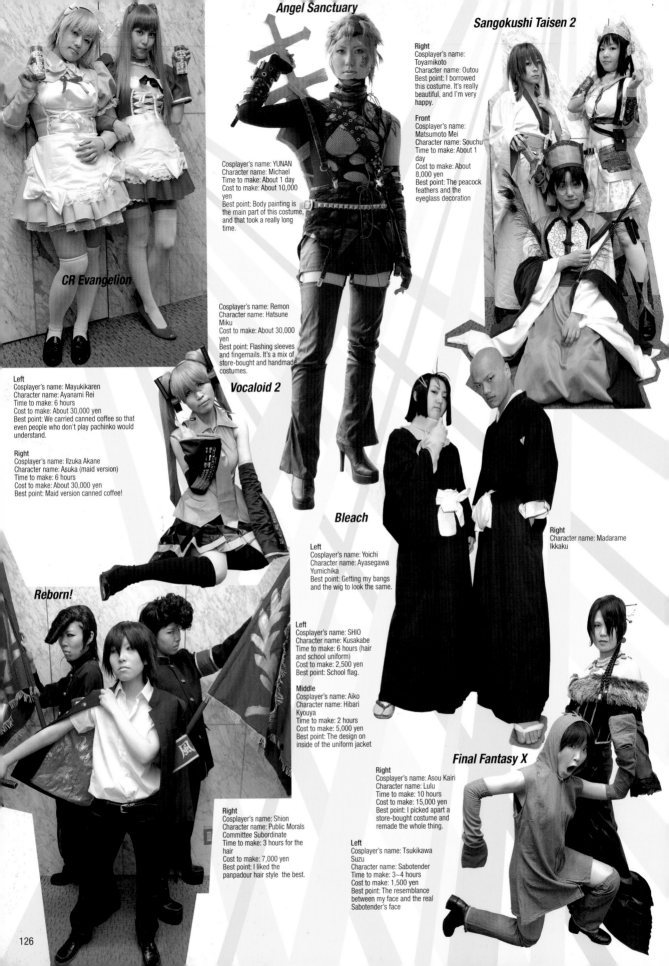

Angel Sanctuary

Cosplayer's name: YUNAN
Character name: Michael
Time to make: About 1 day
Cost to make: About 10,000 yen
Best point: Body painting is the main part of this costume, and that took a really long time.

Sangokushi Taisen 2

Right
Cosplayer's name: Toyamikoto
Character name: Outou
Best point: I borrowed this costume. It's really beautiful, and I'm very happy.

Front
Cosplayer's name: Matsumoto Mei
Character name: Souchu
Time to make: About 1 day
Cost to make: About 8,000 yen
Best point: The peacock feathers and the eyeglass decoration

CR Evangelion

Left
Cosplayer's name: Mayukikaren
Character name: Ayanami Rei
Time to make: 6 hours
Cost to make: About 30,000 yen
Best point: We carried canned coffee so that even people who don't play pachinko would understand.

Right
Cosplayer's name: Ilzuka Akane
Character name: Asuka (maid version)
Time to make: 6 hours
Cost to make: About 30,000 yen
Best point: Maid version canned coffee!

Cosplayer's name: Remon
Character name: Hatsune Miku
Cost to make: About 30,000 yen
Best point: Flashing sleeves and fingernails. It's a mix of store-bought and handmade costumes.

Vocaloid 2

Bleach

Left
Cosplayer's name: Yoichi
Character name: Ayasegawa Yumichika
Best point: Getting my bangs and the wig to look the same.

Right
Character name: Madarame Ikkaku

Reborn!

Left
Cosplayer's name: SHIO
Character name: Kusakabe
Time to make: 6 hours (hair and school uniform)
Cost to make: 2,500 yen
Best point: School flag.

Middle
Cosplayer's name: Aiko
Character name: Hibari Kyouya
Time to make: 2 hours
Cost to make: 5,000 yen
Best point: The design on inside of the uniform jacket

Right
Cosplayer's name: Shion
Character name: Public Morals Committee Subordinate
Time to make: 3 hours for the hair
Cost to make: 7,000 yen
Best point: I liked the panpadour hair style the best.

Final Fantasy X

Right
Cosplayer's name: Asou Kairi
Character name: Lulu
Time to make: 10 hours
Cost to make: 15,000 yen
Best point: I picked apart a store-bought costume and remade the whole thing.

Left
Cosplayer's name: Tsukikawa Suzu
Character name: Sabotender
Time to make: 3~4 hours
Cost to make: 1,500 yen
Best point: The resemblance between my face and the real Sabotender's face

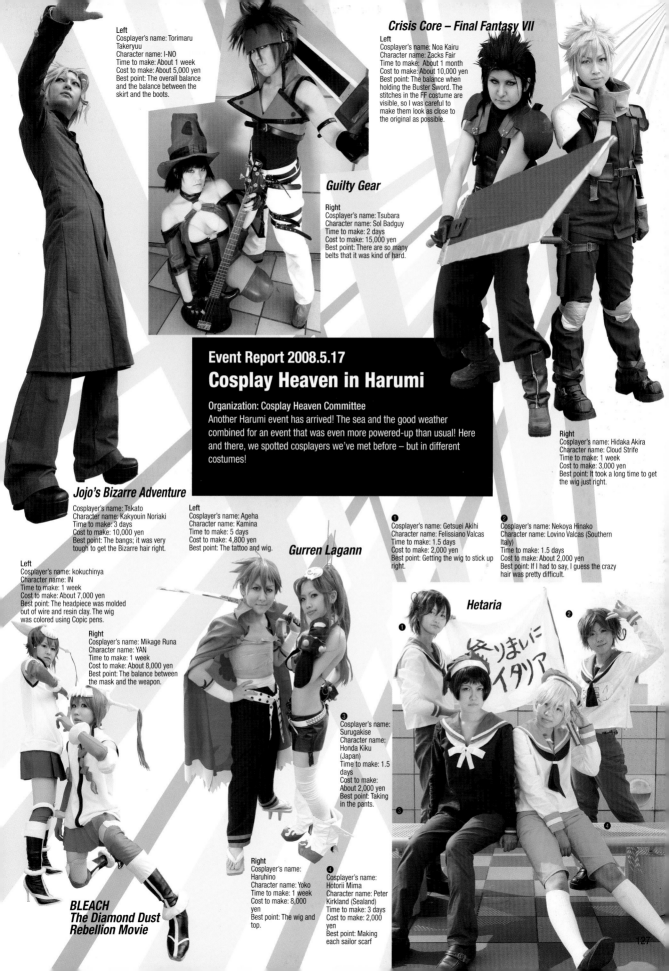

Left
Cosplayer's name: Torimaru
Takeryuu
Character name: I-NO
Time to make: About 1 week
Cost to make: About 5,000 yen
Best point: The overall balance
and the balance between the
skirt and the boots.

Crisis Core – Final Fantasy VII

Left
Cosplayer's name: Noa Kairu
Character name: Zacks Fair
Time to make: About 1 month
Cost to make: About 10,000 yen
Best point: The balance when
holding the Buster Sword. The
stitches in the FF costume are
visible, so I was careful to
make them look as close to
the original as possible.

Guilty Gear

Right
Cosplayer's name: Tsubara
Character name: Sol Badguy
Time to make: 2 days
Cost to make: 15,000 yen
Best point: There are so many
belts that it was kind of hard.

Event Report 2008.5.17
Cosplay Heaven in Harumi

Organization: Cosplay Heaven Committee
Another Harumi event has arrived! The sea and the good weather
combined for an event that was even more powered-up than usual! Here
and there, we spotted cosplayers we've met before – but in different
costumes!

Right
Cosplayer's name: Hidaka Akira
Character name: Cloud Strife
Time to make: 1 week
Cost to make: 3,000 yen
Best point: It took a long time to get
the wig just right.

Jojo's Bizarre Adventure

Cosplayer's name: Takato
Character name: Kakyouin Noriaki
Time to make: 3 days
Cost to make: 10,000 yen
Best point: The bangs; it was very
tough to get the Bizarre hair right.

Left
Cosplayer's name: kokuchinya
Character name: IN
Time to make: 1 week
Cost to make: About 7,000 yen
Best point: The headpiece was molded
out of wire and resin clay. The wig
was colored using Copic pens.

Left
Cosplayer's name: Ageha
Character name: Kamina
Time to make: 5 days
Cost to make: 4,800 yen
Best point: The tattoo and wig.

Gurren Lagann

❶
Cosplayer's name: Getsuei Akihi
Character name: Felissiano Valcas
Time to make: 1.5 days
Cost to make: 2,000 yen
Best point: Getting the wig to stick up
right.

❷
Cosplayer's name: Nekoya Hinako
Character name: Lovino Valcas (Southern
Italy)
Time to make: 1.5 days
Cost to make: About 2,000 yen
Best point: If I had to say, I guess the crazy
hair is pretty difficult.

Left
Cosplayer's name: Mikage Runa
Character name: YAN
Time to make: 1 week
Cost to make: About 8,000 yen
Best point: The balance between
the mask and the weapon.

Hetaria

❸
Cosplayer's name:
Surugakise
Character name:
Honda Kiku
(Japan)
Time to make: 1.5
days
Cost to make:
About 2,000 yen
Best point: Taking
in the pants.

BLEACH
The Diamond Dust
Rebellion Movie

Right
Cosplayer's name:
Haruhino
Character name: Yoko
Time to make: 1 week
Cost to make: 8,000
yen
Best point: The wig and
top.

❹
Cosplayer's name:
Hotorii Mima
Character name: Peter
Kirkland (Sealand)
Time to make: 3 days
Cost to make: 2,000
yen
Best point: Making
each sailor scarf

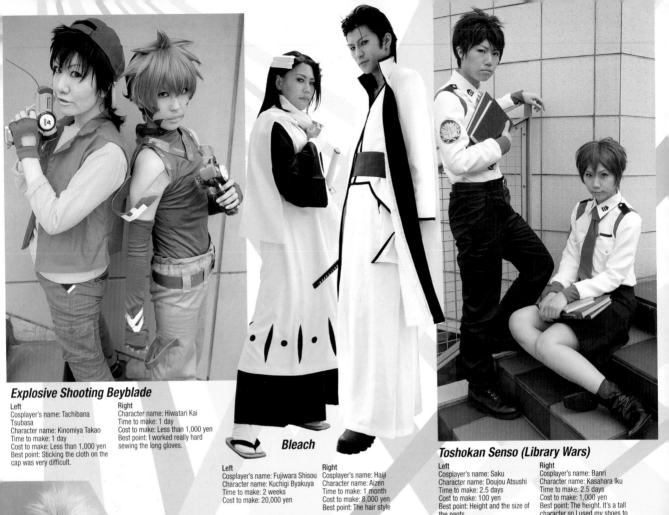

Explosive Shooting Beyblade

Left
Cosplayer's name: Tachibana Tsubasa
Character name: Kinomiya Takao
Time to make: 1 day
Cost to make: Less than 1,000 yen
Best point: Sticking the cloth on the cap was very difficult.

Right
Character name: Hiwatari Kai
Time to make: 1 day
Cost to make: Less than 1,000 yen
Best point: I worked really hard sewing the long gloves.

Bleach

Left
Cosplayer's name: Fujiwara Shisou
Character name: Kuchigi Byakuya
Time to make: 2 weeks
Cost to make: 20,000 yen

Right
Cosplayer's name: Haiji
Character name: Aizen
Time to make: 1 month
Cost to make: 8,000 yen
Best point: The hair style

Toshokan Senso (Library Wars)

Left
Cosplayer's name: Saku
Character name: Doujou Atsushi
Time to make: 2.5 days
Cost to make: 100 yen
Best point: Height and the size of the pants.

Right
Cosplayer's name: Banri
Character name: Kasahara Iku
Time to make: 2.5 days
Cost to make: 1,000 yen
Best point: The height. It's a tall character so I used my shoes to add height.

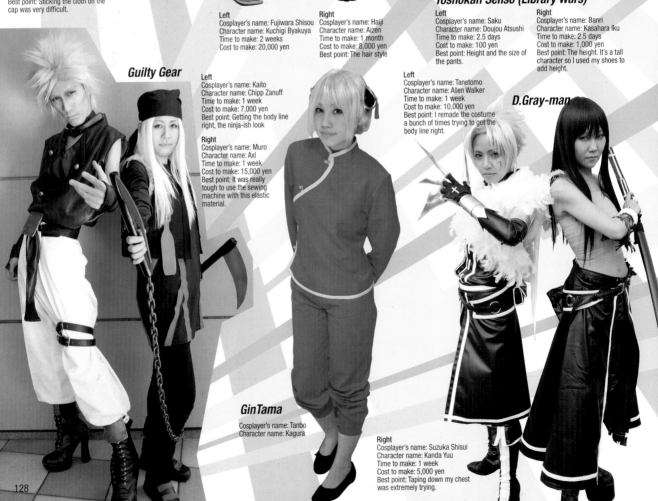

Guilty Gear

Left
Cosplayer's name: Kaito
Character name: Chipp Zanuff
Time to make: 1 week
Cost to make: 7,000 yen
Best point: Getting the body line right, the ninja-ish look

Right
Cosplayer's name: Muro
Character name: Axl
Time to make: 1 week
Cost to make: 15,000 yen
Best point: It was really tough to use the sewing machine with this elastic material.

Left
Cosplayer's name: Tanetomo
Character name: Allen Walker
Time to make: 1 week
Cost to make: 10,000 yen
Best point: I remade the costume a bunch of times trying to get the body line right.

D.Gray-man

GinTama

Cosplayer's name: Tanbo
Character name: Kagura

Right
Cosplayer's name: Suzuka Shisui
Character name: Kanda Yuu
Time to make: 1 week
Cost to make: 5,000 yen
Best point: Taping down my chest was extremely trying.

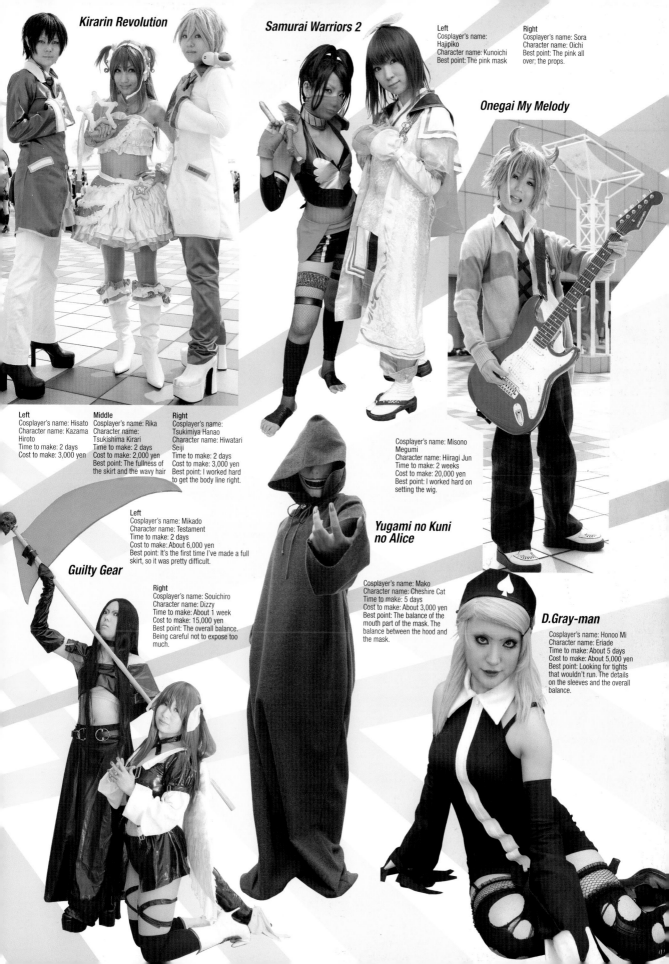

Kirarin Revolution

Samurai Warriors 2

Left
Cosplayer's name: Hajipiko
Character name: Kunoichi
Best point: The pink mask

Right
Cosplayer's name: Sora
Character name: Oichi
Best point: The pink all over; the props.

Onegai My Melody

Left
Cosplayer's name: Hisato
Character name: Kazama Hiroto
Time to make: 2 days
Cost to make: 3,000 yen

Middle
Cosplayer's name: Rika
Character name: Tsukishima Kirari
Time to make: 2 days
Cost to make: 2,000 yen
Best point: The fullness of the skirt and the wavy hair

Right
Cosplayer's name: Tsukimiya Hanao
Character name: Hiwatari Seiji
Time to make: 2 days
Cost to make: 3,000 yen
Best point: I worked hard to get the body line right.

Cosplayer's name: Misono Megumi
Character name: Hiiragi Jun
Time to make: 2 weeks
Cost to make: 20,000 yen
Best point: I worked hard on setting the wig.

Left
Cosplayer's name: Mikado
Character name: Testament
Time to make: 2 days
Cost to make: About 6,000 yen
Best point: It's the first time I've made a full skirt, so it was pretty difficult.

Guilty Gear

Right
Cosplayer's name: Souichiro
Character name: Dizzy
Time to make: About 1 week
Cost to make: 15,000 yen
Best point: The overall balance. Being careful not to expose too much.

Yugami no Kuni no Alice

Cosplayer's name: Mako
Character name: Cheshire Cat
Time to make: 5 days
Cost to make: About 3,000 yen
Best point: The balance of the mouth part of the mask. The balance between the hood and the mask.

D.Gray-man

Cosplayer's name: Honoo Mi
Character name: Eriade
Time to make: About 5 days
Cost to make: About 5,000 yen
Best point: Looking for tights that wouldn't run. The details on the sleeves and the overall balance.

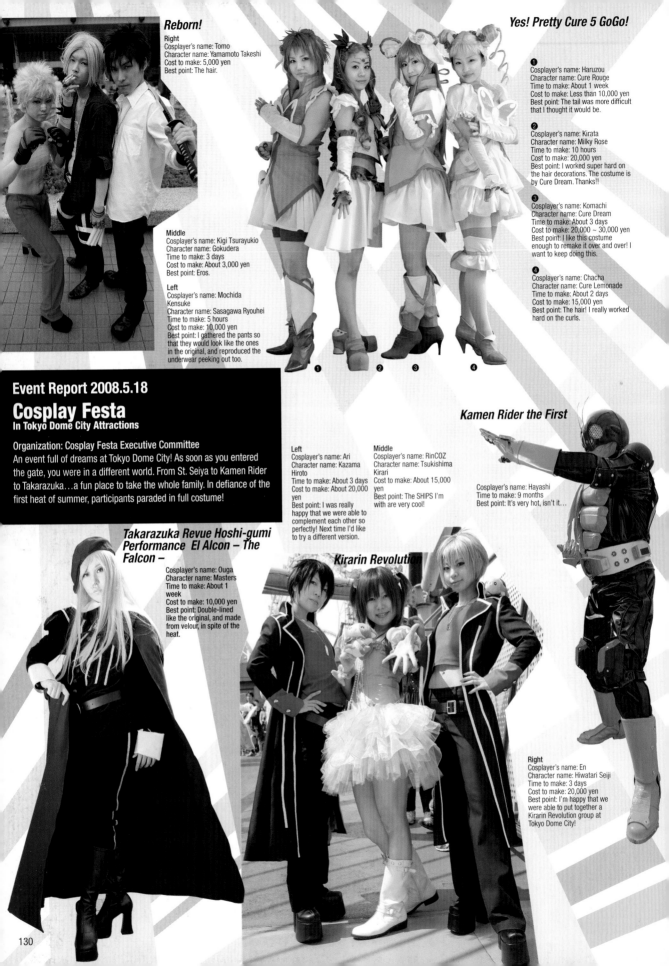

Reborn!

Right
Cosplayer's name: Tomo
Character name: Yamamoto Takeshi
Cost to make: 5,000 yen
Best point: The hair.

Middle
Cosplayer's name: Kigi Tsurayukio
Character name: Gokudera
Time to make: 3 days
Cost to make: About 3,000 yen
Best point: Eros.

Left
Cosplayer's name: Mochida Kensuke
Character name: Sasagawa Ryouhei
Time to make: 5 hours
Cost to make: 10,000 yen
Best point: I gathered the pants so that they would look like the ones in the original, and reproduced the underwear peeking out too.

Yes! Pretty Cure 5 GoGo!

❶
Cosplayer's name: Haruzou
Character name: Cure Rouge
Time to make: About 1 week
Cost to make: Less than 10,000 yen
Best point: The tail was more difficult that I thought it would be.

❷
Cosplayer's name: Kirata
Character name: Milky Rose
Time to make: 10 hours
Cost to make: 20,000 yen
Best point: I worked super hard on the hair decorations. The costume is by Cure Dream. Thanks!!

❸
Cosplayer's name: Komachi
Character name: Cure Dream
Time to make: About 3 days
Cost to make: 20,000 ~ 30,000 yen
Best point: I like this costume enough to remake it over and over! I want to keep doing this.

❹
Cosplayer's name: Chacha
Character name: Cure Lemonade
Time to make: About 2 days
Cost to make: 15,000 yen
Best point: The hair! I really worked hard on the curls.

Event Report 2008.5.18

Cosplay Festa
In Tokyo Dome City Attractions

Organization: Cosplay Festa Executive Committee
An event full of dreams at Tokyo Dome City! As soon as you entered the gate, you were in a different world. From St. Seiya to Kamen Rider to Takarazuka…a fun place to take the whole family. In defiance of the first heat of summer, participants paraded in full costume!

Left
Cosplayer's name: Ari
Character name: Kazama Hiroto
Time to make: About 3 days
Cost to make: About 20,000 yen
Best point: I was really happy that we were able to complement each other so perfectly! Next time I'd like to try a different version.

Middle
Cosplayer's name: RinCOZ
Character name: Tsukishima Kirari
Cost to make: About 15,000 yen
Best point: The SHIPS I'm with are very cool!

Kamen Rider the First

Cosplayer's name: Hayashi
Time to make: 9 months
Best point: It's very hot, isn't it…

Takarazuka Revue Hoshi-gumi Performance El Alcon – The Falcon –

Cosplayer's name: Ouga
Character name: Masters
Time to make: About 1 week
Cost to make: 10,000 yen
Best point: Double-lined like the original, and made from velour, in spite of the heat.

Kirarin Revolution

Right
Cosplayer's name: En
Character name: Hiwatari Seiji
Time to make: 3 days
Cost to make: 20,000 yen
Best point: I'm happy that we were able to put together a Kirarin Revolution group at Tokyo Dome City!

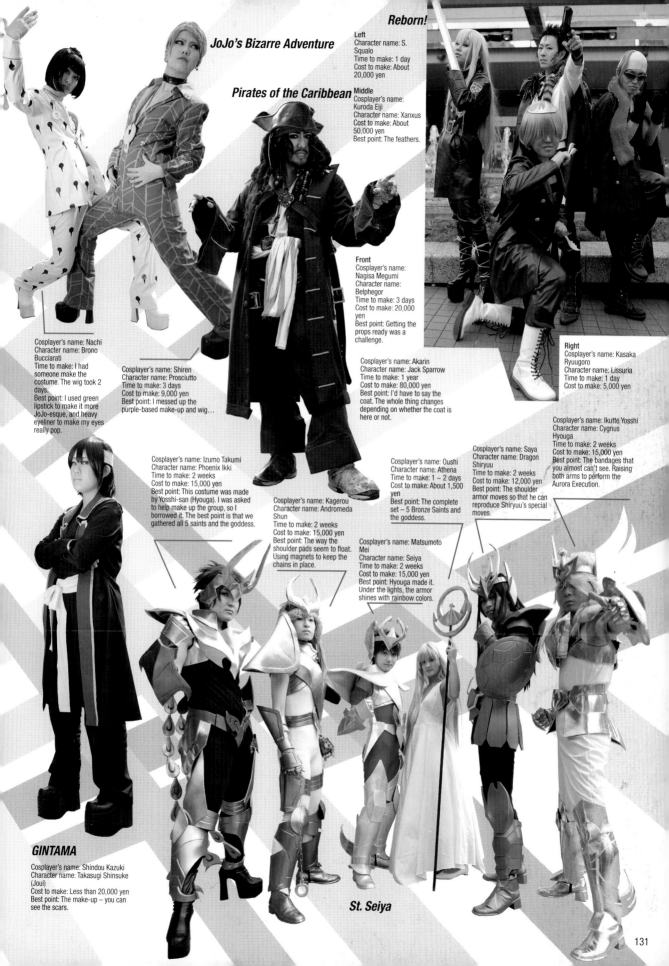

JoJo's Bizarre Adventure

Pirates of the Caribbean

Reborn!

Left
Character name: S. Squalo
Time to make: 1 day
Cost to make: About 20,000 yen

Middle
Cosplayer's name: Kuroda Eiji
Character name: Xanxus
Cost to make: About 50,000 yen
Best point: The feathers.

Front
Cosplayer's name: Nagisa Megumi
Character name: Belphegor
Time to make: 3 days
Cost to make: 20,000 yen
Best point: Getting the props ready was a challenge.

Right
Cosplayer's name: Kasaka Ryuugoro
Character name: Lissuria
Time to make: 1 day
Cost to make: 5,000 yen

Cosplayer's name: Nachi
Character name: Brono Bucciarati
Time to make: I had someone make the costume. The wig took 2 days.
Best point: I used green lipstick to make it more JoJo-esque, and heavy eyeliner to make my eyes really pop.

Cosplayer's name: Shiren
Character name: Prosciutto
Time to make: 3 days
Cost to make: 9,000 yen
Best point: I messed up the purple-based make-up and wig…

Cosplayer's name: Akarin
Character name: Jack Sparrow
Time to make: 1 year
Cost to make: 80,000 yen
Best point: I'd have to say the coat. The whole thing changes depending on whether the coat is here or not.

Cosplayer's name: Ikutte Yosshi
Character name: Cygnus Hyouga
Time to make: 2 weeks
Cost to make: 15,000 yen
Best point: The bandages that you almost can't see. Raising both arms to perform the Aurora Execution.

Cosplayer's name: Izumo Takumi
Character name: Phoenix Ikki
Time to make: 2 weeks
Cost to make: 15,000 yen
Best point: This costume was made by Yosshi-san (Hyouga). I was asked to help make up the group, so I borrowed it. The best point is that we gathered all 5 saints and the goddess.

Cosplayer's name: Oushi
Character name: Athena
Time to make: 1 ~ 2 days
Cost to make: About 1,500 yen
Best point: The complete set – 5 Bronze Saints and the goddess.

Cosplayer's name: Saya
Character name: Dragon Shiryuu
Time to make: 2 weeks
Cost to make: 12,000 yen
Best point: The shoulder armor moves so that he can reproduce Shiryuu's special moves.

Cosplayer's name: Kagerou
Character name: Andromeda Shun
Time to make: 2 weeks
Cost to make: 15,000 yen
Best point: The way the shoulder pads seem to float. Using magnets to keep the chains in place.

Cosplayer's name: Matsumoto Mei
Character name: Seiya
Time to make: 2 weeks
Cost to make: 15,000 yen
Best point: Hyouga made it. Under the lights, the armor shines with rainbow colors.

GINTAMA

Cosplayer's name: Shindou Kazuki
Character name: Takasugi Shinsuke (Joui)
Cost to make: Less than 20,000 yen
Best point: The make-up – you can see the scars.

St. Seiya

What is the WCS....?

The World Cosplay Summit is an international cosplay event hosted by Aichi TV and held every year in Nagoya, Japan. The event was started with two goals in mind – to showcase the cosplayers who play a major role in the visual introduction of manga and anime around the world, and to remind the Japanese themselves not to take this part of their culture for granted. The first WCS was held in 2003, with five cosplayers from three countries: Germany, France and Italy. It has gradually grown in scope, with the 2008 WCS featuring 28 cosplayers from 13 countries. This year, in recognition of the attention the event attracts overseas, the Ministry of Foreign Affairs, the Ministry of Land, Infrastructure and Transport, and the Ministry of Economy, Trade and Industry all added their support. The event has expanded to two days, starting with a grand parade on the first day, followed by the Championship on the second.

According to Aichi TV, when covering anime and manga events overseas, it is instantly obvious that the participants had developed a love for Japan and Japanese culture through their exposure to anime and manga, and this is most visible in the cosplayers. The cosplayers compete at anime and manga events in their home countries, and the top pair from each competition is flown to Japan to compete in the Grand Championship in Nagoya. The events range in size from relatively small (J-pop.con in Copenhagen, 3000 attendees) to large (TNT GT2 in Mexico City, 30,000 attendees) to huge (China Joy in Shanghai, 100,000 attendees). From numerous contenders, the best of the best were selected, and these 28 cosplayers gathered together under the hot skies of Nagoya to strut their stuff.

More than 12,000 people gathered at Oasis 21 in Nagoya to watch the contestants battle it out for the World Cosplay championship!

The Brazilian team accept their first-place award to thunderous applause, the second win for Brazil!

Special Report on WORLD COSPLAY

No.1 Brazil

The Brazilian team took the stage to huge applause, with fans in the audience waving large Brazilian flags. Their performance was simple, but effective, and nailed the grand prize.

Left: Jessica Moreria Rocha Campos (21)
Character Name: Django
Best Point:
She liked everything about their costumes. We thought the tattoos were amazing and the red contacts totally cool!

Right: Gabriel Niemietz Braz (26)
Character Name: Jo
Best Point:
For Gabriel, the 35cm heels he had to wear were the high point of the evening.

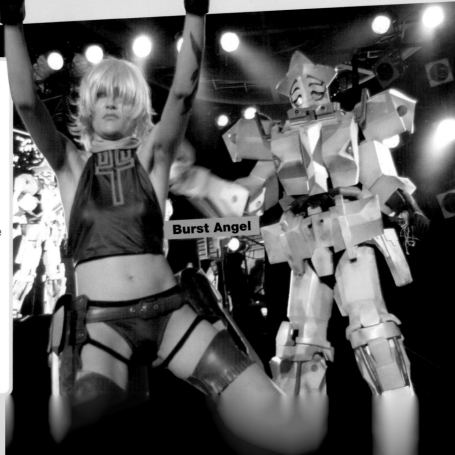

Burst Angel

No.2 China

The duo from China put on a drop-dead sexy and gorgeous performance, with a rather elaborate set and some very graceful dancing. It went off without a hitch to earn them 2nd place!

Left: Zhang Li (22)
Character Name: Kasuga
Best Point:
It took 4 years to complete her costume. She likes that it is very faithful to the original.

Right: Zhao Chin (21)
Character Name: Nouhime
Best Point:
This costume took 5 years to complete! Zhao particularly likes the action and dance in their performance.

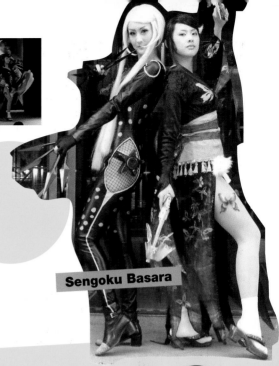

Sengoku Basara

SUMMIT 2008

28 cosplayers from around the globe gathered in Japan in August for the 6th World Cosplay Summit, but Nagoya's heat was no match for the fiery passion of these determined competitors! Text by Mary Scott Kennard, Photo by Aichi Television Broadcasting Co.,LTD

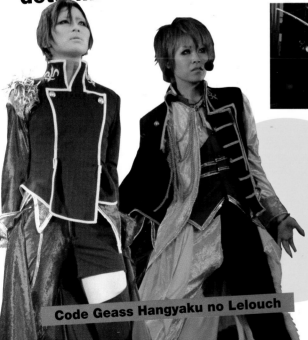

Code Geass Hangyaku no Lelouch

Left: Yui
Character Name: Lelouch
Best Point:
She combined his school uniform and the uniform Lelouch wears as Zero so that she could express his soul.

Right: Minoru
Character Name: Suzaku
Best Point:
This costume also combines elements that show both sides of Suzaku – the student and the warrior. Minoru particularly liked the bare set and their performance.

Japan

Brother Prize

(Osaka)

The team from Osaka put on a fantastic performance that was a big fan favorite – a hit especially with the women in the crowd as they played up the relationship between Lelouch and Suzaku! Woo-hoo!

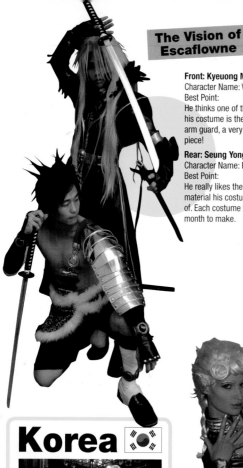

The Vision of Escaflowne

Front: Kyeuong Min.Kong (29)
Character Name: Van Fanel
Best Point:
He thinks one of the best points of his costume is the shoulder and arm guard, a very nice-looking piece!

Rear: Seung Yong.Kong (26)
Character Name: Folken Fanel
Best Point:
He really likes the hair and the material his costume is made out of. Each costume took about a month to make.

Spain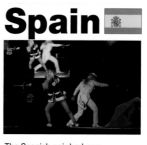

The Spanish pair had one of the more elaborate sets of the evening, and a fine performance to go with it – including a complete costume change for Utena in the middle. These two are a real couple! (They met at a cosplay event – it's destiny!)

Revolutionary Girl Utena

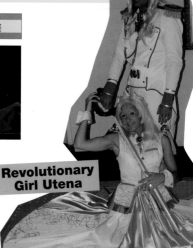

Front: Maria Pérez (25)
Character Name: Utena
Best Point:
The best points for Maria are the two costumes she wears. They both like the accessories, including the swords (all handmade).

Rear: Nicolás Cabrerizo (25)
Character Name: Akio Ootori
Best Point:
Each of their costumes cost about 1,200 USD to make, and took almost a year! He also likes the swords.

Korea

The dynamic Korean duo put one perhaps the most acrobatic and athletic performance, eliciting a storm of applause from the audience – and gasps at the death drop! Kakkoii!!

Left: Renee Gloger (22)
Character Name: Giorno Giovanna
Best Point:
It's shiny! Renee especially likes the rhinestones. Her costume cost nearly 1,000 USD, and took 4 months to make.

Right: Sonnya Paz (21)
Character Name: Jolyne Kujo
Best Point:
Sonnya likes it all, from the wig and make-up to the spider-web top and lace-up pants. This one also cost about 1,000 USD, and took 7 months!

USA

Rather than a dramatic performance, the US team went for a kind of dance-off between Giorno and Jolyne. There was some great dancing, and they even managed to capture some of the grotesque Bizarre World poses!

JoJo's Bizarre Adventure

Preliminary Rounds (by country)

Each country has its own process, but in general, a company or event sponsors the preliminary round or rounds in each competing country. In some countries, cosplayers are recruited over the Internet, or at small competitions at regional events. All costumes must be from Japanese anime or manga, and must be handmade. At the end of the preliminary rounds, one team of two cosplayers will have been selected to represent their country in Japan!

Paris, France
JAPAN EXPO 2008
(July 3~8, 2008)
70,000 attendees

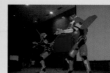

Rome, Italy
ROMICS 2007
(Oct. 4~7, 2007)
20,000 attendees

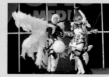

Barcelona, Spain
SALON DEL MANGA 2007
(Nov. 1~4, 2007)
67,000 attendees

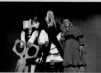

Copenhagen, Denmark
J-pop.con 2007
(Nov. 2~4, 2007)
3,000 attendees

Thailand, **JAPAN WEEK 2007** (Sept. 23, 2007), 10,000 attendees / United States, **NY Anime Festival** (2007 Dec. 7~9, 2007), 20,000 attendees / Korea, **Everland Cosplay Festa 2008** (June 1, 2008),

Thailand

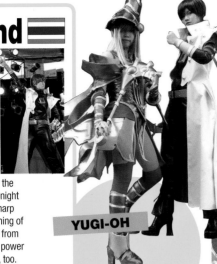

This performance got the biggest laughs of the night when things took a sharp turn with the summoning of …Pikachu and a drill from Gurren Lagann!? The power level bars were great, too.

YUGI-OH

Left: Jittraporn Distraprom (22)
Character Name: Black Magician Girl
Best Point:
She wanted to entertain everyone, and they certainly succeeded at that!

Right: Julaluk Lohanawakul (18)
Character Name: Seto Kaiba
Best Point:
The props used in this performance were some of the best of the competition.

France

They really did look like a CLAMP manga come to life! The performance was very elegant and quite well-rehearsed – it went off flawlessly. It was one of the most beautiful of the evening.

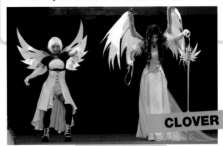
CLOVER

Left: Cecil Auclair (21)
Character Name: Suu
Best Point:
Each costume took about a year to make. Suu cost about 400 USD. Cecil likes to enjoy acting out the characters.

Right: Laura Salviani
Character Name: Oruha
Best Point:
Oruha cost nearly 700 USD to make. Laura also likes to have fun on stage, and likes the details of the costumes.

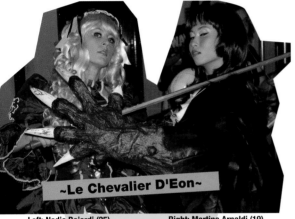
~Le Chevalier D'Eon~

Left: Nadia Baiardi (25)
Character Name: Lia
Best Point:
The costume change from female to male was very impressive.

Right: Martina Arnaldi (19)
Character Name: Anna
Best Point:
The giant claw was exceptionally well done and intimidating.

Germany

The German team did a nicely dramatic rendering of the relationship between Utena and Anthy, including drawing the sword from Anthy's body. There was even ribbon twirling!

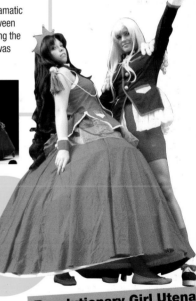

Left: Katharina Wehrman (19)
Character Name: Anthy
Best Point:
She liked the challenge of sewing the dress, and particularly its femininity.

Right: Ann-Katherine Fischinger (21)
Character Name: Utena
Best Point:
Utena's uniform – even though it resembles a boy's uniform, it's absolutely girlish!

Revolutionary Girl Utena

Italy

The Italian pair acted out a synopsis of Chevalier, with some elaborate sets and costume changes. They were one of the teams who did their own lines in Japanese – quite a challenge in front of so many people!

Kassel, Germany
CONNICHI 2007
(Sept. 8, 2007)
20,000 attendees

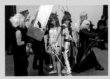

Mexico City, Mexico
TNT GT2 2008
(Feb. 2~4, 2008)
30,000 attendees

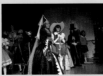

Sao Paulo, Brazil
JBC 2008
(June 21, 2008)
10,000 attendees

Osaka, Japan
Cosplayers Jam
(July 13, 2008)

Tokyo, Japan
Cosplay Festa
(May 18, 2008)

10,000 attendees / Singapore, **COSFEST 2008** (July 5~6, 2008), 10,000 attendees / China, **China Joy 2008** (July 19, 2008), 100,000 attendees

Cosplayers on Parade!

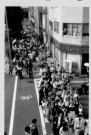

The WCS got a great start on Saturday, Aug. 3, with the now-traditional parade through the Osu district of Nagoya. The competitors led the nearly 100-meter line, followed by hundreds of regular cosplayers. Many of the competitors wore different costumes than they wore for the competition, and in spite of the heat, a grand time was had by all!

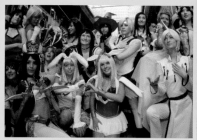
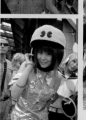
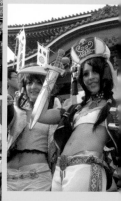

Mexico

Another great performance, this time by the team from Mexico, acting out a fight between Angewomon and Lady Devimon. It had to be hard to move in those heels, but move they did!

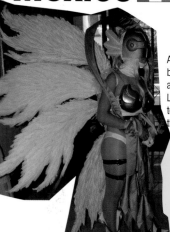

Right: Tersa Garcia Hernandez (24)
Character Name: Lady Devimon
Best Point:
Tersa likes the all-black color of the costume and the chains. (My high school teachers were never this cool!)

Left: Alin Nava (22)
Character Name: Angewomon
Best Point:
Each costume took about 4 months to make. Alin thought the wings and helmet were the best part of her costume.

Digital monster

Japan (Tokyo)

Nausicca of the Vally of Wind

The Tokyo twosome tackled one of Japan's most beloved anime movies, and did it proud, with a lot of really neat touches to spice up the performance.

Left: Shigure Naoki
Character Name: Nausicaa
Best Point:
Each costume took about a month to make, and cost about 700 USD.

Right: Kikiwan
Character Name: Ohmu, Oobabasama
Best Point:
For both, the best point was the spirit of love they brought to the performance.

Denmark

These two acted out a scene from Reservoir Chronicles, and if I'm not mistaken, they not only did their own lines, but also sang! It was very well done.

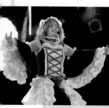

Left: Liuwina Haeklund (25)
Character Name: Sakura
Best Point:
The white parts of her dress – it took hours to sew them. The sleeves were really tough, too.

Right: Lisa Hvidberg (16)
Character Name: Syaoran
Best Point:
The combination of the performance and the costumes.

Tsubasa-RESERVoir CHRoNICLE-

Singapore

Another cosplaying couple! They acted out a dramatic scene from the anime version of Romeo and Juliet, complete with a mid-act costume change.

Left: Gerald Tham (24)
Character Name: Romeo
Best Point:
The ability to present the sequence of the story in a short stage performance.

Right: Goh I Hwa (23)
Character Name: Juliet
Best Point:
The detailing of the costumes, the speeches and the performance, as well as the contrasting colors.

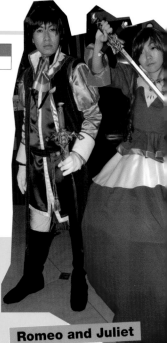

Romeo and Juliet

COSPA

Information on new items from famous cosplay costume company Cospa! (They cooperated in shooting the color pages at the front of the book.)

The long-awaited costume for Angelique, from the animated version of Neo Angelique Abyss, is finally here!

"When the time is right, a young woman of royal character will rule this land as the 'Queen-to-be'". This gorgeous costume is well-suited to Angelique, a young woman of destiny. The costume even includes accurate reproductions of her wrist and leg adornments, hair ornaments and decorated pendant. The bodice is fully lined. The sleeves snap on and off.

Product name: Angelique Costume
Sizes: S/M/L/XL
Price: 66,150 yen (including tax)
Set includes: Bodice (outer sleeves, back ribbons included), skirt, choker, lace ribbon for wrist (1), lace ribbon for legs (2), pendant, hair ribbons (4)

©KOEI Co., Ltd./Neo Angelique Production Committee

Product name: Yoite's Coat
Sizes: SS/S/M/L
Price: 29,400 yen (including tax)
Set includes:
*The shirt under the coat in the image is not included.

Supervised by the author, Yoshimizu Kagami!

From the popular anime series Lucky ☆ Star, which is always creating a stir, we're again offering the Ryouou Academy High School girls' uniform!!

A Lucky ☆ Star OVA has been scheduled for release – you just can't keep this series down! Just as in the show, the skirt is pleated from front to back, and there is a pocket on the right side. A winter costume is also available.

Ryouou Academy High School Girls' Summer Uniform
Product name: Blouse Set
Sizes: S/M/L/XL
Price: 18,900 yen (including tax)
Set includes: Blouse, ribbon

Product name: Skirt
Sizes: S/M/L/XL
Price: 12,600 yen (including tax)

© Yoshimizu Kagami/Lucky ☆ Paradise

We began offering Yoite's coat for sale!

Nabari no Ou is the story of a war between ninja using the forbidden technique "Shinrabanshou". From that series comes Yoite's coat. The slender silhouette sets off the design stitching, and accurately recreates this stylish coat from the series. We even recommend this coat for everyday use. Bangten Junior High School boys' uniforms are also available.
©Kamatani Yuuki/Square Enix · Nabari no Ou Project

Information about items used in the opening color pages:
The Melancholy of Haruhi Suzumiya: Socks (Black) (Reference product)
Persona 3 Hero Gekkoukan Academy Boys' Jacket Set 40,950 yen (including tax)
Persona 3 Hero Gekkoukan Academy Pin/3rd Year/White 945 yen (including tax)
Persona 3 Kirijou Mitsuru Blouse and Ribbon 16,800 yen (including tax)
GinTama Okita/Shinsengumi Costume Set 10,290 yen (including tax)

Store Information: **COSPA**
Address: Hagihara Bldg. 2F5-3 Maruyamachou
Shinagawa-ku, Tokyo, Japan
(Café de Crie is on the 1st floor.)
TEL/FAX: 81-(0)3-3770-3383
http://www.cospa.com
Open : 12:00~20:00
Closed: Irregular schedule
*Preparations are underway for accepting orders from overseas.

Cos Cute

Cos Cute, who also cooperated with the opening color pages (Shinku from Rozen Maiden and Suzumiya Haruhi), also offers many recommended products!

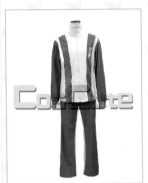

Prince of Tennis
Higa Junior High Jersey, Tennis Outfit
4-piece set

The embroidered logo and color of the uniform in this 4-piece set make this one of Cos Cute's most-recommended items. It accurately recreates the Higa Junior High's trademark purple color. As in the original, the color design is different on the front and back of the pants.

Price: 12,800 yen (including tax)
Set includes: Jacket, pants, sleeveless shirt, shorts (4 items)

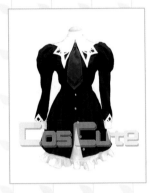

Strawberry Panic
St. Miator Academy Uniform

The one-piece overdress opens at the front with golden buttons. It accurately recreates the designs of the sleeves and collar, and the puffy shoulders and skirt. Uniforms from St. Spica Girls Academy and St. Lulim Girls School from the same story.

Set includes: One-piece overdress, skirt, collar, necktie (4 items)
*A pannier is used in the photo, but not included with the costume.

Rozen Maiden Suiseiseki

This dress is has a full, round skirt and is made of a dark emerald velvet with lots of lace. The blouse and vest are elegant and gorgeous. In addition, Cos Cute also offers costumes for all the other Rozen Maidens, including Hina Ichigo and Souseiseki!

Price: 22,500 yen (including tax)
Set includes: Blouse, vest, skirt, hair band, pannier (5 items)

Store Information: **Cos Cute**
Address: Utsunomiya Festa 2F
Mageshichou 2-8 Utsunomiya-shi
Tochigi, Japan
TEL: 81-(0)28-634-3222
Operating hours: 10:00~20:00
http://www.cos-cute.com
*If you can transfer payments to Japan Net Bank, you can place orders through the web site.

Information about items used in the opening color pages:
The Melancholy of Suzumiya Haruhi Kita High School girls' uniform 21,700 yen (including tax)
Rozen Maiden Shinku 21,500 yen (including tax)

Recommended cosmetics for hair and make-up

When doing the hair and make-up for this book, we tried many different products before settling on the ones recommended below. Here's a comprehensive introduction to our secret tools.

Mitsuyoshi

Hair Silver
A secret trick to using this is to mix it with Lining Color when you need a lighter color, and using as an eyebrow mascara.

Itabake (Paint brush)
This is indispensable in applying body paint. It can also be used with wet make-up from other companies.

Greasepaint
If you're choosing based on covering ability, this is the best foundation.

Sponge puff
Because it's so wide, it's very useful when applying all-over body make-up – perfect for cosplayers! Of course, you can use it with regular foundation as well.

Sharena Cleansing Oil
The refreshing feel when you use it is great, and it's gentle on your skin, too.

Stage Foundation Pro
There's a great variety of colors, it covers well, and more importantly, it's cheap!

New Product Information!
New colors in Sharena's popular Lumiere Color line of vivid colors! It's hard to find bright colors like these. Enjoy creating unique and personal make-up. There's a great variety of colors, it covers well, and more importantly, it's cheap!

Sharena Lumiere Color
Price: 1,260 yen each (including tax)

Face Cake
It gives your skin a look of translucency. It won't wear off easily, and resists sweat well.

Sharena Liquid Foundation
It spreads well, and has good covering ability. Includes ochre, a tone that's hard to find in stage make-up.

Manufacturer Information: **Mitsuyoshi**
http://www.mitsuyoshi-make.com/
*For orders from overseas, send an e-mail or fax to Okuda Ltd.
E-mail: sales@cosme-okuda.co.jp
FAX: 81-3-3803-4454

Chacott

Make-up Color Variation
The colors are very nice, and it can be used for eye shadow, of course, but also on the entire face.
One of the best things about it is that it's relatively inexpensive, and you get a lot of it.

New Product Information!

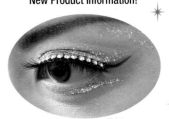

Point Eyelashes
These are particularly recommended for people using false eyelashes for the first time. They are meant to be applied just at the outer corner of the eye. You can use them everyday.

For cosplayers, we recommend the Lamé Glitter, available in 5 colors – Silver, Gold, Rainbow, Pink and Blue. It's an easy-to-use brush type, and resists sweat, which also makes it great for body painting as well as make-up. Just a little bit of lamé adds sparkle and shine and makes you really stand out! In this photo, we used Blue.

Lamé Glitter
Price: 3,465 yen each (including tax)

Manufacturer Information: **Chacott**
http://www.chacott-jp.com
* You can place orders through the web site's English pages.

139

Eye Shadow and Powder Blush
There are many different colors available

Eyelashes
The shape is excellent, as is the included adhesive.

Sculpting Blush
Compared to regular cheek blush, this has a more delicate tint.

Waterproof Eyeliner
The tip is superfine, which makes applying thin lines very easy! And it won't run!

New Product Information!
This new product is a colorless mascara foundation with fibers.
You probably have some mascara lying around - you love the color, but it doesn't have much volume. This product adds power to any mascara, and it contains pantenol, which is gentle on your eyelashes. A must-try product!

Full Cover
It doesn't wear off easily, and has excellent covering ability.

Manufacturer Information: **MAKE UP FOR EVER**
http://www.makeupforever.com/

Lash Fiber
Price: 2,835 yen (including tax)

176 colors in all! Color Contact shop Color ☆ Paradise 007

All of the color contacts used in our opening color pages were from this company. Contacts that make the eyes look larger, fashionable and unique looks, delicate color hues – all are available here! Many are available in prescription strengths as well, so even if you have poor vision, you can wear these. Of course the company has obtained permission under the pharmaceutical affairs law to sell corrective medical devices, and all contacts are produced in compliance with all medical safety criteria and standards, and are therefore safe for the eyes. Check it out!

Manufacturer Information: **007 Express Delivery Contacts**
http://www.007s-contact.jp/

These are the contact lenses used in the opening color pages!
Vampire Hunter/Aulbath Venus Eyes Royal/Royal Red
The Melancholy of Suzumiya Haruhi/HaruhiVenus Eyes Airy/Airy Chocolate
Persona 3/Hero ...Angel Color Edge/Edge Blue
Persona 3/Mitsuru ...Venus Eyes Candy Color/Candy Violet
Rosen Maiden/ShinkuVenus Eyes Crash Color/Blend Blue
Rosen Maiden/SuigintouFour Eyes Pattern/Red Fleck
Black Jack...Fresh Color/Gray

New Product Information!
Great news for cosplayers who like characters with red eyes!
From the popular series Venus Eyes, a new natural-looking red is in the works. Put them in, and you'll see a big difference!

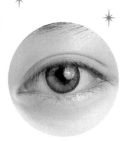

* Color contact lenses are treated as medical devices

Maid Beauty Parlor O~bu presents:
How to create that certain character

To start with, anime characters have a lot of hair! Depending on the angle, the hair style looks different! Regular hair cutting techniques just can't do the job. CosPlay Note went to cosplay events and asked cosplayers to fill out a questionnaire – and the one thing the majority of them worried about was how to handle wigs. So we've asked O~bu-san, who cut and set all the wigs used in the opening color pages, to provide the scoop on wig-cutting tricks and how to create hair for your characters. Try them for yourself as soon as possible!

First, the basic techniques

For characters with a lot of hair, or whose hair puffs out in places, use scissors to thin the hair at the roots and then backcomb to add volume. Wigs are silkier than real hair, so if you don't have a lot of very short hair, you won't be able to get the hair to stand up. Beginners should probably use thinning scissors. A lot of anime characters also have hair with jagged clumps, so it's important to be able to cut the ends evenly. To do this, place tension on the ends of the hair, and with scissors or a razor, cut the hair in a chipping motion. As you approach the ends of the hair, chip away more hair. If you can master these two techniques, you'll be fine. Set the hair and use spray or wax to hold it. Each character has its own unique characteristics, so look for those and do your best to recreate them.

Suzumiya Haruhi
The main point is the kind of puffy look. The image is of a perky young girl. Thin the roots and backcomb for volume. Clump the ends of the hair, apply hair spray to fix the style, and you've got Suzumiya Haruhi!

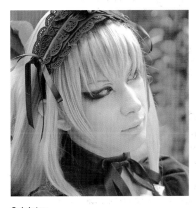

Suigintou
It's important here to balance the hair in back with the bangs and side hair. Once you've achieved the overall look, backcomb the hair in front to create a rounded silhouette. For the vital hair in front, use a razor to thin the hair from the middle to the tips, use your fingers to make the final touches, and use hair spray to set the style. A perfect reproduction!

The Hero
The hairstyle for this character is different depending on the angle. The trick is to balance the volume of the bangs and the side hair. The hair on the left and right starts at the same length; however, this means that when you turn to the side or otherwise move your head, you don't get a feeling of volume. Change the length of the left and right and arrange. Sometimes you'll need to use a power technique. Clip the edges, use spray to clump the hair together and set the style.

Black Jack
Black Jack is a man with a tragic past; the shock of an explosion turned half of his hair white. This character has an almost absurdly large amount of hair, but if you can reproduce the large shock of hair in the front, you'll be OK. First cut and combine black and white wigs, and then style the wig. You'll also thin the hair here to provide volume, but be careful not to thin it too much, or you won't have enough hair to work with. Thin bit by bit, carefully, keeping an eye on the volume. Notch the ends a little, and backcomb for volume. If it looks like you can thin it a bit more, do so until you reach a good balance. Set with hairspray. You can overcome it with love!

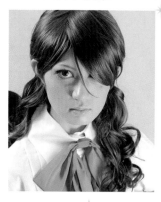

Mitsuru
Adjust the volume of the hair while shaping the hair.
I used a curly wig, but you can also use curlers. For hair from the top of the head, use 32 mm curlers, and for hair at the nape of the neck, use 25 mm curlers. Use spray to make the hair shine.

Store Information: Maid Beauty Parlor O~bu
Address: Saison Akihabara 1F, Soto Kanda 4-8-3 Chiyoda-ku, Tokyo, Japan
TEL: 81-(0)3-5296-2006
http://www.o-bu.jp/ (Japanese only)
Open: Weekdays / 12:00~20:30
 Saturday / 12:00~21:00
 Sunday, holidays / 11:00~20:00
*On Fridays, Saturdays and the night before a holiday, last orders are at 21:00.
Scheduled days off: None (The café may be closed now and then depending on circumstances.)

Hibari-Tei

You can meet some of our models at this shop. It's a café and bar that features guys dressed as maids. There's no set location – instead it moves from here to there. Check the Hibari-Tei blog to find out where they'll be next.
It's so popular that there's always a line of people waiting to get in, and we're looking forward to the next time we go!
If you're planning to visit Japan, be sure to look in yourself! You'll probably fall in love with the place!

The maids at Hibari-Tei – they're so slender! It's hard to believe they're guys.

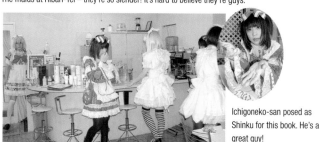

Ichigoneko-san posed as Shinku for this book. He's a great guy!

**There are new entries in the blog almost every day!
It's always crowded, so plan to get there early.**
Hibari-Tei HP:
http://www.hibari-tei.com (Japanese only)
http://blog.hibari-tei.com/ (Japanese only)

Cos ★ Note's Recommended Wigs

Cyperous

"There's so much volume!" "It's so silky the hair never gets tangled!" "It stands up to heat well, so it's easy to use!" "There are so many colors and styles!" These are just some of the comments on the wigs from Cyperous, who collaborated with us on recreating the exciting hairstyles in the opening color pages for this book. Hair volume is a vital requirement for anime cosplayers. O~bu-san, who styled the wigs, had this to say: "There were no gaps anywhere – the hair was attached in fine detail, and it's very close to the way human hair grows in. Styling these wigs was very enjoyable. The quality is very high. I think that of the wig makers, Cyperous creates the ones that are easiest to use."

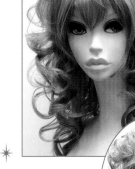

These are the wigs we used in the opening color photos!

The Melancholy of Suzumiya Haruhi·Haruhi FST-55-606 Dark Brown
Persona 32 ptMitsuru .. F301-118 Wine Red
Persona2 ptThe Hero ... CFST-40-4_BL Blue bangs X Black
Rozen Maiden2 ptShinku FC-330 Rozen
Rozen Maiden2 ptSuigintou FST-80-1900 Dark Silver
Black Jack .. FST-40-2 Bangs Pure Black X Near Black
CFST-40-1900 Bangs Dark Silver

Manufacture Information: Cyperous

http://cyperous.com/index.html
* It is possible to place orders from the HP's English page.

Store Information:
Address: 2-8-4, Kujou, Nishi-ku, Osaka-shi, Osaka, Japan
Open: 9:00~19:00
Closed: Sundays and national holidays
TEL: 81-(0)6-6584-9316

New Product Information!!

Cyperous announces new models one after another. This Princess wig is their newest release. It's hard to get this kind of volume on your own. The balance of the bangs is a major selling point. The wig is of course made using heat-resistant, cutting-edge fibers. A wig like this is great for everyday occasions, too – not just for cosplaying!

Product code: SC-536-27_369
Color: Brown mesh
Price: 6,900 yen

Model ✳ Profile

J'zK (Jayzkay) Nickname: Chazuke-kun
*Rozen Maiden – Suigintou; Black Jack
In 2002, became an h. NAOTO model.
Since winning a modeling audition, he has continued to model while also working as an assistant to the unorthodox pop unit ALI PROJECT. He is in great demand as a "beautiful young man model" or a "corpse doll talent." He also works for the unique cross-gender maid café Hibari-Tei as a project manager and scout. He was the main model in Graphic-sha's How to Draw Yaoi 2 Pose and How-to Edition.

http://tyazuke-un.jugem.jp/
http://tyazuke-dashi.jugem.jp/

kia
*Persona 3 – The Hero
Transcending the barriers of gender, kia works as a self-styled DOLL-type model.
Kia was born into a modeling family, and raised as a girl when young. Life and death, existence and nothingness – kia is interested in these circumstances, and engages in many activities outside of modeling.

MySpace:http://www.myspace.com/1000005523/

Ruri
*How to put on make-up model

KANA
*The Melancholy of Suzumiya Haruhi – Suzumiya Haruhi; GinTama – Okita Souji; Persona 3 – Kirijou Mitsuru

seek (Shiiku)
*VAMPIRE HUNTER Aulbath
Born Sept. 14, 1979. Bassist. Author.
Since 2007, he has been running Mix Speaker's, Inc. In 2006 he published an essay collection, Bonjin Suizokuen. At scheduled intervals, he holds independently planned live performances, titled Gyogun, that are a mix of talk show and acoustic performance.

http://www.mixspeakersinc.com/
http://ameblo.jp/seek-suityu-cafe/

Ichigoneko
*Rozen Maiden – Shinku
A self-styled "Cute Boy Hunter"! He works at the cross-gender maid café Hibari-Tei. Under the theme "Cute," he has posted Lolita fashion photos on his homepage.

http://strawberrycat.chu.jp/

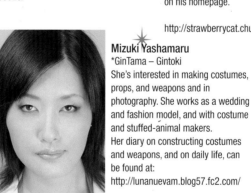

Mizuki Yashamaru
*GinTama – Gintoki
She's interested in making costumes, props, and weapons and in photography. She works as a wedding and fashion model, and with costume and stuffed-animal makers.
Her diary on constructing costumes and weapons, and on daily life, can be found at:
http://lunanuevam.blog57.fc2.com/

A self-styled "Aesthetics Illusionist," she is a wandering artist obsessed with her work. She is quietly expanding her participation in Gothic-Lolita events and competitions, and performing one-woman exhibitions. She also works as a model for Gothic-Lolita magazines.

http://www13.ocn.ne.jp~/croix/

Aran
*How to put on make-up model

Dolphins

by Dorothy Francis

Perfection Learning®

Dedication
For Richard

About the Author
Dorothy Francis has written many books and stories for children and adults. She and her husband, Richard, divide their time between Marshalltown, Iowa, and Big Pine Key, Florida.

Ms. Francis holds a bachelor of music degree from the University of Kansas. She has traveled with an all-girl dance band, taught music in public and private schools, and served as a correspondence teacher for the Institute of Children's Literature in Connecticut.

As an environmentalist, her goal is to make her readers aware of the creatures around them and their need for nurture and protection.

Ms. Francis has also written *Toy Deer of the Florida Keys* and *The American Alligator*, which are part of the Animal Adventures series.

Acknowledgment
I wish to thank the staff at the Dolphin Research Center on Grassy Key, Florida.

Image Credits: Innerspace Visions/©Hiroto Kawaguchi p. 8, Innerspace Visions/©Robert Pitman p. 10, Innerspace Visions/©Doug Perrine p. 11, Innerspace Visions/©Doug Perrine p. 12, Innerspace Visions/©Doug Perrine p. 14, Innerspace Visions/©Doug Perrine p.19, Innerspace Visions/©Doug Perrine p. 20, Innerspace Visions/©Doug Perrine p. 30, Innerspace Visions/©Doug Perrine p. 33, Innerspace Visions/©Doug Perrine p. 34, Innerspace Visions/©Ingrid Visser p. 38, Innerspace Visions/©Jeremy Stafford-Deitsch p. 43; Innerspace Visions/©Doug Perrine p. 49; Laurel Canty Ehrlich, Dolphin Research Center, Grassy Key, Florida pp. 23, 25, 28, 29, 37, 41; corel.com pp. 6, 17

ArtToday (some images copyright www.arttoday.com); Corel Professional Photos title page, pp. 5, 13, 47

Paperback ISBN 0-7891-5243-6
Cover Craft® ISBN 0-7807-9656-x
5 6 7 8 9 PP 10 09 08 07 06

Contents

1. Hello, Baby 6

2. Fin(ger)prints 12

3. Lucky's Lagoon 17

4. Dolphin Folklore 23

5. A Dolphin Research Center 28

6. A Swim with the Dolphins 34

7. Captivity or Freedom? 39

8. A Threatening World 42

9. The Training Session 47

 Dolphin Facts 51

 Glossary 54

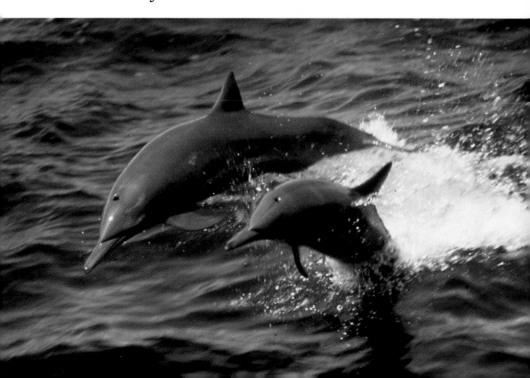

Hello, Baby

Jason Blake clutched the **gunwale**. He tasted salt as sea spray misted his face.

Ned, Jason's uncle, brought the boat to a near stop. The slowed motor hummed. Then Ned grabbed his camera. Ned worked as a wildlife photographer. He sold his photos to scientists.

Jason felt lucky. His uncle lived in the Florida Keys. And Jason was his guest for the summer.

Jason wanted to write about the wildlife in the Keys. He hoped to use Ned's photos. Then maybe Jason could get the story published.

"There they are!" Ned shouted. He pointed over the **bow**. "My marine patrol friend called. He said that he had seen a pod of bottlenose dolphins. They were feeding in this area."

"Pod?" Jason asked. "Like alien pods? I've seen those in movies."

"No," Ned laughed. "A *pod* is a small group of dolphins swimming together. A large group is a *herd*."

"I don't see a thing." Jason sighed. He peered into the rolling water.

"Keep looking," Ned said. He eased the boat forward.

"Dolphins have a protective coloring called *camouflage*," Ned continued. "This coloring helps them blend in with the sea. The dolphins look like gray-black shadows."

"See? Over there!" Ned was pointing to the left.

"Wow!" Jason cried. "They're huge."

"Adults are sometimes 13 feet long," Ned said. He snapped pictures. "Dolphins weigh up to 400 pounds. Sometimes they surround a school of small fish. Then they take turns eating."

8

"How do they do that?" Jason asked.

"The pod guards the school," Ned explained. "Then one dolphin swims through the school. It eats whatever it can catch. After that, another dolphin takes a turn."

"Smart," Jason said. "But these dolphins aren't doing that. One's down deep. The others are above and below it. Oh, look!" Jason leaned over the side of the boat. "What's that? Something's rising to the top."

"We're lucky, indeed," Ned said. "It's a newborn. It's taking its first breath.

"Dolphins help each other," Ned continued. "Especially at the birth time. The female needs rest. So her helper pushes the baby up for air. The baby must breathe quickly. Or it will die."

 9

Jason watched the baby dolphin. It opened the **blowhole** on top of its head. It wheezed as it sucked in air. Then it went below the surface again.

"Cool!" Jason said. "Awesome! Even baby dolphins are big. That one must be three feet long."

"Right," Ned said. "It probably weighs about 30 pounds.

"Dolphins know how to swim when they're born," Ned added. "They use their flippers and tail **flukes** to push themselves through the water.

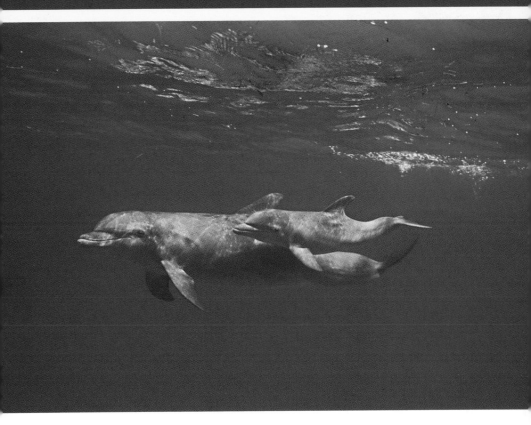

But the babies stay close to their mothers.
They nurse on their mothers' milk for many
months."

"They're leaving," Jason said.

Ned aimed his camera. "I want some shots
of their fingerprints," he said.

Jason raised his eyebrows. "Dolphins have
fingerprints?" he asked.

 11

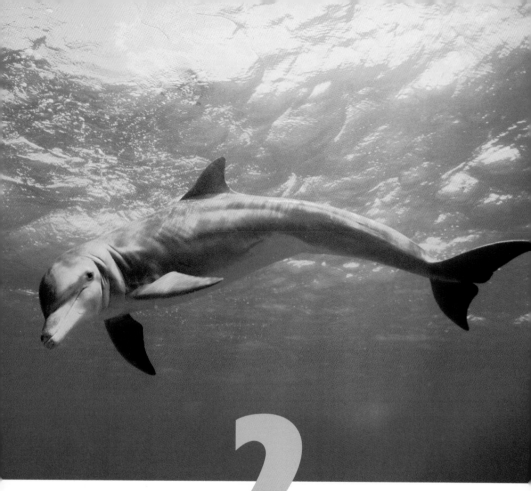

Fin(ger)prints

"Where are dolphins' fingerprints?"
Jason asked. "They don't have hands. Do
their side flippers have fingers?"

12

"No," Ned said. "I was joking. I took pictures of the dolphins' *fin* prints. But they're not on the side flippers. Those are **pectoral fins**. They are made of bones and **cartilage**. Dolphins use them for steering. They use both the pectoral fins and tail flukes as brakes."

dorsal fin

fluke

pectoral fins

fluke

"Each tail lobe is called a *fluke*, right?" Jason asked.

"Right," Ned answered. "Flukes are pads of tough, dense tissue. They have no bone or muscle."

Ned went on. "Dolphins' back muscles move the flukes up and down. This sends the dolphins forward."

 13

"But I was snapping shots of **dorsal fins**," Ned explained.

"I know what they are. They're the big fins along dolphins' backs," Jason said. "But why are you taking pictures of them?"

"I'm going to send them to my friend in Australia," Ned explained. "He works at the Dolphin Research Institute. This group works to protect dolphins. The scientists are searching for ways to identify individual dolphins. So they use photos of the dolphins' dorsal fins."

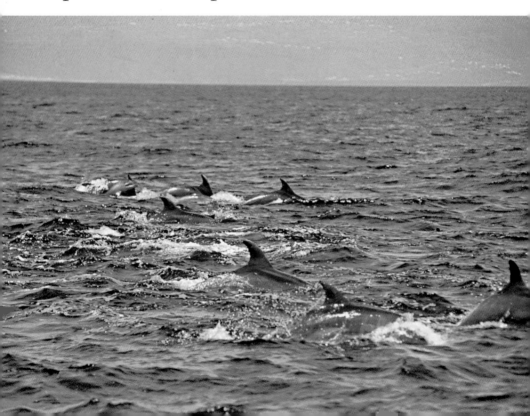

"How do they do that?" Jason asked.

"They snap photos of dorsal fins from small boats," Ned said. "They also dictate what they see into tape recorders.

"Scientists think each dorsal fin is *unique*," Ned continued. "They're one of a kind. Scientists hope to use them to identify individual dolphins."

"You mean like the police identify humans with fingerprints?" Jason asked.

"Right," Ned agreed. "Researchers use the notches on dorsal fins for identification. But some fins don't have notches."

"Then what?" Jason asked. He grabbed the gunwale as the boat hit a wave.

"Photos help identify unnotched fins by shape and size. One day, these researchers may succeed. Then they can track the movements of individual dolphins."

"I hope they succeed," Jason said. "It will help them protect dolphins."

Ned headed toward shore. "That's why I'm sending my friend dorsal-fin prints," he said. "Who knows? He might see a Florida Key dolphin in Australia. Nobody knows how far they travel. They are creatures of mystery."

"I'd like to work with dolphins someday," Jason said. He pulled out a notebook. He wrote about the day's sightings. His notes would be helpful in writing his story.

"Let's motor to Lucky's **Lagoon**," Ned suggested. "Lucky is a dolphin. He's like a pet. Only he lives in the wild. He swims to Adam Jackson's dock at feeding time. Want to meet him?"

Chapter

3

Lucky's Lagoon

Trees ringed the shore of Lucky's Lagoon.
Three pelicans watched the boat arrive.

"Those birds want a treat," Ned said. "Adam
sometimes shares Lucky's dinner with them."

"Welcome," called a gray-haired man. Jason thought Adam's faded jeans and shirt were cool. He also liked the older man's flip-flop sandals.

Ned introduced Jason. Adam helped him onto the dock.

A fishy odor rose from a bucket Adam carried. The pelicans flew closer.

KERWHAK! Suddenly Adam hit the dock with a stick.

"That's dolphin talk for 'dinner's ready', " Adam said.

Soon, a sleek dolphin swam into the lagoon. He came straight to the dock.

"Up, Lucky," Adam said. He raised one finger. Lucky leaped high. He stood on his tail. Then he splashed back into the water.

Jason ducked. But he was too late! He tasted salt. And he felt the water drench him.

"That's Lucky's big hello," Adam said. He tossed Lucky a dead fish from the bucket.

18

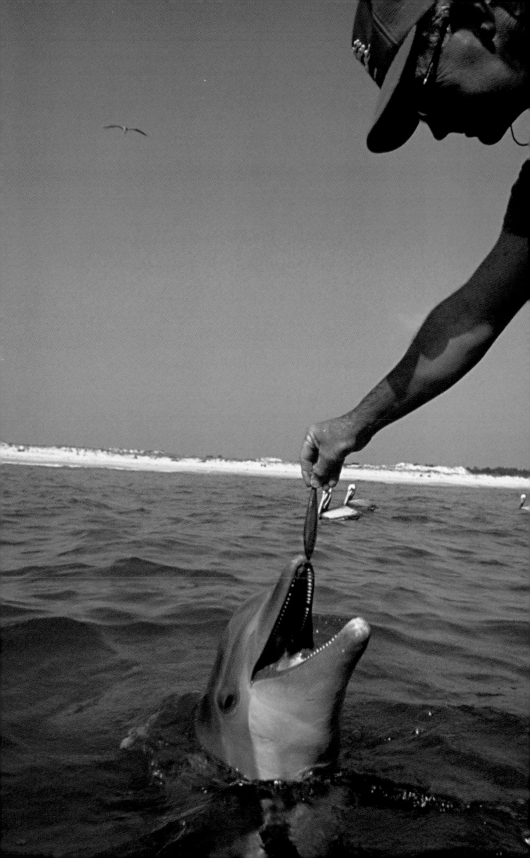

"How long have you owned Lucky?"
Jason asked.

"I don't own him," Adam said. "The
lagoon is open. He comes and goes as he
pleases."

"He's really big," Jason said. "I've never
been so close to a dolphin before."

"He is big," Adam said. "And he's smart.
Up, Lucky." Adam raised two fingers.
Lucky jumped twice. This time Jason
ducked the spray.

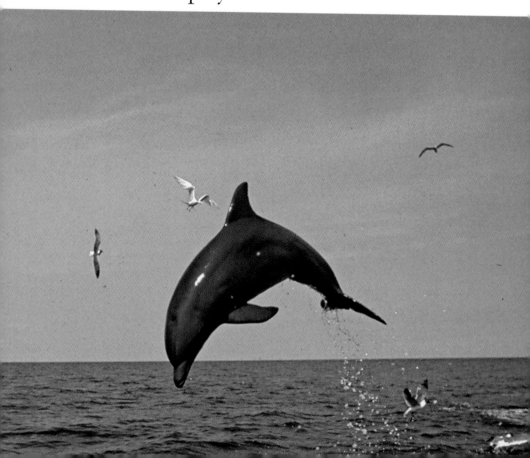

Next, Adam raised three fingers. Lucky jumped three times. Adam tossed him two fish. But the pelicans grabbed one of them.

"He can count!" Jason said. He saw Lucky's blowhole open and close. And he heard Lucky's heavy breathing. "I can see Lucky's eyes. But where are his ears?"

"Tiny ear openings are behind his eyes," Adam said. "He has teeth too. Almost a hundred of them."

"Oh, he's leaving," Jason said. He watched Lucky swim away. But Lucky soon returned. And he was shoving a rubber raft.

"That's his favorite toy," Adam said. He gave Jason a teacup. "Toss this as far as you can. Then watch."

Jason tossed the cup. Water swirled as Lucky dived. Then he surfaced. He was balancing the cup on his nose like a crown jewel.

"Clap," Adam said. "He's a **ham**. He loves applause." They clapped.

Then Adam held the bucket toward Jason.

"Treat time," Adam said.

Jason reached into the bucket. The fish felt cold and slimy. But he heaved two of them toward the water. Pelicans stole them both. Jason tossed one more fish. Lucky grabbed that one.

"What a story this will make," Jason said. "I'd like to be a dolphin trainer some day."

"Come back," Adam said. "I'll let you practice on Lucky."

"It's a deal," Jason agreed.

"But right now we have to leave," Ned said. "We have one more stop to make."

4
Chapter

Dolphin Folklore

"Where now, Uncle Ned?" Jason asked. He braced himself as the boat rolled.

"We're going to the Dolphin Research Center," Ned replied. "It's on Grassy Key. I have a surprise for you.

"But it's a ways," Ned added. "So, how about some dolphin tales? People have known about dolphins for ages, Jason."

 23

"Homer was an ancient Greek poet. He wrote about dolphins," Ned continued. "He lived thousands of years ago. His story hero, Odysseus, honored dolphins.

"Once, Odysseus's son, Telemachus, fell into the sea. A dolphin saw the boy. It thought the boy was in trouble. So it pushed him ashore.

"Odysseus wanted to show his thanks," Ned said. "So he carved the likeness of a dolphin on his war shield. Of course, that's just a legend."

"But would a dolphin do that?" Jason asked.

"It might," Ned replied. "We saw Lucky push that raft to Adam's dock. Dolphins like to push things. It may be an **instinct**."

Ned continued. "An ancient Roman scientist, Plinius, wrote about dolphins. He told of a friendship between a boy and a dolphin. In that tale, the dolphin carried the boy to school each day."

"I don't believe that one," Jason said.

"I agree," Ned added. "But we do have some modern dolphin tales too. You've heard or read about people nearly drowning. Some of them have claimed that dolphins saved their lives."

"What do you think? Did those drowning people imagine it?" Ned asked. "Or did dolphins really push them to safety?"

"I don't know," Jason said. "Dolphins are full of mysteries."

"Some doctors even believe that dolphins have healing powers," Ned continued. "These doctors hold meetings. The meetings allow patients to swim with dolphins. The doctors think that dolphins give off **ultrasonic** sounds. Those sounds might be healing."

"Truth or fiction?" Jason asked.

"We don't know for sure," Ned answered. "Humans go after the things they want. Sometimes good health is their goal. They may put all their thoughts into reaching that goal."

"So maybe positive thinking makes their wishes come true," Jason said.

"Perhaps," Ned said. "But now get ready for your surprise. I've saved a time slot for you. You can swim with some dolphins. Are you up for that?"

Swim with the dolphins? Jason's heart fluttered like a bird inside his chest. Was that bitter taste on his tongue fear? Would Uncle Ned think he was a wimp if he said no?

5
Chapter

A Dolphin Research Center

They finally reached Grassy Key. Jason
read the sign—Dolphin Research Center.
Jason's knees felt like pudding. But he
kept calm.

28

Blue stepping-stones led to a shaded bench. Dolphins splashed and dived in fenced lagoons. Jason shivered at the thought of joining them.

"We'll take a walking tour first," Ned said. "Then you can decide about swimming."

Jason had a choice! That helped him relax.

"How many dolphins live here?" Jason asked. "And where did they come from?"

"About 17 dolphins live in these natural lagoons," Ned answered. "The lagoons join the Gulf of Mexico."

Ned laughed as a dolphin splashed him.

"People bring sick or injured dolphins here for healing," Ned continued. "Some people rescue dolphins from poorly supervised parks. Or from traveling shows."

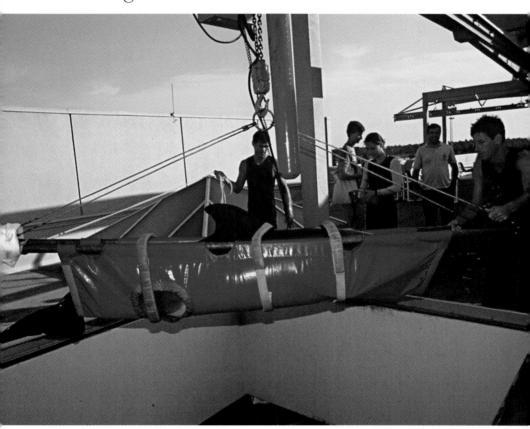

"Were any of the dolphins born here?" Jason asked.

"About half of them," Ned replied. "The center is around 30 years old."

"Humans are threatening all sea life," Ned explained. "This center strives to make people aware of dolphins. Workers here urge people to care for nature and its creatures."

"Are dolphins **endangered**?" Jason asked.

"Some species are **threatened**," Ned said. "Researchers may help protect wild dolphins. They study the ways dolphins live with one another. They study their vision and hearing. They chart their reactions to weather changes. And, of course, they study their eating habits."

"I suppose they eat the fish swimming in the lagoons," Jason said.

"Sometimes," his uncle replied. "But they prefer 'room service'—fish offered by the staff. Workers feed the dolphins regularly. Treats offered after performances are merely snacks."

"Maybe I could do dolphin research someday," Jason said.

A dolphin trainer approached. "Hi. I'm Jill," she said. "Would you like a walking tour?

"I'll introduce you to our dolphins," Jill began. "They'll entertain you. But you need to entertain them too. They like praise and applause. The more you shout and clap, the better they perform."

"What are those clicking sounds?" Jason asked.

"Dolphins make those sounds," Jill explained. "They listen for their echoes. Dolphins hear by **echolocation**. From the echoes, they can tell the direction and distance of objects. Of course, they see well too."

For an hour, Jason watched the dolphins jump. They dove. They did tricks. Jill seemed to have easy control of the huge creatures. How Jason wished he could help train a dolphin! It looked so simple.

Then came the moment of truth. Did he want to join the dolphins for a swim?

6

Chapter

A Swim with the Dolphins

Yes! Jason thought. I want to swim with the dolphins.

The thought scared Jason. But what a great scene for his story!

 34

Jason and three men followed Jill. They went to a lecture room. Jill told them dolphin facts. And she stated the swimming rules.

"Our dolphins are trained to swim with humans," Jill said. "You should never try to swim with wild dolphins. That would be dangerous."

Then Jill looked right at Jason. "Relax," she said. "You're going to have fun. Stay to the side of the dock. The space in front of the dock belongs to the dolphins. Don't splash or shout."

"May we touch them?" Jason asked.

"Yes," Jill replied. "Pat them on their backs or under their chins. They like that. Don't pat their stomachs. That could make them **aggressive**. Give them a kiss on the snout if you care to."

Kiss a dolphin? No way! Jason squirmed at the thought.

"The swim will last 20 minutes," Jill said. "Get into your suits. Let's get started."

Jason wore a wet suit to keep him warm. Then he joined the others at dockside.

"Jason," Jill said, "Merina especially likes children. Will you greet her?"

Jason's heart pounded. But he followed Jill's instructions.

He swam, arms stretched out in front of him. Merina glided toward him. She reached out with her pectoral flipper.

Jason and Merina shook hands. And Ned snapped their picture. Then Jason patted Merina's back. Her skin felt like a sun-soaked beach ball—soft, smooth, and warm.

"How about a back float, Jason?" Jill asked.

Jason nodded. He felt more at ease now.

Jason floated. He kept his feet together as he had been told to do.

Jill had prepared Jason well. So he wasn't startled when Merina's snout tickled his feet.

At first, she pushed him slowly through the lagoon. Then she gave a burst of speed. They skimmed across the water to the fence. And Merina left him there. She returned to Jill.

Jason paddled toward the dock. Then two dolphins swam to his rescue. He recalled Jill's words.

Jason eased between the dolphins. He placed his hands on their dorsal fins. What fun! He grinned as the dolphins towed him to the dock.

Swim time ended all too soon. Jason was about to leave the water. But first, he paddled toward Merina. He patted her head. She made clicking sounds.

Then he kissed her! Or did she kiss him? Uncle Ned's photo would tell.

7

Chapter

Captivity or Freedom?

Jason thought a lot about Lucky, Merina, and the other dolphins he had met. Was it kind to coax them into lagoons? Surely Adam had coaxed Lucky to his dock with food. Was it fair to keep dolphins captive?

"I feel sorry for those penned dolphins," Jason said. "I think they'd rather be free in the sea. Nearly 500 bottlenose dolphins live in **captivity** in the United States. Some people say that there are over 3,000 captive dolphins in the world. I read that in a book."

"Humans began keeping dolphins captive over 100 years ago," Ned said. "People tried to save dolphins that stranded on beaches. They displayed the dolphins to the public."

 39

"I bet tourists were really interested," Jason said.

"Yes," Ned said. "Then film companies set up marine tanks. They filmed dolphins for movies."

"I guess keeping captives can be okay," Jason said. "People need to see them up close. Then they'll become interested in them. Then they'll want to protect them."

"Public awareness is a big benefit of dolphin captivity," Ned added. "But scientists still need more than fin-print data."

"You said that some dolphins have been born in captivity," Jason said. "Dolphins won't become **extinct** if people raise them. Doesn't that make sense?"

"Yes, it does," Ned replied. "Captive dolphins make research possible. Data on wild dolphins is very limited.

"There are many things to consider," Ned continued. "Some people think it's wrong to teach dolphins to perform."

"Those dolphins seemed to like jumping and diving," Jason said. "They even looked as if they were smiling."

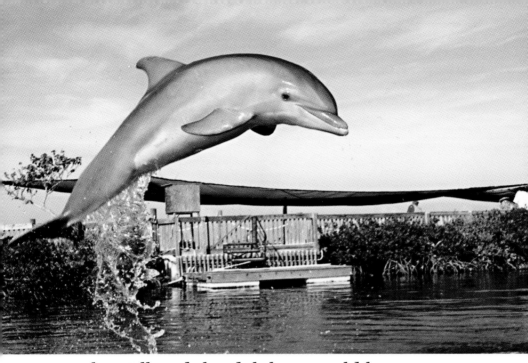

"Plus, Jill said the dolphins could have escaped," Jason added. "Water rose above the lagoon fences during Hurricane Georges. But the dolphins stayed."

"Maybe they knew they couldn't survive on their own," Ned said. "Hand-fed dolphins forget how to find their food. The Grassy Key center has become their home for life."

"I don't know what to think," Jason said. "I've loved meeting captive dolphins. But there are two sides to the question. And it's hard to choose sides. I like to think of them swimming happily *wherever* they are."

A Threatening World

A few days later, Jason and his uncle were getting ready for the day. Jason was about to learn more about dolphins.

"Be sure to wear sneakers," Ned said. "And bring a long-sleeved shirt. We're going to Ned Blake Key."

"A key named after you?" Jason asked.

"Right," Ned said. "Of course, I named it myself. It's uninhabited. And I'm the only one who knows its name."

"So why go there?" Jason asked. He felt the sunshine warm his head and shoulders.

Ned handed Jason rubber gloves. He loaded trash bags onto the boat. "It's cleaning day," Ned said. "I do this now and then. It helps protect the **environment**."

mangroves

"Trash collects in **mangrove** roots. It **pollutes** the water," Ned added. "Polluted water causes diseases in sea creatures. Removing trash is one way I can help."

Jason smelled the salt-scented air. They motored to Ned's island. The water looked clean. But bottles, paper, plastic, and cans littered the shore.

"I would have named it Human Trash Key," Jason said.

"Good choice," Ned laughed. Then he added, "Whales and sharks are the only sea creatures that threaten dolphins. But greater dangers come from humans. In some countries, people eat dolphins. In other places, people catch them and use them for bait."

"Fishing nets endanger them too," Jason added. "Dolphins must surface to breathe. If they're trapped in nets, they die."

"Tuna fishers must use nets that release dolphins," Ned said. "That's a law. But some people ignore it."

They reached the island. Ned shut off the motor. Then the two grabbed trash bags and splashed ashore.

"I'll grab paper," Ned said. "You pick up bottles. Later we'll do cans and plastic. Separating the trash makes **recycling** easier."

Mangrove roots arched from the water like snakes. Jason slipped. He slid. Sometimes he fell. But he soon learned to keep his balance.

Clankety clank. His bag quickly filled with bottles. Ned's bag rustled with paper.

"Now for plastic and cans," Ned said. "It's great to have a helper."

They worked another hour. And they filled two more trash bags.

"Picnic time," Ned said.

They peeled off their gloves. Then they boarded the boat. They sat on the bow and enjoyed sandwiches and sodas. Jason shared crusts with gulls that flew overhead.

"I'm glad we came here," Jason said. "I used to laugh at those roadside signs. The ones that said 'Don't teach your trash to swim.' I won't laugh anymore. Maybe I can organize some kids in the neighborhood. We could clear litter from local beaches."

"Great idea," Ned said. "But now, we're heading back to Lucky's Lagoon. It's time for Adam to keep his promise."

9

Chapter

The Training Session

Adam was waiting for them on the dock.
Again a fish odor rose from the bucket at
Adam's feet.

"So you want to be a dolphin trainer,"
Adam said. "Let's see if Lucky will perform
for you." Adam picked up a stick. He
handed it to Jason. "Give him a call first."

 47

Jason whacked the dock with the stick. A few moments passed. Then Lucky glided into the lagoon. He swam to the dock. Jason remembered Adam's signal.

"Up, Lucky!" Jason shouted. He raised one finger.

Lucky opened his mouth. He swam in a circle.

Was the dolphin laughing? It looked like it.

Jason tried the signal again. He held his finger higher.

"Up, Lucky!" he shouted.

Lucky lifted his head. He clicked at Jason.

"Give him a fish," Adam said. "A treat may get him started."

Jason tossed Lucky a mackerel. Lucky held it for a moment. Then he dropped it.

"He spit it out!" Jason cried. Dolphin training looked easy. But it was hard to do.

"Maybe the fish was too cold," Adam said. "Warm one in freshwater."

Jason turned on a hose. He rinsed
another fish. Lucky spit it out too.

"What am I doing wrong?" Jason asked.

"Maybe he wants smaller pieces," Adam
said. "He can be choosy."

Jason cut the next fish in half. He tossed
it to Lucky. And Lucky swallowed it.
Quickly Jason raised one finger. "Up,
Lucky!"

Lucky looked at Jason for a second. Then
he did a high jump.

"Good work," Adam said. "Give him another treat. I think you could learn to be a trainer. But it will take lots of work."

Jason cut another fish into two chunks. He warmed the chunks in freshwater. Then he tossed them to Lucky. Lucky grabbed the treat. Jason thought he saw Lucky wink.

"Lucky has a mind of his own," Jason said. "Maybe *he's* training *me!*"

Lucky refused to do any more tricks that day. Not for Jason. Not for Ned. And not for Adam.

In bed that night, Jason thought about Lucky. He thought about his visit in the Florida Keys. It had been fun. He had jotted lots of notes. Soon he would write his story.

Dolphins deserved human respect. They deserved understanding. And most of all, they deserved protection.

Jason wanted to be a research scientist someday. And working with dolphins might be a good place to start.

Dolphin Facts

Order

Dolphins belong to the *Cetacean* order.
All dolphins, porpoises, and whales
belong to this order.

Family

Dolphins are part of the *Delphinidae*
family. This family is part of the suborder
Odontocceti. This includes bottlenose
dolphins. It also includes killer whales and
pilot whales.

Porpoises do not belong to this family.
They differ from dolphins. Porpoises have
shorter snouts. They have triangular
dorsal fins.

Size

Bottlenose dolphins can grow to 13 feet
long. They can weigh up to 400 pounds.
Size depends on their **habitat**. Coastal
dolphins have small bodies. Offshore
dolphins have larger bodies.

Color

Dolphins are gray or gray-brown on their
backs, fading to white on the underside.

Shape

Bottlenose dolphins have sleek, streamlined shapes.

Features

Dolphins have pectoral flippers (forelimbs), flukes, and dorsal fins. Their heads are sleek. And they have three-inch snouts. Their teeth are cone-shaped and interlocking. Dolphins breathe through blowholes.

Family life

Dolphins are mammals. Females give birth to living young. The young are born knowing how to swim. Newborn dolphins travel with their mothers. They nurse for about 18 months. Males, females, and young travel in small groups called *pods*. Or they may travel in large groups called *herds*.

Dolphins are social creatures. They communicate by squeaking, grunting, or trilling. They also communicate with body language. They smack tails against water, butt heads, and snap jaws.

Within each pod, some dolphins dominate the others.

Habitat

Dolphins live in all the world's oceans. Many have home areas. They tend to stay in those areas.

Food

All dolphins are *carnivores*, or meat eaters. They like fish and squid. They swallow their food whole or in large chunks.

Life span

Nobody knows for sure how long dolphins live. Some captives are known to be around 30 years old.

Enemies

Natural enemies include sharks, whales, and humans.

Friends

Friends include humans who protect dolphins and work for conservation laws and the enforcement of such laws.

Glossary

aggressive
 fierce or threatening

blowhole
 opening for breathing which is covered with an airtight flap

bow
 front of a boat

captivity
 state of being held in a controlled area or human care

cartilage
 firm body tissue. The top part of the human ear is made of cartilage.

dorsal fin
 large fin located on a dolphin's back

echolocation
 hearing system in which high-pitched sounds are made. Their echoes determine the direction and distance of objects.

endangered
 in danger of being gone forever

environment
 one's surroundings

extinct
 gone forever

fluke
 lobe on a dolphin's tail

gunwale
 upper edge of a boat's side

habitat
 the natural home of a plant or animal

ham
 show-off

instinct
 inborn behavior common to an animal species

lagoon
 area of shallow water separated from the sea

mangrove
 type of tropical tree with massive roots that
 grow above or near the surface

pectoral fins
 pair of fins behind the head, one on each side

pollute
 to make unclean

recycle
 to use again

threatened
 close to becoming endangered (see
 Glossary entry for *endangered*)

ultrasonic
 unable to be heard by the human ear

For more information, contact

Dolphin Research Center
P.O. Box 522875
Marathon Shores, FL 33052
Phone: (305) 289-1121
Fax: (305) 743-7627
Web site: www.dolphins.org
Email: education@dolphins.org

Dolphin Research Institute
P.O. Box 1245
Frankston
Victoria, Australia 3199
Web site: www.dolphinresearch.org.au
Email: dolresin@iaccess.com.au